Painting and Drawing the Head

DANIEL SHADBOLT

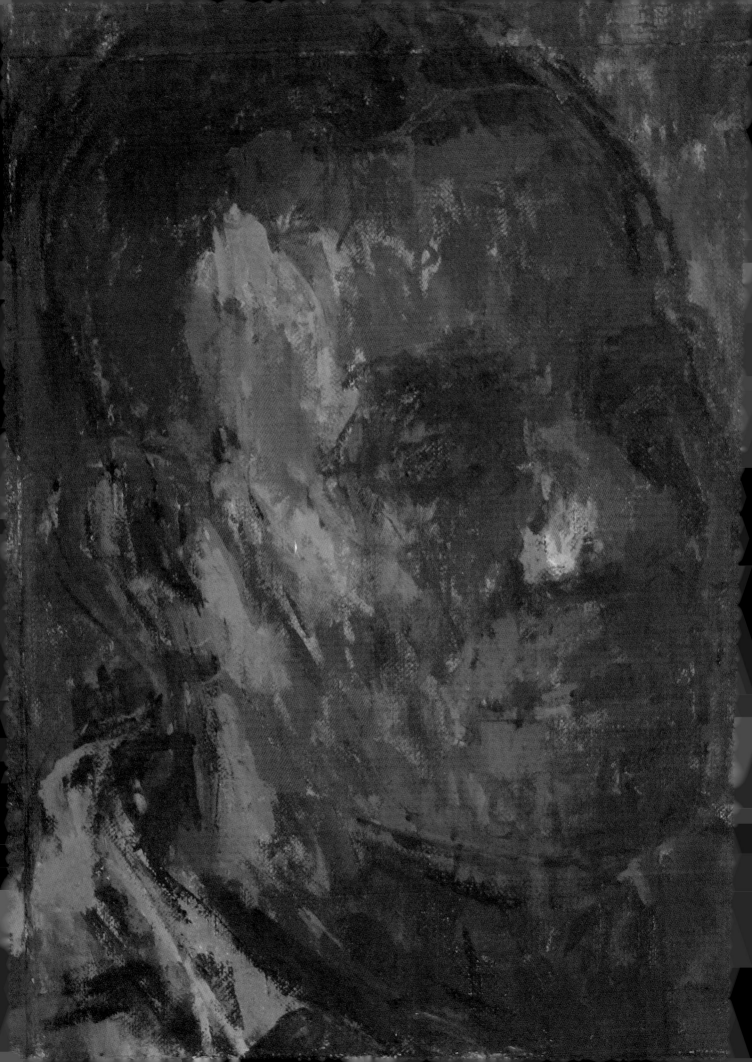

Painting and Drawing the Head

DANIEL SHADBOLT

THE CROWOOD PRESS

First published in 2016 by
The Crowood Press Ltd
Ramsbury, Marlborough
Wiltshire SN8 2HR m

www.crowood.com

British Library Cataloguing-in-Publication Data
A catalogue record for this book is available from the British Library.

ISBN 978 1 78500 163 5

Dedication
This book is dedicated to the artist and teacher Roger Ackling (1947–2015), whose generosity and humility in his teaching was an inspiration and support while I was a student at Chelsea College (2000–3).

A special thank you
I would like to thank The Heatherley School of Fine Art in London for their help with printing the working copies of this text for purposes of revision, and for access to their library. I would also like to thank the first year students of 2015 on the Portrait Diploma course for their help and hard work. Berni Timko, Harriet Doherty, Rosie Kingston and James Betts deserve a special thank you for allowing me to reproduce their paintings in this book. Many of the photographs of my paintings and drawings were taken by Andy Warrington, and I am very grateful to him for this. Chris Moock, Sharon Brindle, Julie Jones and Nicole Ashchurch very graciously gave their time and skill to help with proof-reading. Jason Bowyer kindly wrote a foreword. *Thank you all so much!*

Graphic design and layout by Peggy Issenman, Peggy & Co. Design Inc.
Print managed by Jellyfish Solutions

Contents

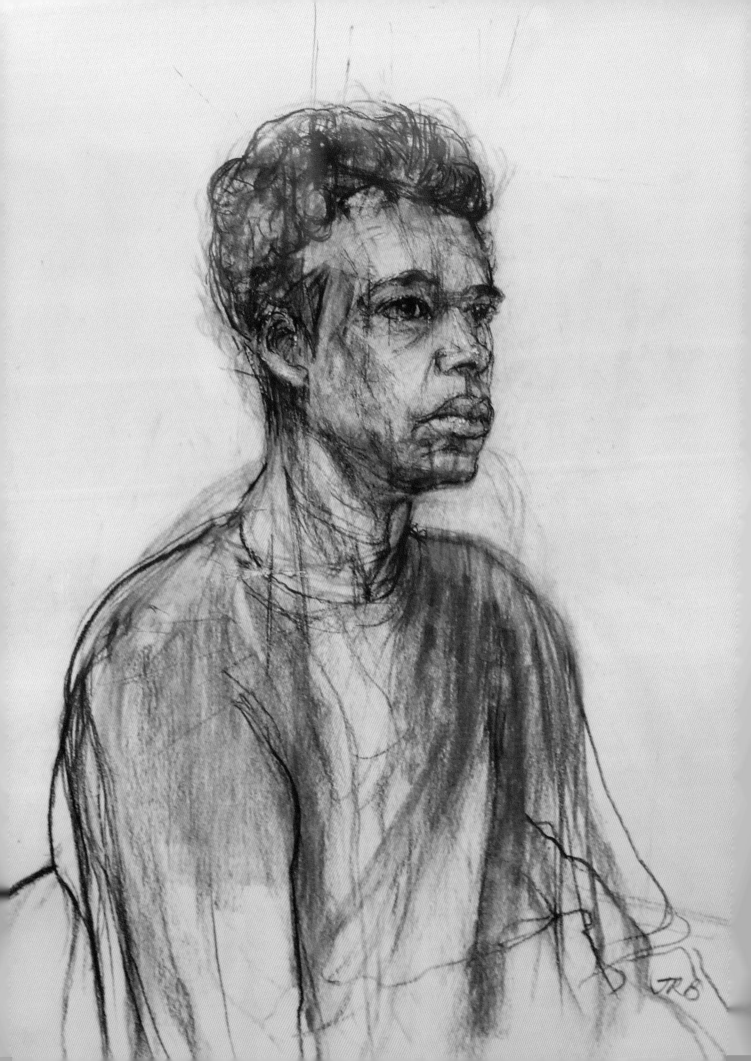

Foreword

To draw and paint a portrait you need to have an understanding of materials, techniques and methods alongside a sound philosophical aim. This book gives you these fundamental skills. Daniel creates a coherent but personal approach to teaching you how to draw or paint a portrait. He is a dedicated painter and teacher who will open your eyes and expand your vision with his thoughtful anecdotes and quotes. The complex process of portraiture is simplified in this book allowing you to look, then draw or paint the physicality and character of the person who has come to sit for you.

Jason Bowyer PPNEAC RP PS

Samuel by Jason Bowyer (charcoal); winner of the Prince of Wales Portrait Drawing Prize, Royal Society of Portrait Painters, 2015.

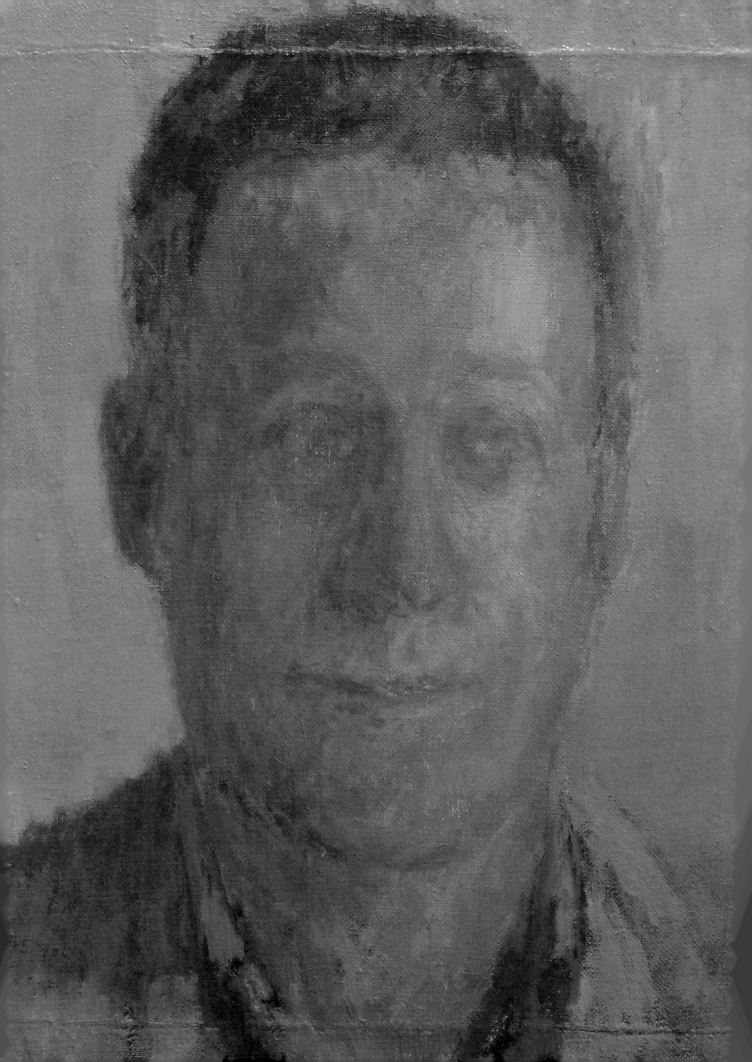

Introduction

Cold exactitude is not art; ingenious artifice, when it pleases or when it expresses, is art itself.

– Eugène Delacroix (1798–1863)

Anticipation of a new subject coming to sit for their portrait concentrates the mind to action: preparations have to be made, equipment should be ready, and a ground colour can even be prepared in advance. You may have studied the sitter's photograph or have tried to remember what the person looks like. After all this, they may contact you saying that they are running late, and at this point you can find yourself unable to do anything else until they have arrived and you can begin.

There is no experience in painting equivalent to the directness of painting the head from life. For one thing it is good to have company in the studio. If it is a friend their face is something you cannot quickly tire of looking at, and conversations had whilst painting can enrich the day. It is certainly different from copying from another source. I first became involved with portraiture after tackling still life and imaginary landscapes collaged from *National Geographic* magazines at school. I used photographs of people that I knew well and would attempt to paint their likeness whilst I was alone. I set out with the aim to make the picture as life-like as possible, but now looking back at these pictures they appear to have a particular style.

Hugh Valentine, 2010; an informal portrait to accompany a more formal commission.

Working from life

I have come to put more trust in the pictures made in response to working from life, with the person actually being there. Sometimes a picture will work - and quickly too - while at other times it goes on and on without seeming to achieve anything worthwhile. This is probably the greatest vulnerability of portrait painting, that there is never a guarantee of obtaining the desired result. Over years of accumulated experience, you can learn practices and methods which will give the best chance of success, but even then, there is always a chance that the picture will collapse from within and appear lifeless. This can be an unhappy moment and you can lose all patience or belief in the construction of an image. At such a point it is good to remember how exciting beginning a picture can be.

Once begun, a picture can seem to have a life all of its own, with each mark placed one after the other in a logical or emotional response without a single error until the painting is finished. Needless to say this is the rarer kind of progress, and the majority of paintings will register somewhere between success and failure. The more experience of painting you gain the better you will be equipped to understand what is working and what is not, although there is no immediate formula to success. Painting is unpredictable and can sometimes be resistant to your intentions, but never forget the importance of feeling and intuition in your work.

About this book

The book as a whole is a collection of lessons I have been taught and have come to consider as good practice for anyone painting the head from life. Since the head is connected to the figure, much of this approach to painting could be applied to life or figure painting too.

The first part (Chapters 1–4) gathers together the essentials, offering a reference section that is broad in its scope and can be used in a variety of ways, depending on your level of experience. You may for example wish to skip the first chapter and read it after the rest of the book. The second part (Chapters 5–9) describes the practical aspects of making an observed painting from life over several sessions. In the third part (Chapters 10, 11) there are notes on painting self-portraits, showing how to use yourself as a model – something that can be done at any time – followed by a concluding chapter discussing problems, issues and advice on portrait painting.

How you see things

A good starting point to consider is this: how can we look at something specific but still keep a grasp on the whole painting?

In very general terms, the way I can teach you to paint the head is to reverse the order in which you decide to paint it. Rather than starting with the eyes, look at the outline of the head and the big shapes within it. Working inwards from this outer structure can lead to the drawing of the features being better related, since they will fit into the shape of the head, rather than the head being drawn in around it.

As you may expect, this instruction is only a guide or an alternative approach. It is a method, like all other methods, which you should try if you have not already. You may of course find it suits your drawing better to build up and outwards from the centre.

The main practice is to be able to control your looking. This, over time, will form the basis of training your eye. To paint from life successfully, it can be a case of looking in the right way at the right time. My reason for tending towards a 'whole picture' approach is that often the eyes are the dominant feature in a picture. There is nothing wrong with this, since it is surely the eyes that are most revealing. Always we must paint what we see, but also we must bear in mind that *how* we see is influenced by what we are thinking about. Throughout the years I have spent painting, the way I see paintings has developed. I think vision in painting is highly personal and that it changes over time.

One aspect of continually looking at paintings that affected me was the consideration of the various surface areas of a picture. How much space does the head occupy in relation to the rest of the picture? Alternatively, you might question the amount of canvas that supports the painting of the eyes as a fraction of the whole surface area of the painting. Does the head benefit from having space around it? There are no definite answers to this question, but it is important that you consider it within your vision. Many paintings reveal upon closer inspection a vast discrepancy between the detailed work the painter put into painting the eyes of a portrait and the thinly painted background that surrounds it. As a whole, this may not be very satisfying to look at for any length of time.

Think of Gainsborough's half-length and even full-length portraits. The eyes are brilliantly painted, but what you will see first is the head as a whole. One of the most difficult things to draw is the relationship between the eyes and the head, and seeing somebody's feet at the same time as seeing their head is practically impossible. All the detail in the head is lost temporarily in your vision as you look at the whole from a distance. It is very difficult to train your eye to see everything. In a small portrait the eyes might occupy one twentieth of the whole picture surface. In a bigger picture the eyes will be a much smaller fragment of the whole. This awareness of the relative area size should put order into the construction of a picture, making the larger areas initially a greater concern for the painter.

The sitter's experience

As a model, sitting for a portrait is initially a pleasant way to spend your time, but it can develop into an incredibly tiring and concentrated activity. Eye contact with the painter can be tricky to maintain. Conversation can help but may also be distracting.

As a good way to improve your understanding of the process and to develop empathy for the person modelling I recommend sitting for a friend who paints. It is worth remembering that in an art class setting there are guidelines for modelling times: a fifteen-minute break after every forty-five minutes of painting is standard, and if the class runs for several hours, then stretch breaks are usually taken every twenty-five minutes or half-an-hour.

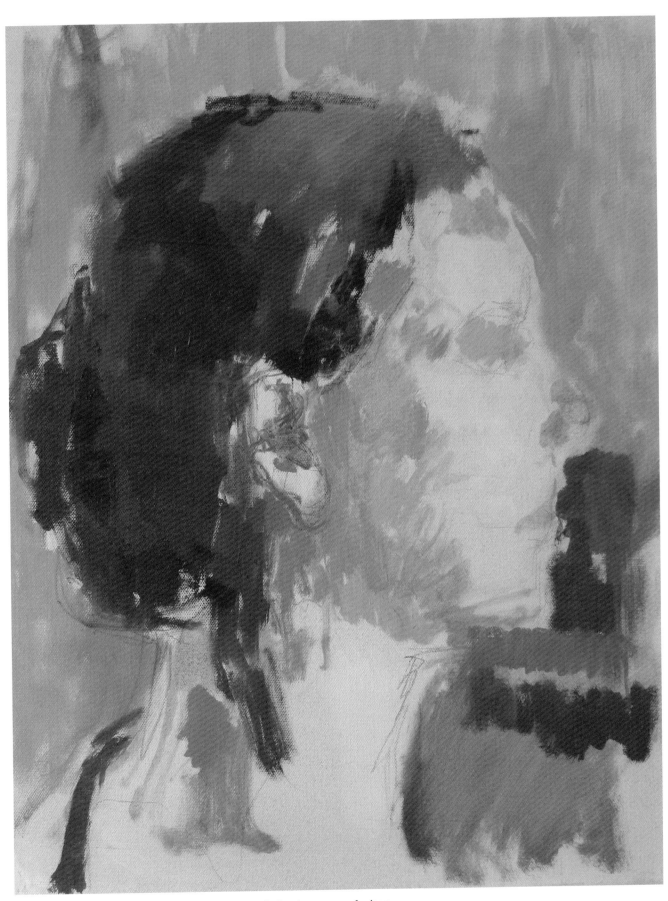

Natasha (profile study), 2011; a beginning of a painting, laying down areas of colour.

Jill, 2012; first stage.

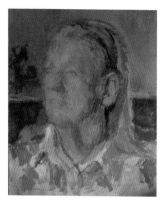

Jill, 2012; second stage.

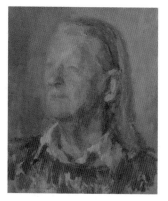

Jill, 2012; third stage.

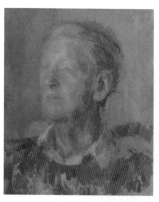

Jill, 2012; fourth stage.

The painter's vision

During a painting it can be difficult to keep following your vision. Without realizing it there may be a shift of scale in the drawing, which changes the picture. We tend to draw what we are interested in as larger than that which we are not so interested in, but with training this can be countered and the distortions can be minimized so as to increase the objectivity of the drawing.

Paul Cézanne (1839–1906) said that he wanted to create as much inter-relation as possible in his drawings. This is not the same as accumulating detail. Cézanne's 'inter-relation' seems to me to mean 'seeing' something at the same time as something else and connecting those two elements in the picture. This is different to looking at things in a sequence. It will take a long time in terms of effort and practice to be able to do this, but doing it will also help to explain the construction of space in a Cézanne drawing which may only consist of a few lines.

There are many things to watch out for, but as a first step, the most important is that you must follow what you see. In other words be careful that you do not look more at your painting than your model, and whenever you see something different, make the change to the picture no matter how dramatically different it is. Chasing the model like this with the drawing is the most reliable way to keep the picture up-to-date with how you are seeing.

Preparation and change

One example of being prepared to change everything at the last minute is captured in this series of photos that document a painting I was doing of Jill. In the first four photos of this picture each session builds on the previous without a major alteration. In the last session a movement of the head suggested an alternative composition that I thought would be an improvement to the image. The light source also changed as the position of the model was altered.

All of the preliminary build-up over hours of observation was a help in order to know better what I wanted to paint, and in generating the conditions where a risk could be taken. This process is not to be recommended when first starting out as it can lead to frustration and fragmented images. It is generally better to build up a calm consolidation of drawing over time. However, taking a chance with a picture can lead to a more refreshing visual arrangement.

Deliberation and patience are traditional components to the making of a portrait, and working from life is the best way to gain a sustained look at a real head, especially as seeing takes a long time. Getting to know your subject should lead to changes and surprises. Sometimes it is necessary to be flexible to meet these shifts in perception.

Jill, 2013.

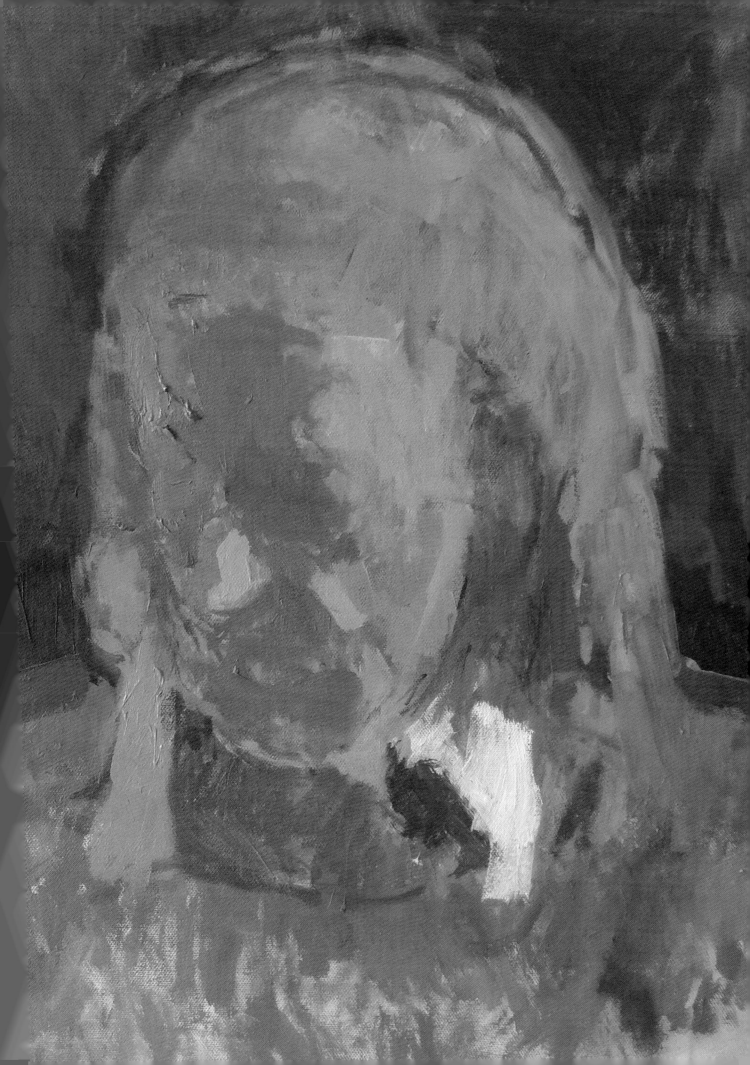

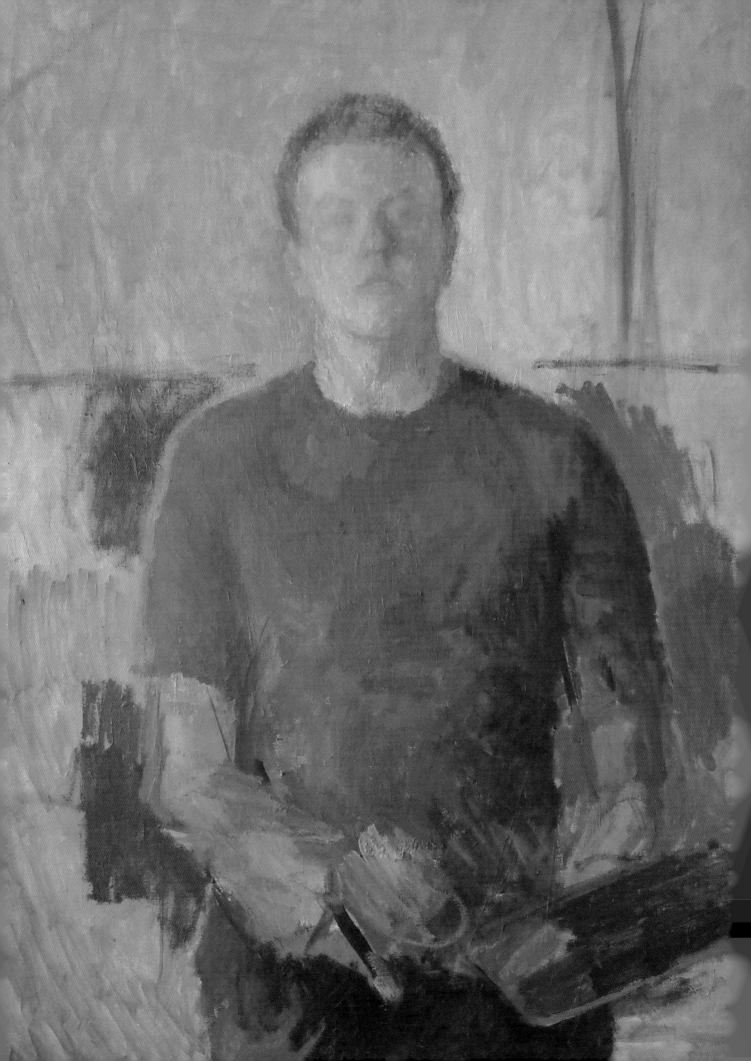

Equipment

When I was at Chelsea College of Art and Design, Mali Morris confessed how interesting she found each painter's palette to be. The individuality of the palette potentially reflects something about the artist who uses it. She claimed that this subject was worthy of attention in itself. Exhibitions of paintings frequently have the painter's tools placed in a cabinet as artefacts worthy of curiosity. When an artist is well known, the plainest objects associated with their working practice become of interest. These 'tools of the trade' give an insight into how an artist works and how they achieve particular effects through their favoured materials.

The equipment you are using may be the last thing on your mind, since you are so absorbed by the subject (what it is you want to draw or paint), but the equipment that you use is and will become very important to your painting and drawing. While all you may be concerned with at this point is how you want to draw or paint, an awareness of what limitations your equipment might have will give you a better understanding of how to improve what it is you are doing.

What your artwork is, whether it is a canvas or a drawing, will be the first thing immediately noticeable to the viewer. The materials I enjoy working with best are canvases that I have stretched, sized and primed myself. This can be impractical and time-consuming but it does give the best understanding of the craft and the tradition of using these materials, which

goes back for several hundred years. Since paintings prepared in this way have survived that amount of time, it gives a picture a good chance of preserving its qualities. Also the process of sizing and priming a canvas can be applied to board and paper, so that once you have prepared your own canvas you will have the understanding and experience required for the preparation of many surfaces as the basic principles remain the same.

I have divided the equipment notes into two sections: something to paint on and something to paint with.

Something to paint on

Every painting is painted onto a surface of some kind and the term for this is the 'support'. In order to prepare your own painting support you will need some canvas or linen, some stretcher bars, an amount of size (for instance rabbit skin glue) and some oil primer. Alternatively you may prepare a board or wooden panel. Even paper of a substantial weight can be stretched and prepared for painting; the paper should be heavy or thick so as to avoid wrinkling and is stretched onto a drawing board with a sticky gum tape.

There are a variety of primers that can be made fairly easily and which will be much more economical to make and use than the shop-bought primers. These can be researched but it is best to see first-hand by demonstration any method or technique before attempting it yourself.

Self-portrait with Palette, 2010; the use of a large mirror makes a larger self-portrait more practical.

Standard stretcher sizes

Standard stretcher sizes are given in inches, one advantage being that there is more chance of them fitting an older frame. (One inch is 2.54 centimetres, and this can be helpful to calculate the dimensions of a picture; the measurements in centimetres are rounded up to the nearest 0.5cm.)

Inches	Centimetres
10 × 12	25cm × 30.5cm
12 × 16	30.5cm × 40.5cm
16 × 20	40.5cm × 51cm
20 × 24	51cm × 61cm
25 × 30	63.5cm × 76cm
28 × 36	71cm × 92cm
30 × 40	76cm × 101.5cm
40 × 50	101.5cm × 127cm
40 × 60	101.5cm × 158.5cm

Initial purchases

These raw materials that I am suggesting will add up to over £100 but they will be an investment and you will get more use from them over time. If at this point it is beyond your budget then just use a shop-bought pre-primed canvas that you can paint directly onto.

The first thing you will need is your support. Buy some medium fine linen (approx. £30 for a metre – usually sold in 2 metre widths). This will be soft to the touch and flexible (not stiff like the pre-primed linen). Linen and canvas come in different weights and grain sizes (from fine to coarse).

Buy stretcher bars for the dimensions you require, let us say a 61cm × 51cm standard size (24 × 20in). Stretcher bars vary in design and depth; a standard 19mm depth (¾in) will cost £20–30 for all four lengths (usually sold in pairs).

Buy a pack of rabbit skin glue granules (approximately £10 for a 500g bag) and a small tin of oil primer (£40–80). The traditional primer is one which contains lead white. In my experience this is the best primer. It may prove difficult to get hold of due to recently introduced health and safety legislation. The oil primer that does not contain lead white will be more economical and will generally serve the same purpose. If you cannot get an oil primer then an acrylic primer can be used. Gesso is another alternative preparation.

Preparing a size

Prior to stretching your canvas, you will need to soak your rabbit skin glue granules. This is called a size and it acts as a barrier between your support (your canvas or board) and the paint, by penetrating the absorbent support. To prepare your size, use twenty-four parts of cold water per one part rabbit skin glue. This preparation can be a lengthy process, due to the drying times, and so it may be best to prepare a few canvases at a time. A third of a small cup of rabbit skin glue granules will be enough for two or three layers over several canvases.

Put this mixture of cold water and rabbit skin glue into an old saucepan. Stir well with a palette knife. There will seem to be a lot of water in relation to the granules at this point. Do not heat the mixture yet since the granules have not had time to absorb the water. Leave to stand for at least twelve hours. Stirring occasionally will help to circulate the grains and aid the absorption process. You will see the granules swell, so that by the end of the twelve hours there will be a lot less water noticeable above the layer of the thicker granules.

Rabbit skin glue granules in a saucepan with cold water, before absorption.

The amount of absorption after twelve hours.

Assembling the stretcher

Most stretcher bars will have smoothed rounded edges for the front, or a bevelled front edge. This is so that contact with the picture surface is minimized. Piece the bars together, putting the cross bars in first if there are any. Rock the stretcher on its end to ease the corner joints together. Use a wooden mallet to knock them firmly together and a set square to make sure that they are at right angles (90 degrees). It is frustrating and a waste of time if you realize, once the stretcher is assembled and the canvas stretched and primed, that your picture is not a true rectangle. Measure the two diagonal distances from corner to corner; if this distance is the same then the canvas is square. The wedges that are usually supplied by the stretcher maker are inserted into the inner corners, so that the right angle of their triangular shape is pointing towards the centre of the canvas. The wedges are useful for keeping the stretched canvas fully taut.

Stretching a canvas

Keep the direction of the weave of the canvas parallel to the stretcher. Lay the stretcher face down onto the canvas. Cut enough extra canvas surrounding the stretcher so as to cover the sides or depth of the stretcher bars. Two or three inches (5–6cm) on each side are usually enough.

Starting with the longest dimension first, put in a tack or a staple (staple guns are easiest to use) at the mid-way point. Opposite this first point is the position for your next staple. Pull up the slack canvas across the stretcher from your first staple to make it fairly taut, remembering to keep the direction of the weave fairly straight. (You can use canvas pliers, which are a useful tool, but I think they are best used with pre-primed canvas.) Pull quite tightly but not so tight as to cause a tear, and then secure with your second staple.

Now you have the desired tension in one direction it is time to evenly stretch, in a cross shape, perpendicular to the first direction. Pull both loose ends of the canvas at the same time in order not to pull it too far one way. Then fix the third side with your third staple. Without twisting the weave now pull again on the opposite side, making the centre of the canvas taut. The fourth staple on the fourth side completes the cross shape. This pattern of fixtures to stretch the canvas is routinely used and it can be thought of as 'north, south, east, west', to help remember the pattern ('top, bottom, right and left' will serve the same purpose).

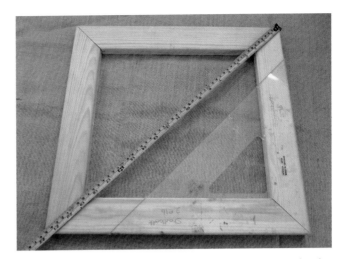

Assembling the stretcher, with tape measure across the diagonal and set square.

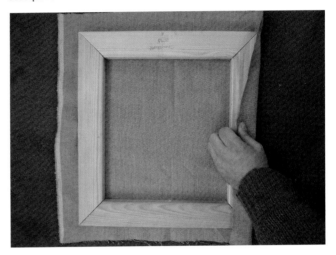

Aligning the weave of the linen with the stretcher.

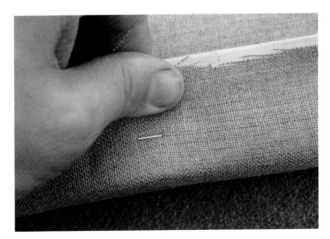

First staple.

Stretching the canvas – ready for the corners.

Rear of canvas – all fixed.

Front view of stretched canvas.

Heating the rabbit skin glue; the last granules to dissolve.

Glue size heated through and ready to apply.

Corner detail.

Continue now by repeating the same order, working with opposite lengths, and put your fifth staple a bit to the right of the first one. Three or four centimetres gap can be left at a time without losing too much tension. Now put in your staples to the right with each of the other positions, in the same order: 'north, south, east then west'. Always pull the slack out from the centre of the canvas. Once you have gone around putting one to the right, it is time to do the same but to the left, keeping to the same sequence and starting from the first staple. Repeat this process alternately to the right and then to the left until you are getting close to the corners.

At the corners, pull from both sides, then fold one side over and secure with a staple. The extra canvas at the corner point can be folded once along the stretcher join (at 45 degrees) and then folded down (at 90 degrees), pulling out all the slack and securing with more staples. It does not matter too much which way you secure your corners as long as they are consistent, taut and tidy.

Applying the size

Once the rabbit skin glue has absorbed the water you can gently heat it on the hob, stirring until it becomes a continuous colour and you can no longer see any individual granules. Use a low heat and be very careful not to boil it, as this will damage the size. Apply to the stretched canvas with a varnishing or decorator's brush. The canvas will darken slightly with the warm size application. It does not matter if the liquid size is not exactly hot to touch when it is applied, as long as it is still in a liquid form and not beginning to congeal.

As the size dries the canvas will contract, making the stretcher satisfyingly drum-like. Make sure your stretchers are sturdy enough; the larger the stretcher length the deeper the stretcher size should be, to avoid warping under tension. Avoid wrinkles in the canvas by ensuring that it has been stretched evenly. Both of these problems with a canvas may require you to remove staples and secure the stretcher with either corner supports or cross bars. It does require practice to find the way that stretching a canvas works best for you. Your sized canvas will dry with a finish that is brittle and harder to the touch than before. The size creates a barrier and makes for a less absorbent canvas support.

Two coats are plenty, and some people advise using only one coat. Other artists advise that the size should be applied with the brush in one consistent direction for one layer, and then applied in a different direction for the second layer. This method is meant to improve the coverage of the size. Allow a day or so between the layers. In the saucepan, when left for an hour or so the glue size will have cooled into a jelly. It is best to re-use it before it goes mouldy. Every time it is re-heated it becomes a bit weaker.

The primer

The sizing process can be done during the week, so that by the end of the week you will be ready to put a coat of oil primer on. The primer will need several days to dry between coats, making the whole process take about two weeks. Starting from the beginning then, the earliest you should expect to paint on your canvas is in approximately two and a half weeks.

It will take much longer for oil primer that contains lead white, which should, after two coats, be left to dry for six months. Alternatively, using only one coat of size and one coat of acrylic primer may mean that the canvas will be ready to paint onto in just a matter of days, although this may not be your preferred surface to work onto.

Prolonged drying time is one reason for you to have shop-bought canvases available, as they are immediately ready to be used. Bear in mind that the shop-bought canvases are not as well primed as your self-prepared canvas will be. This will mean that they are much more absorbent. You can create a better surface to paint on if you apply a single coat of primer to a pre-primed canvas. As with everything a good amount of experimentation will give you the best idea of what you want from your materials.

Applying the size to the canvas.

Close-up view of the size application.

Tin of oil primer and equipment for priming.

Scooping the primer out of the tin, after stirring.

Thinning the primer with a palette knife.

Collecting the primer on the brush.

Priming the canvas.

Cleaning the palette – note safety wear.

SAFETY WITH PRIMERS

Ventilation is essential when you are using an oil primer, especially one which contains lead white since the fumes are toxic and can easily give you a headache, and repeated exposure can lead to severe health problems. These safety precautions should always be followed:

- Ensure that the windows are open, and whilst the primer is drying use that room as little as possible.
- Wear a face mask which will minimize the amount which you breathe in, and try to keep your distance from the fumes (for instance by not leaning over the tin while you stir it).
- Wear plastic gloves and safety goggles to protect your skin and eyes from direct contact and in case the solvent should splash in your face.
- As soon as you open the tin of primer be conscious of the length of time that you leave the lid off. Minimize the contact with the air by scooping out small amounts at a time onto a glass palette. Glass palettes are preferable for mixing and thinning the primer and can be cleaned more easily than wooden or plastic palettes. Oil primers can dry out the surface of your wooden painting palette.
- Keep your head away from the tin when stirring. The tin of primer will probably need a good stir before use, as over time the paint sits on the bottom and the oil rises to the surface.
- Always clean up immediately afterwards, never leaving solvents out or tins of primer left with the lid off.

Safety goggles, plastic gloves and mask.

First layer of primer.

Priming the canvas

You will need: solvents, rags, face mask (breathing protection), safety goggles, plastic gloves, a large ceramic tile or thick sheet of glass laid onto a sturdy piece of wood, palette knife, varnishing brush, oil primer and kitchen towel.

The first coat of primer can be thinned with solvents to ease the coverage of the canvas. The second coat can be a little thicker but will probably need some solvent to help spread the paint across the surface.

First layer of primer (close-up detail).

A second coat of primer?

Once the first layer of primer is dry you may wish to lightly sand down the surface. This can remove any dust or hair that has attached itself. This method will also help to keep your painting surface even. Turn the canvas over, and run a long palette knife under the canvas from the back, separating any places where the size or primer has come through the weave of the canvas and attached itself to the wood of the stretcher bars. If this has made the canvas sag a little then use the wedges (inserted with the 90 degree edge facing away from the stretcher – not aligned with it) which can be tapped at with a hammer until the canvas is again as taut as before. In severe cases of sagging canvas it can help to wet the whole back of the canvas – when it dries it will even out. It can be necessary to unpick and re-stretch part of a canvas.

Only one coat of primer is still a fairly absorbent surface for painting on, which may not suit the look of paint that you want. Two coats creates a more solid white ground which will be both stable as a bond between your paint and your canvas, and also give you a painting surface that is not too absorbent. The canvas will be ready to paint on as soon as the second coat is touch dry. This will take approximately four or five days.

After priming, leave your canvas face up to dry. This will

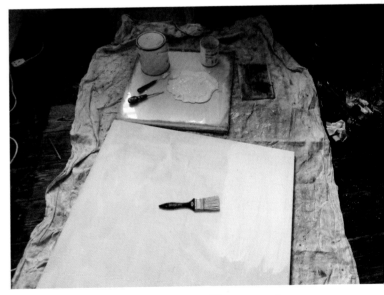

Second coat of primer (photograph shows a different canvas).

take a day or two after which it can be hung on the wall to keep it out of the way. It should not drip after this time. Every case and condition is different, but if the first layer of primer is fairly thin then you should be able to apply the second coat after three or four days.

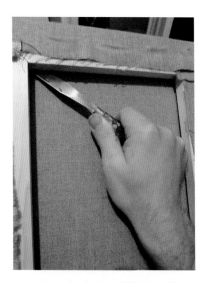

Using a palette knife to free any edges of the canvas that are stuck.

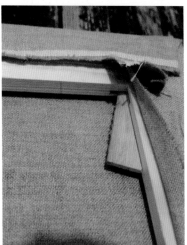

First wedge inserted.

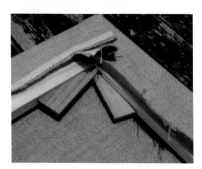

Both wedges in place.

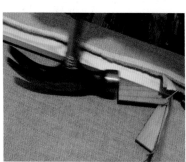

Tightening the stretcher.

Timing

Canvases primed with lead white oil primer will benefit from a six-month period of drying before being painted on. This is so that the whole layer of paint is completely dry and stable. It is best to either wait the whole six months or to work immediately onto the touch-dry primer. This is because the paint that you put on will then be drying at the same time as the primer, or alternatively the paint will be drying on to the already dry primer (both of these alternate instances being stable for the paint). It is inadvisable to start painting onto the primed canvas in between these stages as the paint layer can cause a separation in the primer layer itself if it has not completely dried.

With practice you can be prepared in advance with surfaces prepared twice a year. It will perhaps always be necessary to mix using self-prepared surfaces with commercially prepared ones. This way you can develop a feel for the difference between the two. You may end up preferring one over the other. Surface preparation is all about finding the right level of absorption for your painting. The more paint that you apply the less absorbent the support becomes.

As your painting accumulates layers you will find that the painting may dry quicker. This all depends on the thickness and oil content of the paint but it is worth thinking about what is happening in terms of the bond between the support or canvas and your painting. The general instruction is to paint 'fat over lean' ('lean' refers to paint with little or no added oil and 'fat' is paint which has the most oil added to it). This means that the longer you work onto a picture and the more layers it develops, then the more you will need to add oil to the paint in order for it to bond well with the thinner paint that is underneath it. Another way of thinking about this is that when you begin painting you can thin it right down with solvent and still you will be able to see what you are doing. As the painting progresses you will need to use more paint in order to make an impact, in order to be able to see what you are doing. Used correctly, oil will help to avoid the effect of 'sink' in the painting.

Palettes.

AVOIDING THE EFFECT OF 'SINK' IN THE PAINT LAYERS

Paintings made in one session do not usually suffer any technical problems since all of the painting has the same drying rate. Problems can occur when a painting is made with many layers over time, especially if the 'fat over lean' rule is not applied. What can happen is that the top layer, if it is less oily than the bottom layers, will sink into the lower layers of paint, giving the painting a dull, dry and deadened look. In such an emergency the paint can be brought back with retouching varnish. To avoid this dissatisfying eventuality, always increase your oil content incrementally. This can particularly be a problem for paintings made with several thin layers. Lynton Lamb, in his 1954 book *Preparation for Painting* says: 'To avoid sinking-in we should first wait for the undercoat to dry thoroughly, and then give the top coat more oil than that beneath.'

Something to paint with

Before starting with the oil colours you will need a palette to mix them on. Any surface can be used for this purpose. Artists from the past have used plates, table tops, walls and doorways. Scraps of cardboard can be used when nothing else is available. Disposable palettes that you can tear off sheet by sheet are available in art shops.

Palettes

For repeated use the best design is a small wooden palette. These are light in weight but sturdy and the thumbhole has chamfered edges so that it is comfortable to hold. This palette will improve with age as the more linseed oil is rubbed into it, the smoother and less absorbent it becomes. Keeping the whole palette clean in between painting sessions will give you more mixing area for new colours.

Palettes come in a range of sizes from the smaller square edged sort that may fit into a painting box (approximately 14×10 inches) to much larger studio palettes. The smaller palette is practical for landscape, and is the best sort of palette for focused work, where large quantities of paint are not needed. I generally use the smaller palette since it is preferable to hold. If I am about to paint somebody I will sometimes prepare more than one palette. This is to save time by not having to clear up the first palette, and instead just to be able to start again with a clean one.

Larger studio palettes, sometimes shaped like a kidney, can be more useful when working on a bigger scale, since there

Linseed oil.

is more room for larger quantities of mixed paint. A dipper can be attached to the thin edge, near the thumb hole, and this can be used to keep your painting medium in. In the studio it can be worthwhile to have a thick sheet of glass that can sit on a table top or a piece of wood, which will give you a potentially larger surface for colour mixing which is also easier to clean. If it is glass you might like to keep a light toned surface underneath to help the visibility of the colour mixtures. A sheet of paper or piece of wood (painted white) will work well.

Mediums and solvents

Linseed oil is traditionally used with oil paints. It is what the dry pigments are mixed with to make the paints in the tubes ready to use. Because of the different natures of pigments, the colours will vary in consistency from the tube. It is useful to note that each manufacturer will make paint their own way, adding to the particularity of every tube of paint. Some pigments are heavier than others. The pigments will also respond differently to the addition of linseed oil. Some tubes of paint will need more oil to be added, while others will seem very wet from the tube. Artists who are familiar with pastels may wish to take out some of the oil content of the paints. This can be done by leaving the paint overnight on an absorbent surface such as newsprint, before use. The paint will feel dryer and more condensed.

Solvents – turpentine, white spirit or low odour solvents – are the most necessary piece of cleaning equipment. It is possible to thin the paint just with solvents. They do not add the gloss and flowing sensuality that oil mediums provide, but they will all thin the paint. White spirit is the most economical solvent and is ideal for getting the paint off the brush. Turpentine is pleasant to use partly because of its fragrance, and it will also give the colours a glistening appearance. It is however more expensive than white spirit.

In general solvents are good for thinning and removing paint while oil is helpful for making it stick. Oil painting mediums are different in consistency and will add to the experience of paint application, usually thickening the flow of colour and adding gloss. Cold-pressed linseed oil darkens less with age than other linseed oils. It can be useful to keep small glass jars for transporting oil when you are travelling for your painting.

Brushes

A wide variety of artist's paintbrushes are available in art shops. It is useful to own a range even though at times you may paint with very few brushes. They range in size from 0 to 12, with 0 being a watercolour sable or synthetic, and size 12 being a solid handled brush with bristles several centimetres wide. The sizes I find most practical range between a 4 and an 8. These will be somewhere between 1cm and 2cm wide.

Brushes are shaped as rounds, flats or filberts. Flats can be long or short. Long flats have a broad coverage, and a spring in the bristle length that is pleasant to work with. Filberts have a rounded edge, which leaves a less angular stroke. Rounds are best for lines and will leave the more controlled and smaller kind of mark. A large round will hold a surprising amount of paint and with a good amount of oil will be capable of making a long continuous brushstroke.

Brushes are made traditionally with sable or hog's hair. Synthetic hair brushes are available and are made to imitate characteristics of either hog or sable, and also can be made to combine characteristics of both. Sables are soft and pliant, for where the touch is gentle and perhaps more delicate. They have a much finer feel than hog's. Hogs are stiff and can be used to drag and manipulate the paint with a greater depth of surface

thickness. Hogs have the greatest versatility and can withstand a rougher handling. I recommend being able to feel the brushes before you buy them in order to see and try out the spring of the bristles to see what you think you might like. Hogs give your painting a more broken and rough look, whereas sables give a smoother finish.

The kind of brush you like to use will play a large part in the appearance of your painting, so it really is worthwhile to experiment and find what you like the best. So much of the aesthetic of how the paint goes down on the painting is dependent on what you use as well as how you use it. An artist's touch can be very personal. You should keep a fine brush, such as a size 1 round, so as to give yourself a tool capable of achieving fine detail in your painting. Some people like to use a 'rigger', which is a long haired round brush.

Cleaning brushes

As paint hardens when it dries it is important to remove it from the brushes soon after painting. Brushes should be cleaned with solvents first to remove paint, and then with soap and water afterwards. Use low-odour solvents or white spirit. The best soap to use is one with a high moisture content (in other words the least drying) and I recommend olive oil soap.

After washing the brushes out and removing the paint with solvents and absorbent paper towels, leave the brushes to dry horizontally, and if possible in contact with something absorbent like kitchen towel, but with the bristles still the lowest point. The bristles of a good quality brush continue far into the metal casing (the 'ferrule') and the spring of the brush is maintained best by keeping paint outside this part of the brush. This is one reason for leaving the brushes in a horizontal or downwards facing position whilst they are wet.

Leave the brushes to dry for at least a day before re-using. For this reason, alternate the brushes that you use. In between painting sessions take the paint off the brush with solvent and a rag, and then leave some oil on the brush to keep them from going stiff with dried paint. If you are not going to use them for several hours it will be beneficial to wash them with soap and water. Do not use hot water, since this can damage the bristles and use soap which is the least drying.

The importance of keeping the brushes clean cannot be overstated. Letting paint sit on the brushes, especially when it is thick and deep, will eventually dry and harden the bristles, making them harder to clean, and ultimately increase your expenditure by having to buy new ones. There is nothing like using a new brush, so always try to keep some unused brushes for this purpose, as a bit of a treat for your painting.

Brushes – hogs and sables.

Other tools

Palette knives are very useful. They only need a quick wipe to be clean again, and they are the best tool for moving the oil paints around. It is worth keeping a few in case you lose one when travelling. For moving paint the trowel shaped knife is best, while the flat shape has other benefits.

The maul stick is a rest for your painting hand; particularly useful for the portrait, when real precision is demanded for the face. You can make your own or use a stick for the same purpose. If you buy one in an art shop the end will have a soft covering designed for resting on the canvas.

Dippers are metal pots that can be slotted onto the edge of a palette, providing quick access for medium or solvent. If your palette is held in your hand then solvent will spill from a dipper. In this instance, use oil in your dipper and keep the solvent in a jar on top of a nearby surface.

Easels

Radial easels are a good choice for portrait painting. Their design enables a greater flexibility in the tilt or lean that suits you best for working on, and you can get quite close to the model too. This function is also good for controlling the reflected light on the picture surface. Canvases can be worked on at a standing height with this kind of easel. The only problem with them is that sometimes over time they can slip, under too great a weight. If you are working on board then it does not have to be very large before the weight of the board can become an issue for the easel. A-frame easels have a locking mechanism that prevents slipping. This makes them immediately more practical for larger or heavier pictures.

Oil colours

Oils are the most versatile form of paints. With thinners the oils can be as transparent as a watercolour, but when accumulated and thick, oils can create a density of colour that other

RECYCLING SOLVENTS

Solvents are self-cleaning. If you put the dirty solvent into a glass jar, screwing the lid on to minimize the fumes, then after a few days the paint will settle on the bottom and the solvent will be left cleaner at the top. It can work to have a sequence of jars that create a recycling unit. Each time you transfer the solvent from one jar to another – with a few days to settle in between – it will become cleaner, making it more effective for cleaning.

Recycling solvents into glass jars.

mediums cannot recreate.

You can mix your own oils relatively simply, although in terms of time this may be a luxury you cannot afford. Some art shops will stock pigments in jars. It is worth looking at these just to see how beautiful the colours are in this form. If you are curious about mixing your own then you should invest in a Muller and slab for this purpose. I sometimes use a ceramic tile with a glass Muller. Add the linseed oil gradually to make your oil paint. The amount of oil necessary to make the paint the right consistency is less than you might think. It is advisable to use the Muller to coat the pigment with oil for a longer time than when the paint visually appears to be ready to use. This is a time-consuming practice.

Oil colours that have been manufactured and put into tubes are categorized into two grades or standards; artist's quality and student's quality. There is nothing wrong with experimenting with student quality oil paint as it is very similar stuff in many respects. However, if you need more responsive colours that mix well, or if there is a need for the colours to keep as well as possible over time, then I strongly recommend buying artist's quality oils. It is better to have a smaller quantity of a higher quality oil paint. The quality of oil paint is reflected in the price. If you have only ever used lower quality oils then when you first use a high quality tube of paint you will be impressed by how much further just a small amount will go. The higher the pigment quality the less the colour will fade over time. It is best to buy a few good colours to get you started: white, yellow, red and blue. If you are fairly new to painting then buy the mid-range priced colours rather than the most expensive ones.

Oil colours in tubes.

Pigment, oil and muller for grinding pigments.

All colours have their own individual character and can behave in very different ways. The best method of getting to know your colours is by experimentation, although some characteristics can be understood by reading the label. One of these characteristics is the opacity or transparency of the colour. All colours are categorized by the manufacturer as opaque, semi-transparent or transparent. Generally the earth colours are opaque, for instance, and 'lakes' are transparent. Covering power and tinting strength are other characteristics that you can also find on the label of a tube of paint.

Earth or 'classical' palette (economical)

- Lead white/Titanium white
- Yellow ochre
- Light red, Indian red or Venetian red
- Black

Chromatic palette (expensive)

- Lead white/Titanium white
- Lemon/Cadmium/Indian yellow
- Cadmium red/Alizarin crimson
- Cobalt blue/Ultramarine
- Emerald green/Viridian

The earth palette is the most economical set of colours that a painter can use. It is possible to make a suggested blue with the grey made from black and white. Since all colours in painting make reference to what we see, it is understood that the colours are equivalents. The relationships between the colours in the picture are important to the painter. Looking at a painting is different to looking at things in real life; and when we look at a painting we look into it to see what is suggested. For both of

these reasons, as a general rule, it is better to use less paint but to suggest more in the picture. By this I mean, and this will be explained later in the book, that it is possible to use a very limited range of colours for a picture. Most painters will use a combination of these colours, and each palette (as a set of colours) is not mutually exclusive.

The earth colours are so called as generally they are made from different coloured earths. As materials go these have to be considered among the cheapest since they exist in such quantities. The rarer pigments have always been more expensive. There is a reflection of this range in the price of more expensive and higher quality paints, where the earth colours are considerably cheaper than the higher series. Paints are graded in series – with the higher the series number or letter (series 5 or E being one of the highest), the more expensive the paint. Earth colours are series 1 or A, and therefore are the cheapest in the range.

Economically it makes sense to begin with the earth palette and to then expand into the chromatic palette over time. For the best example of how your sensitivity to colours can reveal the effect of relation in colour, have a range of mixtures for red and yellow with your earth red, yellow ochre, white and black. Then, try using just the black and white together against this to make a suggestion of blue. It is surprising just how blue this grey can look when seen against the yellow and red.

White

White is the pigment generally needed the most in all painting. Always keep a good amount so that you do not run out. For a century or so now, the most commonly used white has been and still is titanium white. This is opaque and its tinting strength is very strong. Compare its effect on a colour alongside

a more transparent white such as zinc white. Experiment with both to see what works best.

Some whites contain lead carbonate, such as lead white, flake white and cremnitz white. This lead white form of oil paint is the traditional white that has been used for centuries. It has a heavier and more substantial feel. Lead whites are poisonous and so their manufacture is becoming less popular. They may prove difficult to buy in the shops.

Lead white is the most enjoyable white to use as it seems to do what you want it to. It has less tinting strength so that you can use it a little to lighten another colour, and the saturation of that colour will not be lost to such an extent as if you were to use titanium white. Paintings that are made with too much titanium white can have a chalky appearance. It is the consistency of the lead white too that is good to work with. It is a bit like clotted cream in its density. Remember to wear protective gloves when you are using it, and to ventilate the room.

Yellow

Yellow ochre is an earth yellow. It is very light in tone, and can be used to lighten a dark colour instead of white. It is the least vibrant of the yellows, but mixes well with other earth colours.

Genuine Naples yellow is an expensive pigment. It can also be used to lighten other colours instead of white. When used for the portrait it can make mixtures with cadmium red and white that cannot be made as well with anything else.

Lemon yellow is one of the most vibrant yellows, and is good for making greens.

Cadmium yellow is one of the most useful yellows in the chromatic palette. It is an expensive pigment, very strong in its colour and is opaque.

Cobalt yellow (aureolin) is a very transparent yellow and is expensive too, but is unique to use and is a very beautiful colour.

Indian yellow is a transparent fairly deep toned yellow. As a colour it is extremely versatile.

Red

Earth reds such as English red, Venetian red, light red and Indian red are all opaque and heavy colours.

Cadmium red is expensive, but one of the richest reds that you can buy. It is good for its power but can be used delicately too.

Alizarin crimson is a transparent dark red. It is a bit more expensive than the earth red, but not as expensive as the cadmium. It can make a great range of colour mixtures and is extremely versatile.

Blue

Cobalt blue is expensive but wonderful to use. It is quite transparent but is also a very strong colour. More subtle than ultramarine, it will benefit all of the colour mixtures that you make from it.

Ultramarine is the modern form of the traditional lapis lazuli. Now very economical, this is the most versatile and commonly used blue.

Prussian blue can extend the tonal range in a picture as it is so dark. It is opaque and can dominate a palette very easily.

Green

Terre verte is an earth green that has a unique consistency. It is extremely transparent, but can be made more opaque by a thicker application. In the past this green has been used for under painting.

Emerald green is an expensive and vibrant pigment that can be used in a similar way to cobalt blue. As a colour it may not be seen so much in the portrait but can be used to effectively alter the colour mixtures possible from your palette.

Viridian is an expensive pigment which makes a beautifully deep green. It is quite a good corresponding colour to alizarin crimson.

Black

Black comes in various forms: Ivory black, vine black, blue black, to name a few. It is best to use it only to extend a picture's tonal range, when a mixed dark is not dark enough. Mars black is very warm in tone, close to brown. For a long time I did not own a tube of black. I used to mix my darkest yellow, red and blue to create the darkest colour I could.

Earth colours

Some earth colours that I have not already mentioned are raw umber, burnt umber and raw sienna. Raw umber can be used with ultramarine for an effective and dark under-painting. Burnt umber is redder than raw umber; raw sienna is a deeper and a slightly redder colour than yellow ochre; and burnt sienna is more red than raw sienna.

This list of colours is only provisional and there are many more colours available in most art shops. Earth colours have a unique beauty and naturalness in their appearance, and can also be understood as being less saturated or less lurid than the chromatic or primary colours (yellow, red and blue).

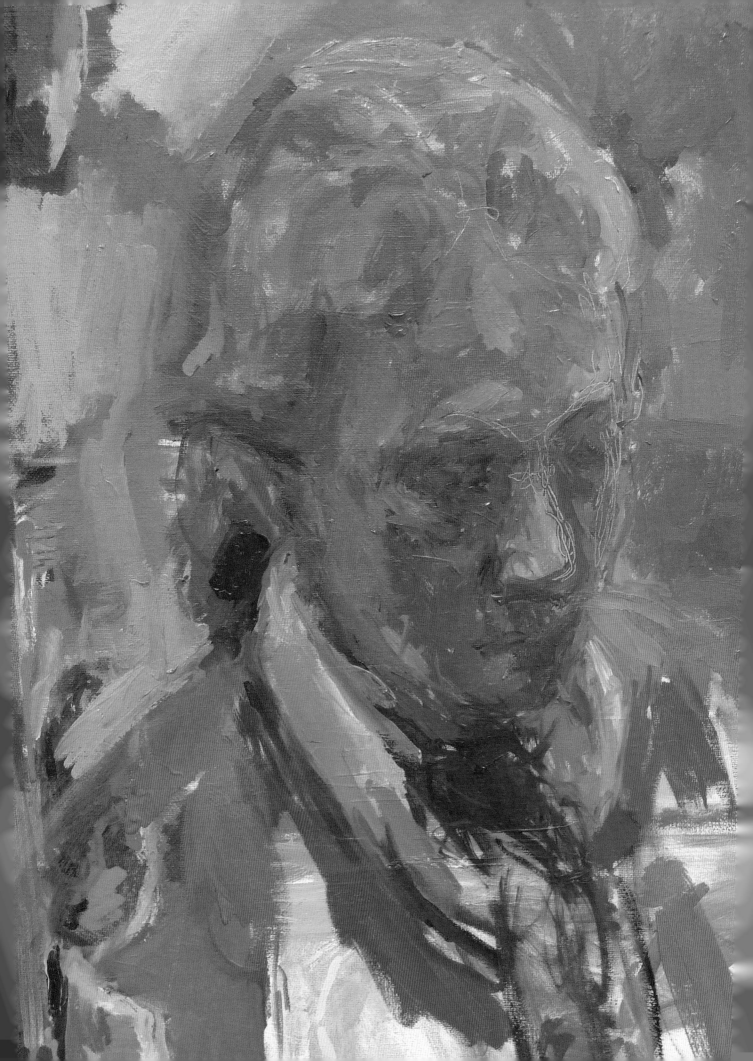

Drawing and Looking

Drawing is fundamental to painting and much beyond that. It is the most immediate way to express an idea. It can also be simple to do in terms of the equipment needed, although there are a huge variety of different papers and drawing tools. It is probably best for you to make your own experiments to determine what you prefer to draw with and what is best for you to draw on. Keeping a sketchbook is the most important tool, so that you can have it with you at all times. That way your interest has the best chance of encouragement and improvement, and you are less likely to forget something you have seen. Small sketchbooks can fit in a coat pocket along with a short pencil and sharpener.

The learning process

Teaching and influences

Painting and drawing has always been taught, and there is a living tradition that is passed on from generation to generation. It is interesting to trace the influences at work in the people you admire, how they became able to do what they did, over time and by being with which other artists. It is tempting to isolate a particular artist and believe in their originality, placing them on a pedestal. However, if you cultivate an awareness of images made throughout history and keep an open eye and mind, your brain will identify all sorts of connections between artists. You will be able to tell yourself very logically that you suspect so and so must have seen this or that artist, as they appear to have borrowed or used something that at first seemed unique to that artist alone.

Aude, 2013; portrait in oils.

Joe, 2014; drawn in conte at a family gathering.

Here, for example, is my artistic 'lineage': I was taught by Roger Leworthy, who had a connection with Euan Uglow (1932–2000). Uglow was taught by Sir William Coldstream (1908–87), who knew Henry Tonks (1862–1937). Tonks knew Phillip Wilson Steer (1860–1942) and John Singer Sargent (1856–1925). Sargent knew Claude Monet (1840–1926), and Steer knew Walter Sickert (1860–1942). James Abbott McNeill Whistler (1834–1903) taught Sickert, and Charles Gleyre (1808–74) taught Whistler in Paris, alongside Monet and Pierre-Auguste Renoir (1841–1919). Gleyre took over Paul Delaroche's (1797–1856) students after he closed his studio in 1864. Delaroche was the leading pupil of Antoine-Jean Gros (1771–1835), who in turn was taught by Jacques-Louis David (1748–1825). David was an influence on Sir Joshua Reynolds

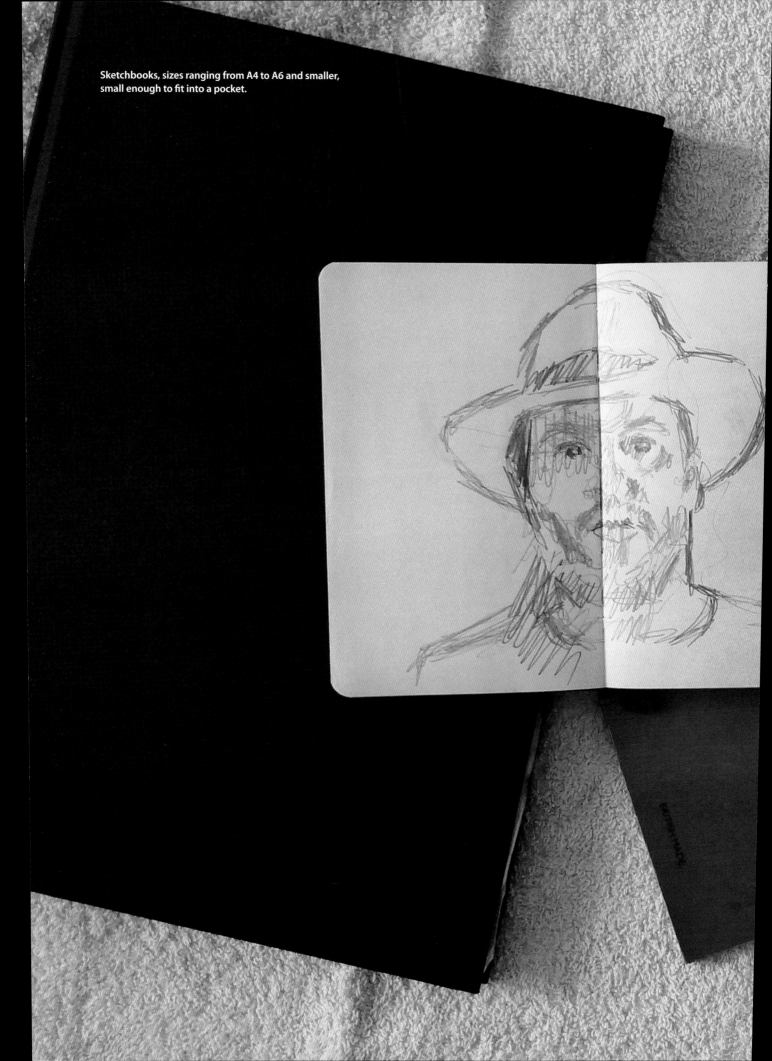

Sketchbooks, sizes ranging from A4 to A6 and smaller, small enough to fit into a pocket.

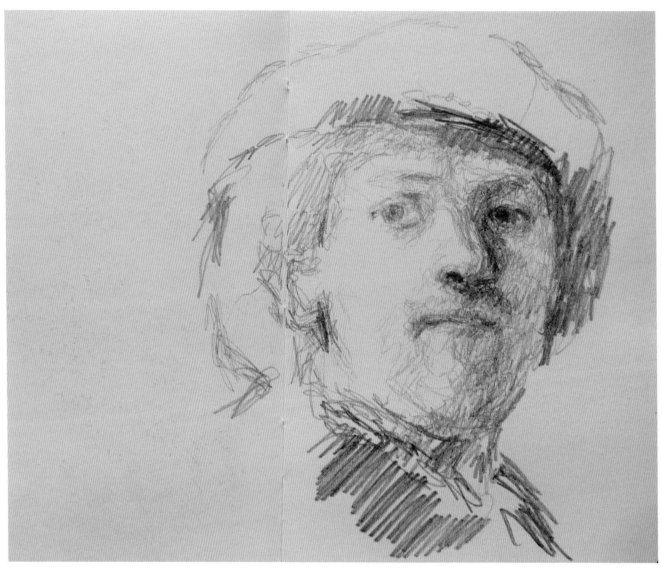

Study made from a Rembrandt self-portrait in the Wallace Collection, London.

(1723–92), showing that historically the English Channel has not divided the flow of artistic exchange. This lineage covers almost three hundred years and shows the importance of contact and influence between living artists. Although the way artists painted in the eighteenth century is different to how people paint now there is still a communication of ideas between paintings and painters.

Copying drawings

Imitation is one way of learning. By this I mean copying what you can see that somebody you admire has done. What you see is conditioned by what you are thinking, and who you are around will influence how you see. In this respect teaching can take a very subtle form, where it is not so much direct instruction all the time – since this allows very little room for an individual's initiative. Teaching in art can happen where

there is a dialogue between two people – where there is a response, and also motivation.

One difficulty with teaching in practice is the difference between the ideals of what to strive for in the work and the practicality of how it is done. Eugène Delacroix said that all painting is an improvisation, and this creative aspect is surely what looks best, especially when it is combined with an intelligent use of materials. How then can improvisation be taught? It cannot, but exercises to do with control will help.

Assistance with navigation in terms of thought processes connected with painting will also have an influence. It can be worthwhile to think about a picture while you are away from it, since training your memory is almost as important as training your eye. Sickert once instructed students to observe in one room, and then to draw in a different room, so as to encourage the study from memory. Try to draw from memory. It will help

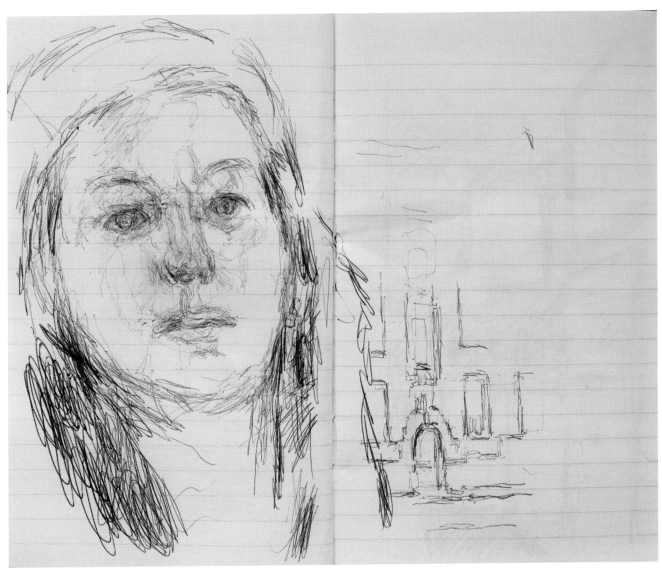

Joanna; **drawing made with a biro pen in a pocket sketchbook.**

you see what you have not retained. This, in turn, can help you with what to look for. Once when I was teaching a group of 10–14 year olds I asked them to draw their kitchen from memory. The results were very strong and some of the drawings seemed so realistic that they seemed to be made from direct observation.

Studying from past artists

It is interesting to think why a certain period in art history is of interest to you at any given time. It is true that from time to time different periods tend to be highlighted culturally by the curators in museums and galleries. It is beneficial to absorb and draw at first hand what is available to be seen, and to do this as much as possible. As an artist your constant reference and guidance, which you can draw from at any given time, is the art of the past. Think of how much time has been put into making the pictures in the museums and galleries. Cumulatively, it is as if several lifespans of attention are all potentially visible to us in our brief visit, and this I find amazing. View the paintings that you draw as solutions to a particular problem that the artist was faced with. Are there problems, set about in a picture already made, that you would like to attempt to reconcile yourself, in your painting?

When we draw from paintings and drawings by other artists we get a chance to trace how that artist has resolved the mystery of appearance. How do we draw what we see? There are so many different approaches it is impossible to list, but if we draw the pictures that we admire by other people then we are learning something by copying. Every artist learns in this fashion. It is also true that half of the work has been done already by it being composed onto a flat surface.

Look more at what you are trying to draw rather than at

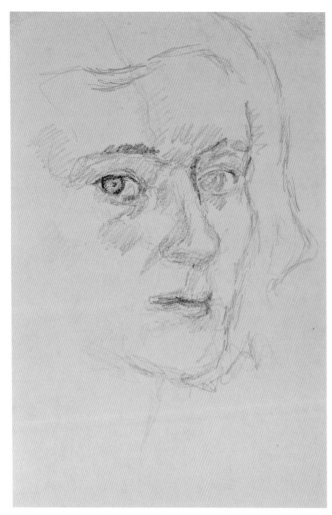

Helen; an example of drawing eye contact with a pencil.

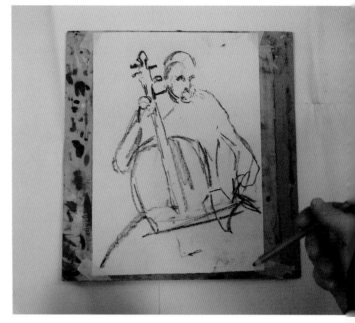

Self-portrait with Cello, 2015; simple drawing set-up of paper on board.

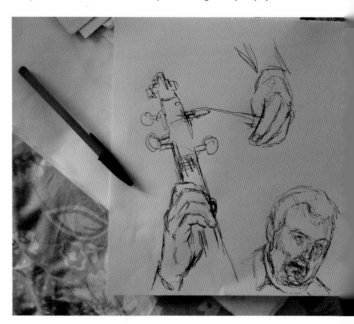

Self-portrait with Cello, 2015; a second example of drawing as a study for a painting.

the drawing you are making. Otherwise you tend to go over the lines again and re-emphasize what you may have already exaggerated, although this can make a drawing have a stronger impression.

Looking at portraits

Why do we like to look at portraits? A portrait can offer us the illusion of being in somebody's company. It can preserve observations of a sensitivity that we could obtain in no other way than this. The way that we look at a painting is different, but in a portrait it can be as direct as the way that we see somebody only rarely in real life. When a gaze comes to life it can be quite thrilling.

For a long time in their early portraits, and to a certain extent in every single picture, artists make use of a picture that already exists to help them strengthen their vision. What we think of as an original image usually has its starting point in another

artwork. To a large extent this is because every picture is more like another picture than it is like an actual vision of something seen. It is for this reason that true originality is refreshing and valuable, and as Cézanne said, it makes a 'new link to the art of the past'.

Another way of saying this is that all art has more in common with other art than it does with actual vision or life itself. This can seem hard to believe for the artist who is so involved with what they are looking at that they cannot see anything else.

It is wise for the person who wants to make paintings to see as many pictures by as many different people as possible. Seeing how another person saw is possible through the understanding of how they have chosen to make that image.

Spend as much time as you can in the company of portraits made by other artists from different countries and from different times. Research the locations of portrait collections, and travel if necessary for this purpose. That one artist will exaggerate one kind of mark and another artist will exaggerate or emphasize something else tells us something of their processes. Ask yourself what kind of questioning that they put their decision-making up against. Staring at another person is such a vivid and changeable process for making a picture, as the face is so mobile and expressive. It is therefore up to the artist to make an image that is both fixed and resilient.

Drawing is a way of engaging with the world around you, and is an absorbing and satisfying way to spend your time. Drawing is best practised in its most simple form – paper leant on a board that is light enough for you to hold without getting tired. You will need the minimum equipment of a pencil, a sharpener and a rubber.

To draw it is necessary to have something to follow; this can be an idea or memory as well as the observation of an object in your vision. Because the world that we see is all surrounding and all moving and also that our position within it is unstable, it can be very difficult to actually attempt to draw what we see. The following method is one way that many artists have used their looking in order to make the drawing of what they saw more consistent and graspable.

In art schools where drawing is taught, a basic range of techniques is quite common: sight size drawing, measurement, line drawing, blind drawing and drawing from memory.

Sight size drawing

Before drawing the model you may wish to practise by drawing the human skull. How do we understand the head as a volume? One way is to observe very closely a skull, since the structure of the skull determines the shape of the head. It appears very different from the side than from the front, and as soon as it is tilted in one direction the relationship of the eye sockets and nasal cavities along with the jaw becomes very complex.

Sit four or five feet (approximately 1½m) away from your subject. Position your paper so it is as close as possible to what you are trying to draw – close, that is, in your field of vision; in other words make the distance as short as possible for your eye to travel between the subject and the drawing. If you are using

paper which is stuck to a drawing board, positioned on an easel, then remember to keep the image or paper perpendicular to your gaze. As your paper is very close to you, much closer than your subject, if you close one eye then you should be able to drag the subject across onto the paper. This is a bit like dragging an icon on a computer desktop, except at the same time you are recreating what you see. This size of the drawing on the paper is what we call sight-size.

When you hold your arm out and measure, with your fingers, something you can see, this is referred to as an objective system of measurement, as your arm should stay the same length. This ability to be objective about the size of things we see is what we are doing when we look around us. When we draw it is useful for us to be more analytical in how we look, so as to be capable of being more thorough in our drawing. Alberto Giacometti (1901–66) would hold his fingers up to his eye to show how small someone was that he could see, crossing a street outside the window of the café he was sat in. Euan Uglow (1932–2000) would make his student as aware as possible of the ratios between the sizes of things, so as to understand appearances better.

Making a start

Look at the model and decide what part is closest to you. Isolate that part and decide on the shape that the frontal plane of it would look like, much as if a pane or sheet of glass was pressed up against it. Now we must analyse the size that this appears to us to be. To do this one method is to hold out your arm straight (so that your measurements are consistent) and to take a measurement by positioning your thumb along a pencil. The pencil should be held so that it is perpendicular to your eye. These methods, along with keeping one eye closed, help to keep constant as many of the variables as we can. Other systems include marking your feet, the legs of the chair and so on.

Do everything that you can to keep things in the same place and to use the same time of day or night to similarly attempt to control the light. Closing one eye and keeping your arm fully outstretched whilst measuring will help develop the objective quality of your drawing. It is possible to discuss the distances we see, and the relations of distances, which we can simplify as a ratio. It is possible to learn a lot about how to draw what you see by beginning to question and relate elements of your subject objectively. The distances or measurements we make will be consistent, making it possible to sustain our looking, and to be able to re-enter the drawing after a break. This system of measuring creates a projected visual plane (the reach of our arm holding the pencil), across which distances can be compared. It is possible to help our drawing by working out

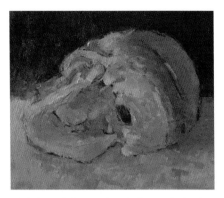

Skull facing left, seen from below; painting by Berni Timko.

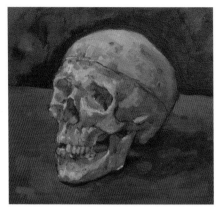

Skull facing left, three-quarter view; painting by Berni Timko.

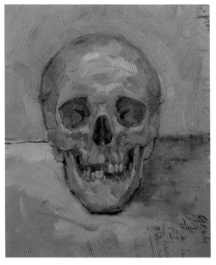

Skull, front view; painting by Berni Timko.

methodically the size and shape of what we see. In connection with this it is better to have fewer marks on the page that we are certain of, than to have many marks that we are less sure about.

Measurement (Part 1)

The measurement we make of the tip of the model's nose, if we are sitting face to face, becomes a fraction of the whole surface of the picture we are making. The tip of a nose might be less than one hundredth of the picture's surface area. If the picture were to be bigger or include more of the model's body then that fraction would decrease. In the same way if we were to zoom in and crop closer to the head then the opposite would be true and the unit of measurement for the model's nose would occupy a larger fraction of the picture, for instance one eightieth. The main point of this system is to understand that every distance is measureable and that once we decide upon a scale there is a rationale we can follow.

Using basic ratios that we observe, our workings out can become more and more precise. We measure one unit of distance in what we see in order to understand better other distances. The next step could be to look at the height or length of the nose. When this measurement begins to relate to other distances that we see, perhaps the height or width of the eye sockets or the larger shape of the face, then the drawing will be well underway. Measure something that can be seen clearly – say the distance from nostril to nostril – meaning the width

of the nose. This is now a unit. Try counting how many of these units go into other distances, like the width of the face. Including or excluding the hair? Be as precise as possible and these marks will become something you can build upon and use as guiding points for lines. This process can be slow and painstaking, but it can be well worth persevering with. The more the measurements relate and build up in the drawing the stronger the drawing will appear.

We may think of drawing as doing one thing at a time, marking where our eye has been. This is fitting for the idea of concentration being about focus and precision. When we look at somebody we generally look at the eyes; however, if we set out to draw a single eye we may end up not being able to connect it convincingly to anything else. It is such a challenge to draw the eye. This one point of focus is made up of different elements: pupil, iris, eyelids, eyelashes, eyebrow. How the eyelids cover up part of the iris is such a challenging thing to draw, as there is constant movement. The pupil is very often the darkest point of the eye, but it will sometimes contain or be right next to the reflected highlight in the eye – which can seem very bright. This contrast is difficult not to exaggerate, and controlling the dominance of the gaze is tricky. For these reasons the eyes can sometimes be seen to be drawn fainter than the rest of the head. At other times the amount of re-visiting the point of eye contact in the drawing, with the need to 'get it right', will make the eyes darker.

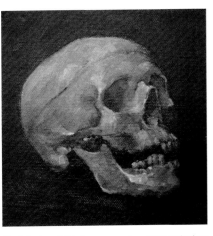

Skull facing right, three-quarter view; painting by Berni Timko.

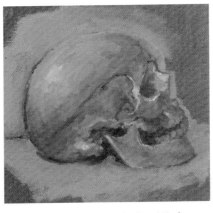

Skull facing right; painting by Berni Timko.

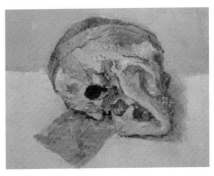

Skull facing right, seen from below; painting by Berni Timko.

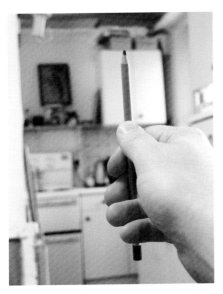

Photograph to show thumb on the pencil for measuring a distance.

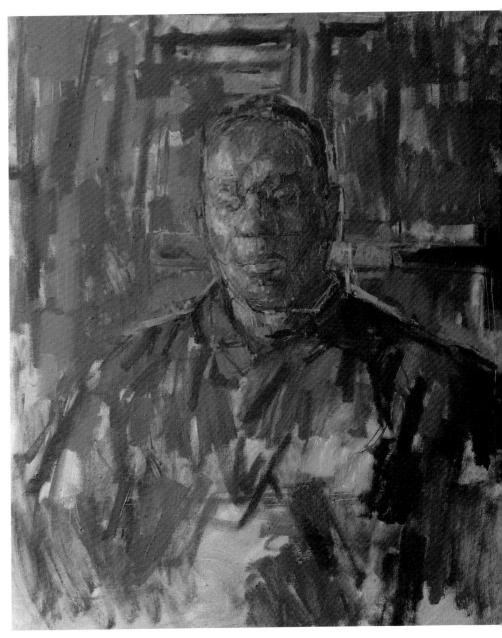

Nicholas, 2009; although painted with fairly loose brush strokes there are many marks that are measurements, which convey a search for the structure and form of the head.

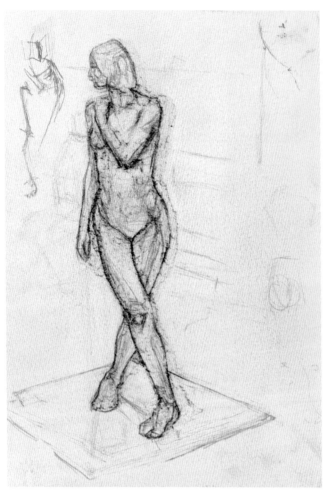

Life drawing made while a student at the Royal Drawing School.

Mel, 2005; a drawing of my sister asleep.

Lynsey, 2001; a drawing made in
Central Park in New York.

Life drawing, 2014; using the line to outline tone rather than to fill it in.

Line drawing

A line separates two areas of your paper or canvas. Lines have beginnings and ends. Some will be fainter and some will be stronger; some may be thick and some thin. Lines that you see will generally be the separation between things. They may be the outline of a form or a shape. They may describe the change of plane, edge, or form of the same thing. They may move away from you or come towards you in space.

Cézanne once said that drawing is merely the outline of what you see. As you draw, rather than shade or fill in a tone, instead put a line around a tone. If you cannot differentiate between tones then put a line around a colour. If this is done accurately, then in a quick series of lines whole areas of tone can be described.

A line drawing can relate in a clear way to a painting. Following an order of contrasts, make the weight of your line correspond to the clarity with which the line can be seen. It is the areas of greatest contrast that are the most visible. They will stand out when you squint your eyes a little. Make these lines the first ones that you draw. Whilst squinting your eyes, attempt to order the contrasts from greatest to least. Really reduce the

A student drawing in class, 2014; using a different weight of line for description of tone.

amount of information in your visual field by closing your eyes completely and then very slowly opening them. The first thing that you see will be the brightest area. Where this area meets a dark area will be what I mean by an area of great contrast. Put the lines down briefly but accurately, and in relation to the space that you see in your vision. By this I mean to help show the distance that you are from your subject. Line drawing can also follow the form of your subject, without so much attention to light and colour.

Looking at your model's head it may be that the lighter side of their face has an outline against a light background that is hardly noticeable. It can make a strong improvement to a drawing if that line is not so bold where it divides similar tones. This is because where the tones are similar the line cannot be seen as clearly as where the line separates a greater difference in tone. It will benefit a drawing to be as sensitive as possible towards the tone of the subject.

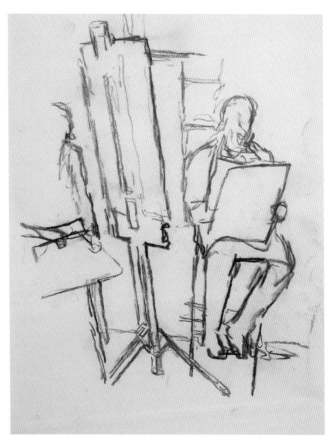

Another line drawing of students drawing in class (charcoal), 2014.

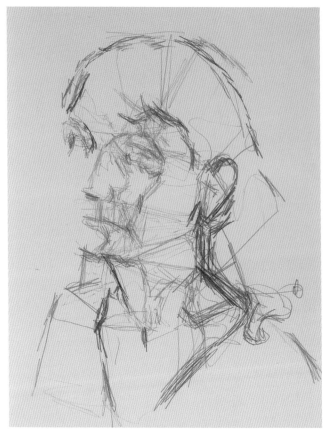

Jenn, 2007; a line drawing made to check proportions of the figure against the painting.

Angles

With a line drawing it can help to analyse the angles between different lines. The more you relate the angles of lines to each other the more consistent the overall drawing will become. Remember that the process of seeing must flatten the image into two dimensions, as that is the nature of the paper or the canvas. The flat shape will only suggest depth, and illusion, by the inter-relation of the angles drawn.

Try not to be fixed in your idea of what a face should look like. You may see one eye higher than the other. The whole head may actually look like it is tilting. Look at the shoulders at the same time as the head. How much lower than the chin do they appear? Is one side higher than the other? The more you develop this kind of seeing more than one thing at once, then the more inter-related your drawing will become. For this reason, if you are in a hurry, it may be simpler to try not taking your pen or pencil off of the page and to keep it moving while you look at the person.

Blind drawing

Keep looking at what you are drawing rather than the drawing itself. This process can be taken a step further by not allowing yourself to see what you are doing with the drawing. This is called blind drawing, where you are not allowed to see the marks you are making; all you can look at is the subject you are attempting to draw.

Blind drawing can lead to interesting marks being made and unexpected juxtapositions where the observations are put down with only the memory of where the drawing started. Touch is vital here since it is only that connection which gives the drawing its orientation or placement on the page. Blind drawing is very helpful to loosen up and to stop scrutinizing the mark made in the drawing. This in turn can be a good warm-up which can lead to less self-critical and tight drawing.

Stefania, 2014; a soft pencil drawing made in preparation for a painting.

Continuous line drawing

Extending a line

When you have the opportunity to sustain a drawing for some time it is up to you to structure and direct your observations on the page. Looking at your subject, hold your pencil, or something with a straight edge, out in front of you and align it with something you can see. Keep the measuring tool that you are holding perpendicular to your gaze so that any measurement corresponds with the picture plane or surface. Extending a line that you can see can help in the construction and placement of your drawing.

This method, where you take a line visible on your model and continue it into space to see what else it connects with, can help you see more clearly where something actually is. Choose a line to extend; the more clearly visible it is then the easier it will be to imagine it continuing into space. It may be practical to choose a line with as little movement as possible; a nose is more fixed than an eyebrow for instance. Now imagine an extension of that line, so as to see what would interact with it; for instance the horizontal line of the mouth in its natural position (where the lips meet), if extended to the side of the head, can help locate the ears in a drawing. This can similarly be done from the eyes. Depending on the angle of the head these relations will shift dramatically, and the closer you follow their positions as you see them then the better the drawing will be. Relation in drawing can be understood as looking at a distance between two points and seeing the position of a third point at the same time. This suggests the shape of a triangle. The first set of relationships making a triangle, which almost every portrait will begin with, are the positions of each eye in relation to the tip of the nose. This triangle will change shape depending on your viewpoint.

In a three-quarter view two triangles suggest themselves; one is between both eyes and the mouth, and the other is between the ear, mouth and eye on that side of the head. You are mapping the face into a picture. How the shapes of these triangles differ will describe the angle of the head of your model and your perspective or viewpoint towards it. When a drawing is really specific it can even describe your distance from the model. An example of how this is apparent is when drawing the model head on, the further away you get the more you will be able to see of the ears. The closer you get, and this can apply very clearly in a self-portrait, the less you will be able to see the ears.

Establish a fixed horizontal and vertical

In addition to extending a line, a very useful method in drawing is to work out where the vertical and horizontal is, in both the drawing and the visual space in front of you. This in essence is a bit like the axis of a graph. For this reason it can be useful to draw a head at rest, as there is less movement. The picture edge, in a reclining profile, will act as this axis. If your subject is sat in front of a wall then you can even draw the edges of your canvas dimensions (once the portrait is underway) as you see them projected into the space around your model's head. This visual reminder of the boundary of your composition will help you to see the shapes of the face in relation to the straight edge. This method is similar to that of the use of a plumb line – a true vertical. This practical assistance to drawing was popular in the twentieth century at some art colleges in London. A straight line can provide a base for the architecture for your drawing. It is easier to analyse the progress of a curve if you can see a straight line next to it.

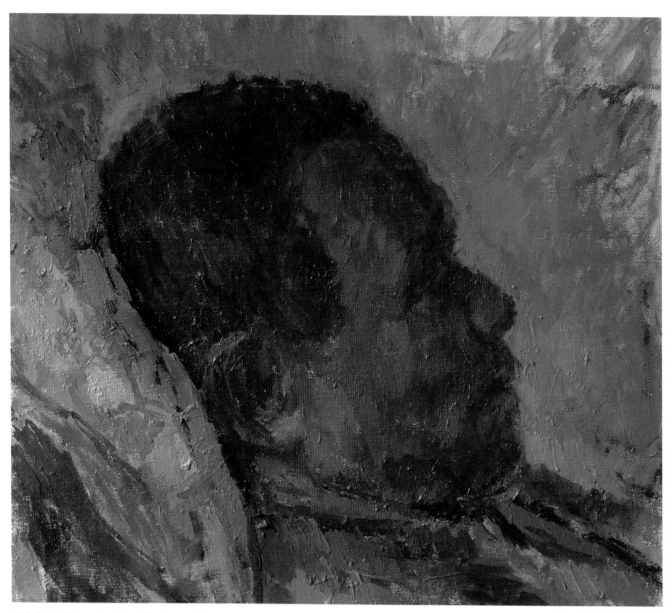

Nicholas, 2010; a painted profile view, made with a horizontal and vertical reference.

Nicholas, 2010; a drawing made at the same time as the painting.

Looking

When you are drawing you set out to draw the lines that you see. The more you observe everything in terms of the mark you can make to stand for it in your drawing, then the clearer the picture will become. Lines that describe the form of the nose, since they are within the shape of the head (frontal view) will generally not have as much contrast as the exterior lines on the edge of the head. The edge of the head can very often be in shadow and this area will always receive less light than the reflective skin of the face. The painter Ann Dowker taught me that the greatest contrast is rarely within the figure. This was when I was attending a life class drawing marathon at the Royal Drawing School. I had started a drawing which emphasized the

shadows within the figure, and it was clear to her then, and to me now, just how much of an exaggeration of tone this was.

Drawings of the head will usually focus on the relationships of the face. This subject becomes easier to portray if seen in combination with the overall shape of the head. For this reason some artists will ask their models to tie up their hair, so that the edge of the head is more visible and more constant.

Construct the face within the shape of the head. When the head is painted after the face it can flatten the appearance of the head. When drawing a profile, look from the ear across the cheek to the nose. Keep these both in your view while you try to see where the eye should go. Because of the face being a fraction of the size of the head, and that its facet is frontal, when viewed from the side the eye will appear much closer to the nose than to the ear. The space around the features to the side of the face – cheek and temple, before you get to the ear – can be under-estimated in drawings.

Think of the anatomy of the head. We all have a basic idea of what a skull looks like but it is worthwhile to study a real one. Compare the large bulbous size of the cranium (try putting your hand around the top of your head) with the much smaller two triangular holes of the entrance to the nasal cavity (pinch your nose). In between are the eye sockets. Seeing the whole head can put the relatively smaller size of the face into perspective.

Portraits of people will always look more like other portraits than like the people themselves. This is largely because all pictures share two-dimensionality. If it appears to have a likeness then this may be in the illusion of depth in the image. Depth in an image can be achieved by drawing or painting things in a consistent way, so that a uniformity of surface encourages the eye to look past this and into the image. It is in this way of seeing that Giacometti talked about style equating to how real something looks in a picture.

Seeing the whole

Be aware of how you are seeing. Vision varies between the telescopic zooming-in on one thing in maximum detail, and the zoomed-out broader perspective that takes in a lot more although in less detail. Whilst drawing or painting it is generally advisable to be able to see in both ways, so as to balance the attraction of detail with the scope of the whole.

Measurement (Part 2)

Measuring a subject can give a drawing a more objective language. When we measure, everything becomes translatable by means of the same method. The skill to do this effectively is in choosing a unit that is easily measurable, fairly fixed and which

SCALE

Working on an A4 sized piece of paper (210 × 297mm), or in a sketchbook, sit four or five feet away from your model. Face them directly and begin drawing their head at a scale that, if you had to, you could draw four or five more heads on the same page. This will make the height of their head two or three inches. This scale is similar to that with which Ingres (1780–1867), Watteau (1684–1721) and Holbein (1497/8–1543) made their wonderful portrait drawings (although I think the Holbeins are larger). There is a single page of several head studies by Delacroix (1798–1863) which is amazing to see.

Try using a 2H pencil, which is harder than a B and will give you better precision for the details. Spend twenty minutes drawing a person. Do this frequently. Look at the portrait drawings made by Alberto Giacometti and David Hockney. Each drawing can focus on a specific angle of the head, and you should try to portray the differences in each study. Aim to focus on the gaze of your model in as determined a way as you can. These drawings are sure to contain a life of their own, and are very precious as studies.

will relate well (multiplied or divided) to the other parts of what is being drawn. It may be that there is a relationship visible that is harder to be sure about. This kind of uncertainty encourages an investigative eye.

Relating the size of the features of the face to the overall shape and size of the head is an endless task. What do we look to use as a unit of measurement? It is simpler if it is neither too big nor too small. Take the height of the sitter's forehead. Count how many foreheads fit into the overall height of the head, including the hair. Turning this unit on to its side, find out the relation of the width to the height by counting across the head. Composing around this substantial shape should anchor the weight of the head in the drawing, and this will determine much of the effect of the picture. The older the sitter the larger their faces will appear in relation to the head.

Look at the early drawings and paintings by David Bomberg (1890–1957) and Frank Auerbach to see how well measured, or felt, those major relationships must have been. The weight of the sitter's cranium seems to be the subject of these pictures. This physicality was a break, historically, from the conventions of portraiture that had gone before. Paintings should be interesting simply as paintings, and it is good to think about this so as to not fall into any stylistic trap of emulating somebody else's paintings for too long. Upstairs at the National Portrait

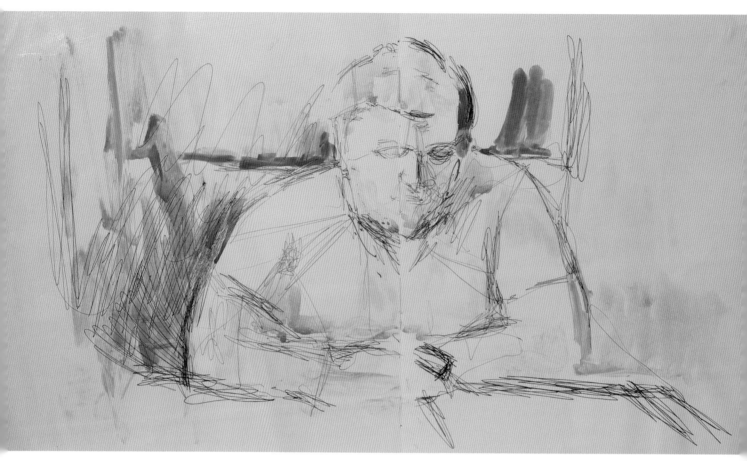

Joe, 2007; a drawing of my brother, in pen with added watercolour.

Gallery in London there are a group of portraits by George F. Watts (1817–1904) which have a 'painterly' physicality which stands him apart from his contemporaries and predecessors.

Drawing with a pen and other media

Pens are enjoyable to use as they are a flowing of ink rather than a rubbing or dragging of graphite or other dry media. The pen's mark can be darker and is sometimes indelible, meaning it cannot be erased. However pen drawings will fade if exposed to too much sunlight. Fixative should not be used with pen as it can make the line bleed and lose its focus. Because of its flowing quality using a pen can aid fast drawing, and is similar to the bolder mark of a soft pencil or charcoal in terms of its visibility. Rembrandt (1606–69) frequently drew with ink since such a variety of mark was possible.

Experimentation with media is the best way to find out what works best for you. A good way to practise your drawing is to attend life classes where the human form is studied. Classes will vary in the level of tuition, and some will be untaught. All classes share the urgency of attempting to draw somebody in front of you, and for this reason it is vital practice for drawing. Do not be disheartened if a few, or even many, drawings do not seem to go as you want them to. The successful image in drawing and painting is famously uncommon, perhaps one in twenty will work, and it is for this reason that we ought to keep doing it. All drawings and paintings have an ability to look very different over time, so do not judge your efforts too soon. It is best to keep putting in, rather than too frequently trying to get something out of it.

When we draw we are concerned with what we see and how we are going to remake it. The problem is in seeing as well as we can. The drawing is a trace of that looking – looking and following and then looking again to see where the drawing should go. Have you seen what you are trying to draw as well as you can? Always it is a case of looking again and of trying again. Build up a series or set of relationships in a group of lines, or set of marks, which can be believed in. Paintings are a bit less direct than drawings in this sense and will require a more elaborate method.

It is extremely helpful to copy drawings made by other artists. When you do this your mark takes on the look of the other drawing, giving it a mimicking quality. This is a useful method to expand your vocabulary of mark making. All artists of the past have learned by copying other artists. This has recently become something that curators of exhibitions are keen to point out. One instance is the replica of a Jacob van Ruisdael (1628/9–82) landscape that Constable (1776–1837) made, which has been on display at the Victoria and Albert museum in London. Trying to draw in a style that you have seen elsewhere enlarges your choice of mark that you can make as a response to what you see. Keep up a belief in the progression of your drawing so that the attitude is of optimism in the next study, and you are sure to be rewarded with good drawings. When you look through the drawings afterwards, the chances are that you will form an idea of what you could draw next.

Conte and charcoal can really alter the effect of your marks. As soon as you begin a drawing with either conte or charcoal, or even pastel for that matter, think how different the feel of it is to the pencil. The quality of mark suddenly has become potentially bolder and this drawing is now capable of containing a greater variety of marks. Colour can have an effect in drawing too, for instance a red conte drawing has a quality all of its own.

Drawings will not come to life if there is too fixed an idea of what a drawing should look like. A good drawing can serve a function, that of showing other people what you see. Even if you are trying to make a drawing very similar to one you have done previously it is likely that the same method will not be enough to bring the image to life. The searching quality of line will be missing if you are not looking hard enough. The artist Daniel Miller once described a drawing of mine as having a 'searching' quality to the line, and I have thought about this since. One criterion for what makes a drawing good could be how well does it show what you have seen? It can help if you make the looking involved in making the drawing the intention of the drawing itself, so that you draw in order to look better at what you are drawing. View a drawing in terms of what information it contains and you are sure to find something that you want to improve on. The scope for what is possible is infinite.

Drawing made from a painting by Albrecht Durer in the National Gallery, London.

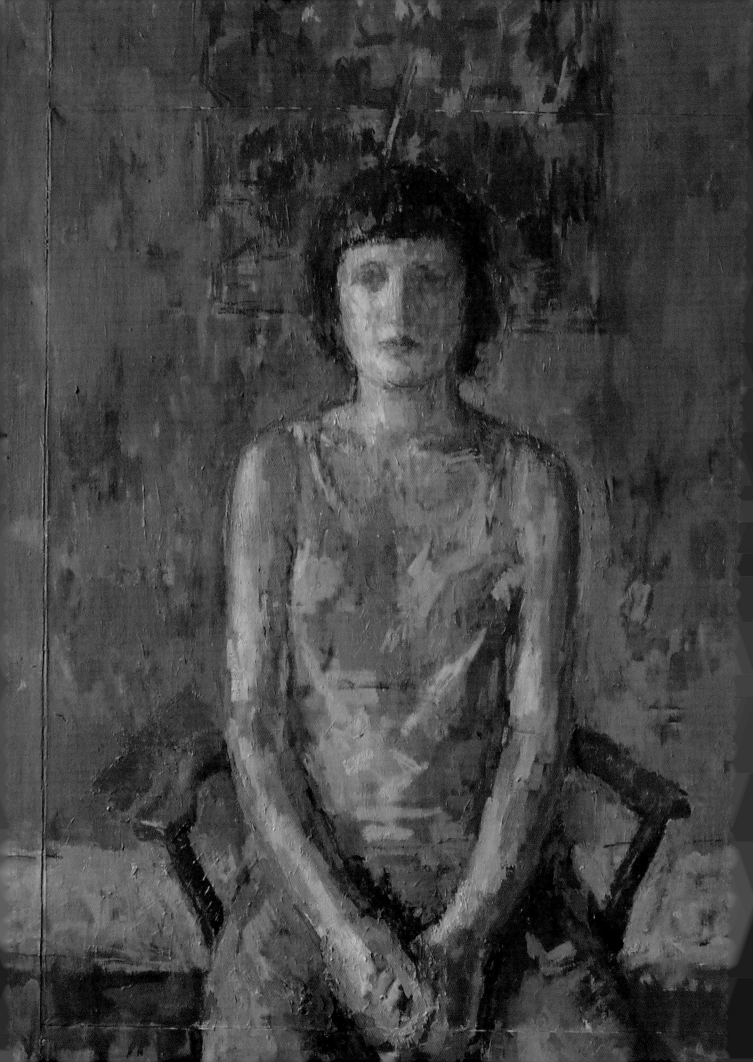

First Principles of Painting

Organization

So much of painting is about organization.

Colours

Starting with the palette, it is good practice to have a system that you are aware of to lay out the colours. One common system is to go from light to dark, with the lightest (white) nearest to the thumbhole. This will make white easier to reach when you are holding your palette, as it tends to be the pigment that painters use the most of. It is sensible to put the colours to the edge of the palette so as to leave the maximum room for your colour mixtures.

It can happen that each painting dictates its own palette. Experiment with different layouts to find what suits you best. When painting portraits quickly and under pressure, the simpler the arrangement of materials the quicker you may be able to manoeuvre the paint.

Set-up

Another consideration is that of the set-up you are using. Whether you work whilst sitting or standing, it is useful to be able to get back from the picture from time to time. When looking at the painting from a greater distance, having a chair to sit on will save some of your energy for painting.

If a painting is made from a close distance then the eye is travelling different distances to various parts of the picture. For instance if the picture is portrait in orientation then the top or bottom of the canvas can, depending on your position and the height of the picture, be much further from your eyes than the centre. If you are looking down at an angle to the bottom of the

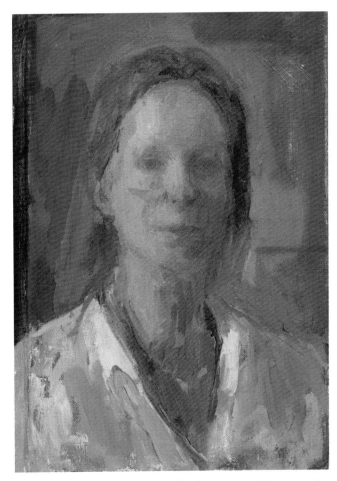

Sharon, 2013 (the artist Sharon Brindle, who agreed to sit in a portrait exchange).

Matilda, 2005–8; a head to hands portrait made and enlarged over three years.

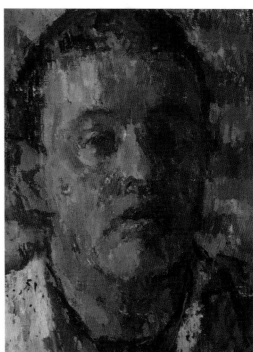

Self-portrait, 2008; note the use of a coloured screen in the set-up behind the head.

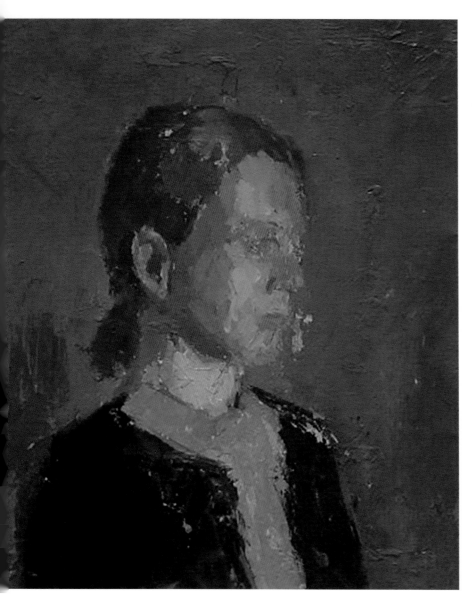

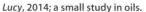
Lucy, 2014; a small study in oils.

years spent painting. Paintings can appear very different close-up or from a distance, and it is the painter's responsibility to be as aware as they can of each effect or appearance.

Layers

Each time we attempt to paint, the challenge is to think as effectively as possible in paint itself. If we are to separate the properties of painting from drawing then the main difference is in the nature of the mark – the range of possibilities from the clarity of a line to the total impression of a washed-in layer of paint over the whole image. In drawing we may use ink for example, across a picture, leaving the white of the page to stand for the area of light that we see. An ink drawing can be made in many layers of washes, with time in between layers allowing for drying. This effect, however well it is made with inks, cannot match the luminous quality of oil paint with all its variety of colour. Mediums can be used to speed up the drying time of oils, but even so it will still require days to settle and be touch dry rather than the minutes that it takes for a water-based layer of ink or acrylic to dry.

painting then the drawing can appear stretched. It is good practice to have your eyes facing the canvas at a perpendicular angle (90 degrees). Raise or lower the canvas to make this practical.

When you get back from the picture, this angle variation of your arc of vision is lessened. A bit like someone walking into a room and seeing a picture for the first time, getting distance can help you to see better what you have been doing, and how well it appears. You may have heard Pablo Picasso's (1881–1973) comment that he would end up marching to and fro from the picture he was painting when it was going badly. If he were involved in the painting to the point of absorption then he need not get back from it. Picasso could trust his immersion in the activity – this, it is worth saying, would have been after many

Initial decisions

In the various stages of a painting what can be the most difficult thing is knowing what to do next. The first step, at any point, is to be aware of the possibilities. The next thing is to have an idea of the result of each of those possibilities, and what they will lead onto. The main difficulty is to prolong the completion of the image so that the picture remains open and as a painter you can still do something with it. Once a painting goes to the touches of detail like the highlights in the eyes, there is less room for revision in the placement of the head. The hardest thing is to balance the necessity of composition or design alongside the intensity of detail which may or may not draw the eye in. In effect you have to see the whole image before it can be painted with any conviction. Usually we are over-eager to get it down without asking first where on the canvas to work.

The most common difficulty that I see is in getting drawn in too soon to seeing the features of the face, or even a single feature, while everything else, or the relation to anything else, disappears. This single point of looking leads to dangers in the picture as the process of building a painting requires as many relations between points as is possible. This is if depth or volume in the representation of the head is desired. This way of looking is tricky as you have to look between things and at many other things in order to draw any single thing well. The drawing and relating will help the continuity of the painting. The contradictory side to this is that until you are involved with the drawing of a head the picture might feel too unresolved or disinterested for you to be gripped by its construction.

There is always a sequence in what you decide is the most important thing to paint, and this is up to you. What you are using, in terms of colour and brush size, should reflect the kind of looking that you are doing.

Using the right tool

Most painters will start with broad brush strokes of thinned paint – larger sized flats or filbert brushes will do this well. Some artists will prefer the mark left by a round brush as it is less blocky. Be aware that once you are using a big brush it will generally make quite clumsy marks if you use it within the head. When attempting to make finer marks use a small round brush, as this smaller mark will seem to be more accurate. Palette knifes manoeuvre the paint well when it gets thick and wet. Rags and absorbent papers can be used to clean or to get a better grip on the painting surface if it becomes too slippery. If you do not feel confident to paint, then begin by using a pencil. When you are ready to paint the mark you make will be clearer. Sketching over the oils with a pencil means that

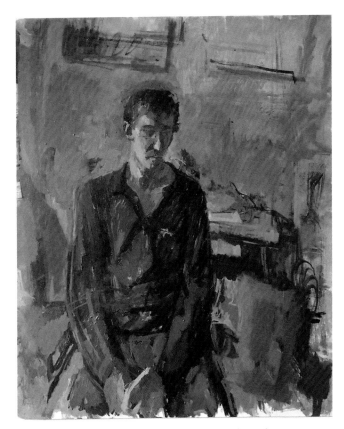

David, 2005; working at a large scale and in a single session.

a colour decision does not have to be made, whilst you are trying to think clearer about the position and colour of what you want to paint.

Very often it is the timing and the switching between the different tools that takes practice. Frustration soon occurs when the tool you are using is not doing what you want it to do. Get to know what tools you have and what their different uses are, and learn to sense when to put down one brush and pick up another. Because of the brush accumulating paint the longer it is used in one session, it is a good idea to have a few of the kinds of brushes that you like, so that you can keep them for different colours perhaps, or even for different tones. A clean brush will apply the paint in a different way to one that is full of thick paint. I have heard that one teacher instructs that the bristles of the brush should not touch the canvas – it is only the paint on the brush that should make contact with the canvas (this may or may not be useful advice).

Controlling the set-up

Are you setting up to paint the portrait in a space that you usually paint in? Is everything you need at hand? It is useful to

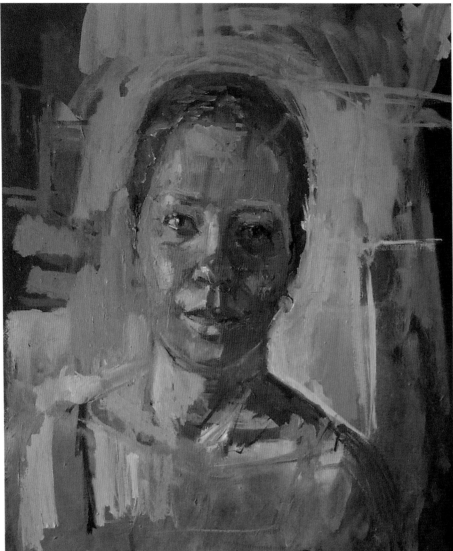

Clare, 2014.

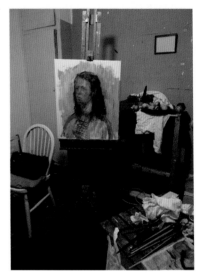

Christelle, 2005; a smaller scale for a closer portrait.

Painting set-up photographed at night.

control as much as possible about the surroundings: where to put your brushes, what you will use for cleaning them, having somewhere to rest your palette and so on. Think through all these details before your sitter arrives so that it is easier once they are there and less time is wasted. Even if you change the position of everything once you are underway, it will be quicker if you have everything that is needed ready to start with.

Create distance to see better

Very often we are close to our paintings but the model is further away, making it hard to compare the two at the same scale. Put the picture further away from you, and move back yourself. Now, standing back, are the model and your picture about the same size? Look and adjust the two heads in order to make them easier to compare. When the painted head begins to look the same size as the actual head, it will appear much clearer

what the biggest differences are. These differences that you can see should inform the next stage of your painting. Anything that you can see and order into something to adjust in the picture will be an improvement to the painting. This method will help your painting to not fall into confusion. It is more effective overall for a painting to have the general areas related better than for a small detail to be believable.

Relating tone

Try this experiment

Take an evenly lit surface, for instance the floor or a wall. Now try interrupting this tone with a finger. For this to work best you need one side of the finger to be in light and the other in shade. What you can then look for is how the evenly lit

Finger photographed against a consistent mid-toned background.

Close-up to show the four areas of tone.

Circle containing an even-sided triangle.

Red.

Red and yellow.

Red, yellow and blue.

surface behind the finger appears to change tone in relation to the finger. For this optical effect to be clearest the evenly lit background should be a mid-tone (not too dark or too light). Can you see a change in this previously even tone?

Whenever I try it I see the background tone appear to go lighter against the dark side of my finger, and the background to appear darker against the light side of my finger. This means that seeing the lit finger and background together makes my eye study the effect of contrast. This is helpful as a theory to strengthen the construction of light effect in a painting. One term for this control of a painted form is modelling, or even better, modulation.

There are four areas to look at (left to right):
1. The background adjacent to the side of the finger that is light;
2. The light side of the finger;
3. The dark side of the finger; and
4. The background adjacent to the side of the finger that is dark.

For this to work properly we need to see the background as actively as we see the finger. Order the tones 1 to 4 so that the background is seen as two tones. When trying to relate these four areas then the sequence makes a distinction which is affected by the surrounding tones. The background (4) appears lighter against the dark side of the finger (3) and the background (1) appears darker against the lighter side of the finger (2).

It can be difficult to train your eye to see evenly over an area rather than seeing a small point that is sharply in focus. The sharp contrast between the light side of the finger in this example almost makes the background appear as dark as the shadow side of the finger. Relating tone is easiest without too much of a sharp focus or narrow vision, but with as broad a scope as possible. At all points in the making of a portrait the effect of light will be helped by the work we do to structure the relation of tones including the whole picture.

Controlling the effects of light and shade

Our observation of tone is clearest under the dimmest lighting conditions. At the end of the day when daylight is fading the last light to disappear in our subject is the brightest. Alternatively when painting on a bright day we ourselves squint our eyes almost shut to try and clarify the tones we see. Both of these descriptions express the general rule that the fainter the light then the clearer the tone.

Tone in a picture is one way in which it is organized. Cézanne said that the abstraction of black and white in the drawing for a painting is like a support for the eye. If we are to think of the paintings by Walter Sickert, then it is clear that the variety of tone in the colour that he used is what describes the form of the picture. What is vital is that the organization of the tone is clear and not confused.

A very common difficulty in painting is when the picture

Locating the halfway position and tone between red and yellow.

Making orange, a secondary colour.

With green and purple mixed, proceed with your wheel by mixing the colours that appear between the primaries and their adjacent secondaries (for example yellow-green, between the primary yellow and the secondary colour green).

Having got all the way around the circle…

… the next step is to make enough mixtures to join up the circle, making a complete colour wheel with a centre.

Pencil positioned to indicate the complimentary colours opposite each other in the wheel (in this case it is purple and yellow).

goes on and on over time and the number of tones in a picture multiplies. The usual danger then is that the tone loses its consistency. Thinking about the light source and the direction of light will help to simplify and order the construction of tones in the picture. It can happen that the effects of light become misleading. Patience and repeated attempts at enquiry are the surest ways to improve. Just as we can develop our sensitivity to this with practice, so the same can happen with regard to colour perception and relation.

Colour handling

Making a colour wheel

It is essential learning for the full experience of painting for an artist to have made their own colour wheel.

This begins with the three primary colours: red, yellow and blue. Using an A3 sheet of paper, first picture a circle, then arrange a good amount of each colour at the corner point of an even-sided triangle. Leave enough room around the triangle for it to become a circle.

Between the red and yellow an orange mixture can now be made. This is called a secondary colour. In the other two spaces two other secondary colours can be made: between yellow and blue there is green, and between blue and red there is purple. For every mixture that is made between two colours it is advisable to keep that colour at a halfway point of tone.

Since blue is considerably darker than yellow it may be necessary to use more yellow in the mixture so as to make a green that is light enough to appear halfway between the primary yellow and blue. Purple is usually the darkest part of the circle and pure yellow is the lightest. The strength and tone of a colour will vary with each different kind of paint that is used.

Keep these colours in a position along the outer edge of a circle. Continue by mixing the colour that is between orange and red. (For sub-divisions of colour it is necessary to mix a good amount of the secondary colours.) Continue by making a mixture between orange and yellow. Apply the same method to mixtures between yellow and green, green and blue, blue and purple, and purple and red. By repeating this process around the circle format, eventually the circle will appear as one continuous shift between colours. This continuation of colour suggests movement, and this may be why it is sometimes called a colour wheel. The colour found to be midway between a primary and a secondary can be known as a tertiary colour.

MIXING COMPLEMENTARIES TO MAKE GREY

The surprising thing about complementary colours is that when you mix them together they can make a grey. Between two complementary colours there is a neutral point where it becomes neither colour. In the centre of the wheel there is grey.

In order to demonstrate this it is worthwhile to make a study on a separate sheet of paper. For instance the red and green that sit opposite each other on the wheel, when mixed together, appear to make a colour that is not red or green. If the colour is mixed exactly halfway between it will appear as a grey. A small amount of white mixed in for this purpose should make it clear whether our mixture is still too red or too green to be grey.

Mixing complementary colours to make greys is good practice for the handling of quantities of paint, and also for getting to know well the behaviour of each colour. When we know the relative strengths of our colours we can make our colour mixtures more efficiently. In practice we learn to use smaller quantities to start with so as to control the mixture better.

Red and green, mixed together, then with added white.

Complementary colours

Every wheel has a centre, joined by spokes to the outer edge. Every spoke or diameter that passes through the centre of the circle, halving the wheel, joins a pair of complementary colours. Red and green are complementary; so are blue and orange, and also yellow and violet. Of these complementary colours yellow and violet are the most contrasted in tone, and red and green are the most similar.

Help in looking

If we are looking for colour and tone within a subject one helpful method is to look away from the light source. If there is a window giving light onto our model, the more we keep our back to the window the better we will be able to see the colours. This is due to the glare of light, which blinds us, reducing our colour sense and limiting it more to dark and light tones.

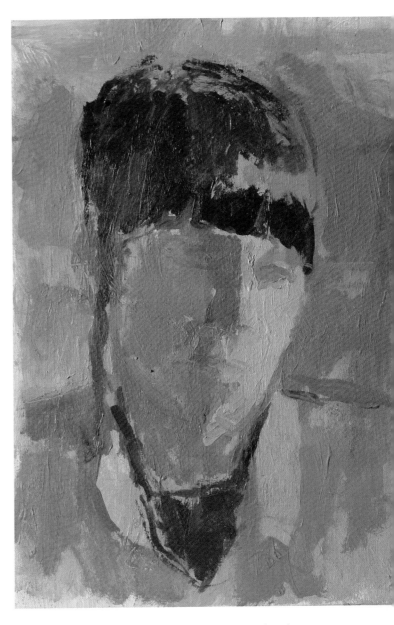

Kim, 2011; oil on board (made when taking turns sitting for other artists, including Kim Scouller).

The next thing we need to do is forget whatever it is that we are looking at and only concentrate on the colours we can see. When we have our model in front of us the first thing to look for is the sequence of four or five colours that would describe them. Simplify the colours to the minimum number. The better the grasp of the relationship of these few colours we have then the better the painting session will be. The main attitude we must adopt as best as we can when painting from life is that of being receptive. If we struggle to look at one colour, trying to make an exact reproduction of it, then the chances are it will elude us as our vision changes. When, however, we pair it with another colour, it forms a contrast or relationship which is a more harmonious way of seeing colour. We rarely understand

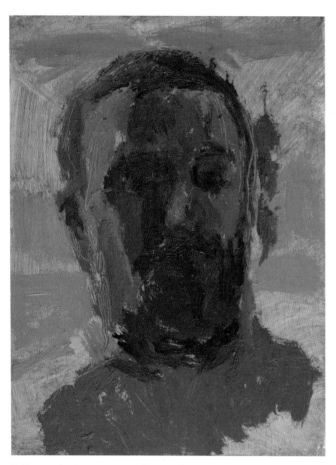

Self-portrait, 2014; a very small monochromatic picture, painted with black and white on a thin blue ground.

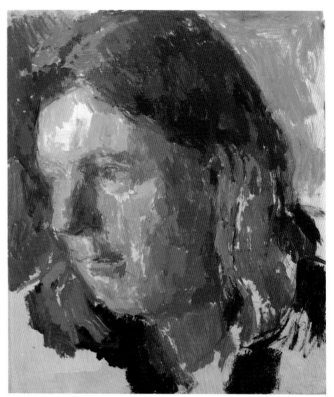

Michael, 2013.

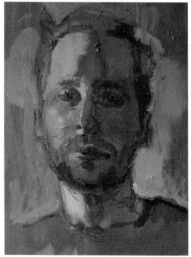

Karl-Peter, 2006.

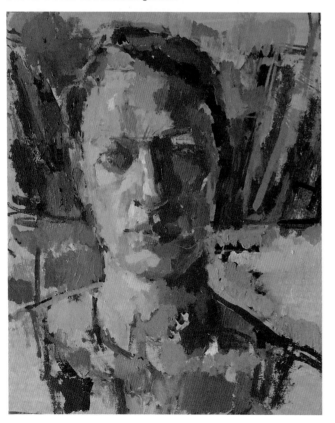

one colour in isolation. Seeing a colour, and more importantly, seeing the relationship between colours, is best achieved by looking at colours in pairs or in threes.

Seeing colours

Light does not exist for the painter! What did the artist who once said this mean? Light must exist as otherwise we would not see anything, but this expresses the fact that the painter is

Claire, 2006.

constantly recreating their equivalent of light in pigment, in paint. When looking at a subject in order to paint it, we must attempt to understand it.

We do not exactly see light, we see a colour. What we see is one colour against another that we must set about recreating. How does one colour relate to another? Is it similar or very different? How many ways can we explain the differences in the colours we see? Can we do it through tone?

The use of a reduced palette makes it clearer to see how much of our vision is informed by tone alone. It can be beneficial to begin a portrait in monochrome. This one colour is probably better if it is more neutral than red, yellow, green or blue, so it can be a good idea to mix a colour that is in-between these saturated pigments. Alternatively we could use an earth colour such as terre vert or raw umber. This simplification of colour into tone can minimize decisions about colour, making the painting process quicker and more immediate.

When we are painting with the tonal representation of a colour, rather than the colour itself, it may be that the mind concentrates in a different way. Look at the model with an eye that is searching to order tone. As mentioned earlier, Cézanne said that the abstraction of black and white was like a support for the eye. This support for the eye is the tonal drawing of a painting. Tone that is constructed well in a picture will mean that either the solidity or three-dimensionality of an object is well represented or else that the variety of tone is structured well in a decorative sense, each of which will help the eye to rest upon the image.

Use of primaries

When we look at a colour and try to understand it, it can help to think of it as a proportion and combination of primary colours. How much red, yellow and blue make up each of the colours seen?

Try for a time to analyse a colour by the content of the primaries that constitute it. Almost every colour seen can be understood and represented by a specific mixture of red, yellow and blue (also with white, but this is best added last). The more we practise this mixing then the more harmonious the colour can become.

Simplify what you use to represent the colour relationships seen. It is the basic exercise for the painter to represent these colour relationships. If we are to study the effects of three colours seen together, then we must look at all of them together.

The classic test of this is to paint a still life of white objects, but to use yellow, red, blue and white, rather than black. Position three white objects in light so that there are tonal variations on each of the sides of the objects. Divide up the areas of tone that

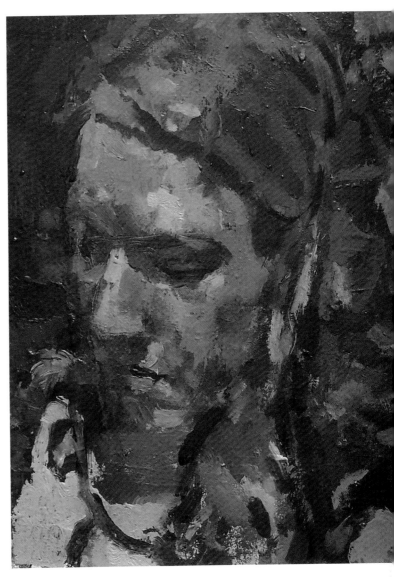

Claire II, 2006.

you see. Unless the lighting conditions are very unusual there is sure to be some tonal contrast. In order to paint these tones most accurately you should observe the colour differences between these areas – which is the most green, or yellow for instance? Also look for the colour out of the corner of your eye rather than in the centre of your vision.

In music a tune is recognized initially by the intervals between the notes played, rather than the key that it is played in. Surely in colour there is an equivalent to this in the relationships between the colours seen. What do we do when we think our painting has gone too purple? Add more of its complementary – yellow. This general theory can be helpful to give the use of the palette an orientation, a direction forwards with the colour mixtures.

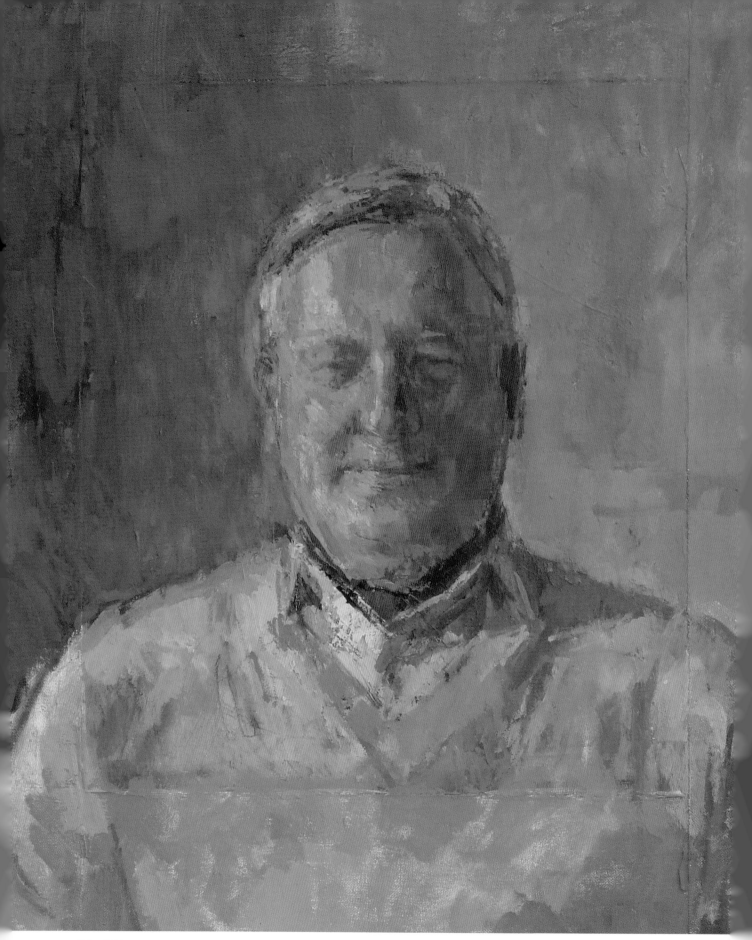

Toby, 2010.

Composition, Perspective, Light and Tone

This chapter aims to cover the multitude of possibilities that the set-up for a portrait can be composed of. This approach is by no means exhaustive and should only be understood as an attempt at indicating possibilities. The model can face the painter, they can be turned to one side making a profile view, or they can be in between these two, which is called the three-quarter view. It is surprising how easily this initial thought can be overlooked, as usually the situation dictates the most natural look of the pose. With some investigation and exploration however we are able to give ourselves more of a chance at getting the image that we want, and of making it more exactly what we want.

When you decide to paint a portrait, the first thing to do is to choose your model. Will it be someone that you know well already? Will it be somebody that you happen to have just seen for the first time? When you feel the desire to paint somebody, ask yourself whether they will be able to give you enough time, and think of what you can do in return. Once you have worked out this problem you should ask permission so as to not waste time. Confirm a time and a place where you will be able to work. If a fee will be charged for the model's time then establish the hourly rate of pay before you begin. In my experience most people like to be painted, but they soon tire of sitting motionless for hours with no end in sight. With a general timeframe agreed, you can begin to prepare everything you will need. Then you can turn your mind to the technical issues at hand.

To start with an illustration to give an idea of how varied the effects are, these photographs of Nicholas were taken in a room with north-facing windows. Three positions were photographed from five different angles. Two of the positions show Nicholas in half light from opposite sides of the room, and the third position show him facing the window so that his face is fully lit. All of these images are of the head only. Each of the positions and perspectives – facing left, left three-quarter view, full face, right three-quarter view and facing right – were photographed with a light, a dark, and a mid-tone backdrop in order to show these alternate effects of the light. Bear in mind that this arrangement shows just a third of the photographs taken. Another thing to consider is that what makes a good photograph may not necessarily make a good painting.

Each position of the model and your perspective towards it is only a starting point. The purpose of looking at all of these potential views is only an initial thought towards the overall design of the image. The painting, once embarked upon, is bound to go its own way. The making of a portrait can be the most changeable and elusive thing, and – whilst it is unnecessary for me to say this but it is worth clarifying – your picture will look nothing like a photograph; it should look like a painting.

The possibilities

Being aware of the compositional possibilities – which only really begin once you start to draw – can help you to choose more consciously what kind of picture you want to make. Being right-handed, I painted for many years with the light coming in over my left shoulder. This set-up has its advantages: the reflected light from the canvas is minimal; the subject is well lit; I had extremely little glare from the light source as the window was not in my field of vision; and I could see the palette clearly as it was not reflecting light from the window. However, as with anything else there were drawbacks to this set-up, chiefly: the same pattern of light was always falling on to the model, and the right-hand side of the sitter's face was always in shadow. This can be seen in many of the paintings reproduced in this book.

Nicholas against mid-tone, profile facing left, light full/from right.

Nicholas II against mid-tone, ¾ facing left, side lit from right.

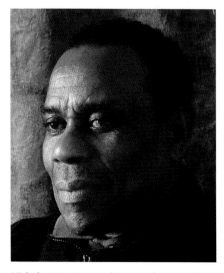

Nicholas III against mid-tone, ¾ facing left, side lit from left.

Nicholas IV against white, almost full profile facing left, lit from the left hand side.

Nicholas V against white, ¾ facing left, lit from the left.

Nicholas VI against white, frontal view with eye contact, lit from the left.

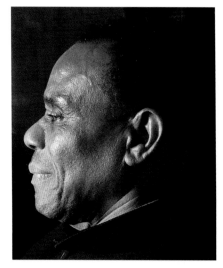

Nicholas VII against black, full profile facing left, lit from the left.

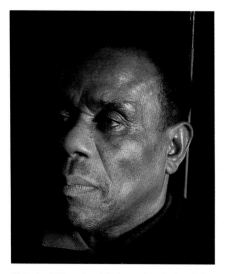

Nicholas VIII against black, ¾ view facing left, lit from the right.

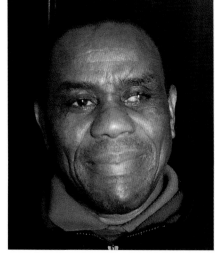

Nicholas IX against black, front view eyes looking slightly to the right, lit from the front.

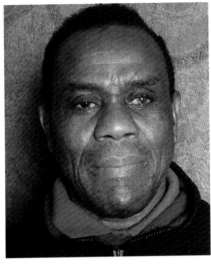

Nicholas X against mid-tone, front view eyes looking slightly to the right, lit from the front.

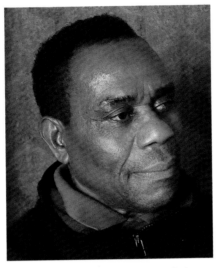

Nicholas XI against mid-tone, ¾ view facing right, lit from the front.

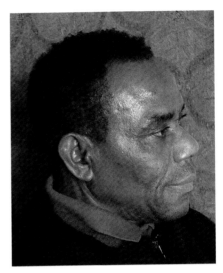

Nicholas XII against mid-tone, full profile facing right, lit from the front.

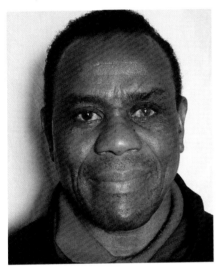

Nicholas XIII against white, frontal view, lit from the front.

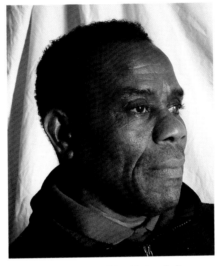

Nicholas XIV against white, ¾ view facing right, lit from the right.

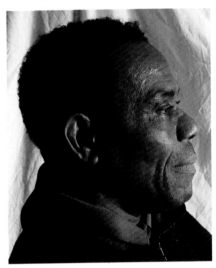

Nicholas XV against white, full profile facing right, lit from the right.

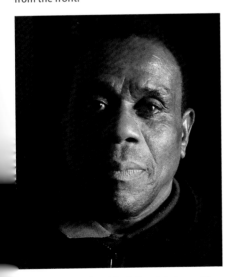

Nicholas XVI against black, frontal view with eye contact, lit from the right.

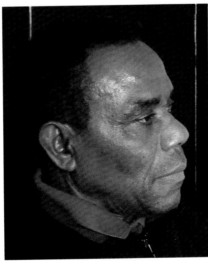

Nicholas XVII against black, full profile facing right, lit from the front.

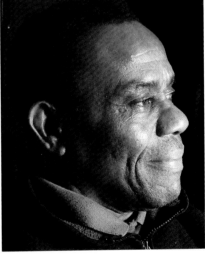

Nicholas XVIII against black, full profile facing right, lit from the right.

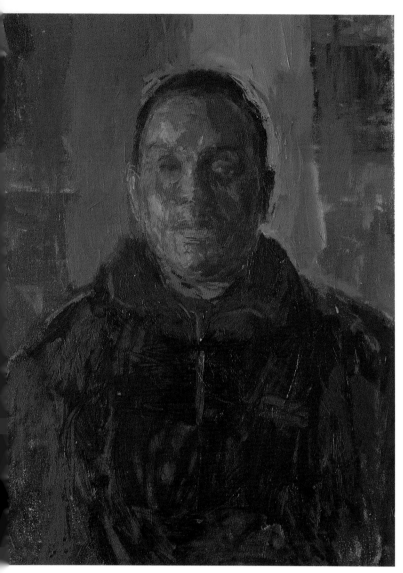

Nicholas, 2015.

Nicholas (profile), 2015.

CONSIDER THE SET-UP

When painting somebody, be aware of the possible set-ups. Ask yourself where to position the sitter in relation to the source of light, and what is the position that you should take in relation to the sitter or model. Preliminary drawings or quick oil sketches at this point will help to determine where your interest lies.

Some artists will make a one-hour study to see if the composition is what they want it to be. So many possibilities can be difficult to think about, but if an idea about a change occurs to you then you should try it out to see if it is an improvement.

View the set-up that you choose each time as developing the way that you want to work.

An artist friend, Sharon Brindle, suggested that I place the model in full light. This really changed my approach to the portrait, making me more conscious of how you can use the light. When the model is in full light it is a very different painting experience, as you do not have the obvious light and dark contrasts to each side of the head. The painting becomes more about the features and less about the contrast of light on their face. Piero della Francesca (1410/20–1492) is a good example of an artist who must have worked with this arrangement of lighting. The effect is that there is no strong light contrast but the delineation of the features is clear. It is a useful challenge to an artist to see the features of the face in this different way. Without strong shadow the painting can have a greater luminosity. There are many examples of this use of light in early Renaissance painting.

Chair, 2015.

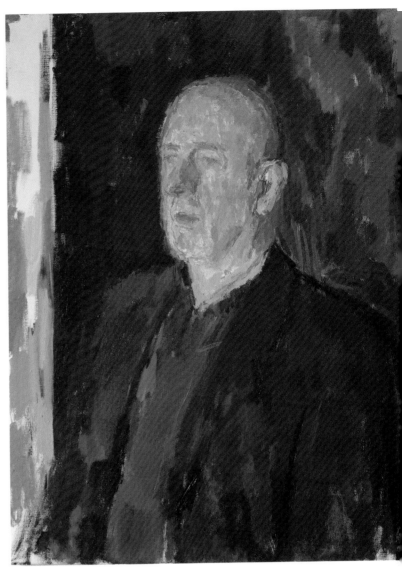

Tim, 2015.

Conditions of light

Morning light first thing can be warm but in my experience is relatively cold looking and can have hardness to it. Making a rule about natural light like this is only an indication or generalization and it is important to remember that the weather can be unpredictable. The best thing to do is to study the particular quality of light at different times of day where you are.

The warmest natural light will most likely come at the end of the day. This can be good for seeing colour. The last hour or so of full daylight can be the clearest and most useful for painting, depending on your subject. When the light begins to go, it becomes the best time for working on tonal relationships. As the room slowly darkens the lightest part of your subject will be the last thing to disappear. It is very helpful, if the tone of your picture is important, to spend time trying to see what can be improved about it. The reduction of light on your subject can make it easier to see the arrangement of tone.

If your studio receives direct light at some point in the day then it will be necessary to work around this. Although the brightest kind of illumination, it can change very quickly,

leading to a frustrating time with the painting. It may be best to work with indirect natural light, and to control this with sheets. A white sheet placed over the lower half of a direct light source will diffuse the light. Tissue, or tracing paper, is helpful too as its transparency gives still greater control over your lighting situation.

Try looking at the painting first thing in the morning, as the room slowly gets lighter. The difference between how you remembered the painting and how it appears, tone by tone, is very useful for knowing what to do next. As mentioned previously, the seeing of your subject and your painting is the most difficult thing. Being as objective as possible will help the painting to improve.

The reflection seen through a nineteenth century Claude glass (thanks to Paul Stalham who appears in the photograph and owns the device).

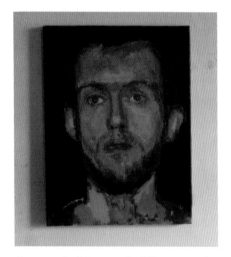

Photograph of the portrait of Alan, as seen in the mirror, reversing the image.

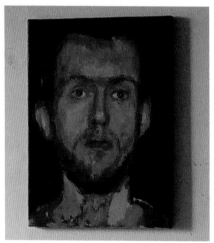

Enlarged photograph of the painting taken from a greater distance; note the loss of detail.

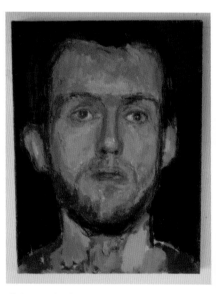

Photograph of the painting taken under dim lighting conditions (picture has been brightened so that it is visible).

Here are some devices and methods to help you see the subject objectively:

1. Using the Claude glass or mirror (a dark mirror which shows the tone very clearly);
2. Looking at the painting in a normal mirror – which reverses the left to right and gives you an unfamiliar view;
3. Moving back to increase distance from the picture, which helps you to see it in its entirety – if you cannot get very far back then photography can help;
4. Reducing the light source – the light diminishing will show more clearly the tonal arrangement in the subject.

Larger compositions

Just because the focus of the painting is on the head it does not follow that the scale is limited. A bigger canvas will give the space necessary for air to circulate around the head. This can add grandeur to a portrait, and having enough space above can also mean that there is room to fit the hands in below. Much of a likeness can be gained by the inclusion of the posture of your subject. It is worth thinking about how you recognize a friend from a distance, by the way that they walk, before you can see their face.

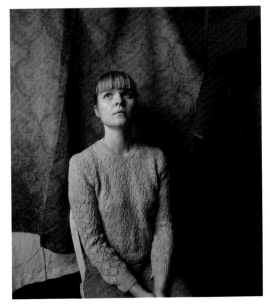

Tuuli, photographed to show the set-up; notice the drapery over a screen behind the model.

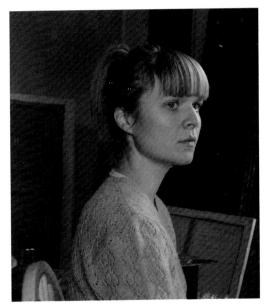

Tuuli, photographed in a mirror.

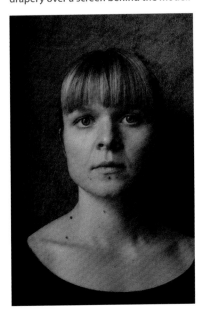

Tuuli, photographed with eye contact.

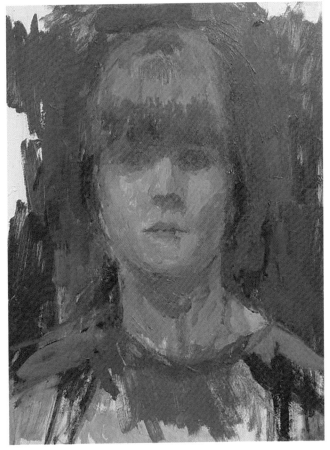

Tuuli, 2013.

From head to hands

Although this book is focused on painting the head, the hands can complement the head and complete its look. The way a pair of hands can sit within the picture can be very expressive or suggestive. How do they sit naturally? Can the hands express a thought? Are they holding anything? Consider where the hands are during the process of your painting and if they are or are not a positive inclusion.

Kaye, 2011.

Model on raised platform

Once the canvas size goes above two feet or so, the picture will become difficult to work across if you are sitting down. Standing up to paint has many advantages. Once you are standing, you may wish to raise the level of your seated model. A raised platform can give the model's head a position level to your own standing view, whilst giving them the support of a chair (with a back rest).

Head resting on hands

A smaller composition of the head can still include a hand or two. This will give a greater indication of the particularity of the head, and can improve a sense of scale. Hands are notoriously difficult to paint since their form is so complex. As with most things in painting, reducing the drawing initially to an arrangement of light will be the best method of construction. Be aware that drawing the outline of each finger, although necessary overall, will immediately flatten the shape, especially if the observation of contrasts is insensitive. Try to see the hand in relation to the head, and especially as a tone.

Ratio explained

Working out the ratio

Ratio in drawing and painting relates to geometry, in the sense that there are many ways in which a picture can be sub-divided. What is the ratio of the width to the height of your picture? If it is a 16 × 20in canvas, for instance, then it is 4:5.

One way of working out a ratio is to divide both lengths by the same number until you get to the lowest numerical expression of that ratio. 4:5 can also be expressed as 1:1.25 since if you multiply 16 by 1.25 you get 20. The way to work this out is to divide the longer length by the shorter length. A square which naturally has the same length of each side will be expressed as 1:1. By this method, mathematics can help the spatial understanding of the drawing and is useful for scaling up work.

Using the ratio

Many stretched canvases that you can buy in the shops share a similar aspect ratio. A 10 × 12in canvas for instance is a 1:1.2 ratio rectangle, which is the same as a 20 × 24in canvas. Here is a list of 1:1.2 shaped canvas sizes:

Inches	Feet	Centimetres
10 × 12	10" × 1'	25.4 × 30.48
20 × 24	1' 8" × 2'	50.8 × 60.96
30 × 36	2'6" × 3'	76.2 × 91.44
40 × 48	3'4" × 4'	101.6 × 121.92
50 × 60	4'2" × 5'	127 × 152.4
60 × 72	5' × 6'	152.4 × 182.88
70 × 84	5'10" × 7'	177.8 × 213.36
80 × 96	6'8" × 8'	203.2 × 243.84
90 × 108	7'6" × 9'	228.6 × 274.32

Alternatives to the 1:1.2 ratio include 1:1.25 in a 16 × 20in canvas, 1:1.285 in a 14 × 18in canvas and a 1:1.333 ratio in a 12 × 16in canvas. The higher the number against the 1 of the ratio then the longer the rectangle shape of the canvas will be.

The diagonal

The diagonal is used frequently in geometry to calculate things. When you are assembling your stretcher, it will only be satisfactorily square to look at if the diagonal measurements are the same from corner to corner. The diagonal, if consistent across different rectangles that start from the same corner, will keep a constant aspect ratio. Visually, this is the fastest way to check if a picture is the shape you want it to be, by checking it against another canvas.

The diagonal, or root, of the square can be used to calculate the length of a rectangle. This is called a root 2 rectangle, and it is made by swinging out the length of the diagonal into a new length, while retaining the previous height. This method can be repeated with the new rectangle shape, making a root 3 rectangle. Repeating the process would make a root 4 rectangle, and so on. Euan Uglow painted a life painting which he titled *Root 5 Nude* and this features in a television documentary on the painter. I have my teacher Roger Leworthy to thank for showing us this whilst on a foundation course at The University of Hertfordshire.

Geometry in composition can also be useful in dividing up a rectangle. The reason for its use is to get to know a surface better. Halve a picture to see where the centre is. This can also be done diagonally. Divide into three, making thirds, or into four making fourths or quarters. When applied to an image it can illuminate the artist's use of space in a picture. In drawing older paintings in museums such divisions can reveal how much information is described in the tiniest part of a picture.

Photograph of a metre stick placed on the diagonal which links the 10 × 12in and 20 × 24in canvases, showing that they have the same aspect ratio.

GOLDEN SECTION

The golden section is where a division of a line or area creates a larger section which relates in the same ratio to the whole, as the smaller section does to the larger. This can be expressed as the ratio 8:13 or less exactly as 5:8.

Diagram to show the location of the golden section within a ratio.

SUMMARY OF PART I

Painting is a cyclical procedure and there are aspects of it, as a practice, that I had not considered until I began to teach. Every picture has its beginning, just like the work made each day must have its starting point somewhere. This validates the view that the content of each of the four chapters of this section can be revisited in order to ensure that as considerations they are kept up to date, and that neglect should not creep in to any aspect of your painting practice.

There will always be some equipment that you have not yet tried, or got to know very well, which you may have discovered in the first chapter. The colours and brushes which you use to paint with can be varied throughout your life. Some artists, after a few decades, will come to use the same tools because of how well they know them. Depending on your approach and level of experience, there is usually no good reason to not keep experimentation a part of what you do. When you visit friends who are artists, keep an eye out for the tools in their studio and ask any questions that you can think of to try to learn as much as possible. Remember that some may find this sort of enquiry an intrusion, and that ultimately the studio can be a very private place.

Drawing (Chapter 2) should continue throughout your life and it will always help to inform your practice as a painter. Never stop drawing, since it is a connection with what you see or want to see, and it can be so much more direct than painting. It is harder to draw than not to draw, but remember that you will get out of it what you put in – so every effort may bring its reward. Your sensitivity to drawing will also change, so it is a constant guide to look at drawings by other artists. Bear in mind that the art of the past would not have been possible without the drawings that informed the paintings. Try to see these drawings if you can, the ones by the artists that you most admire, that helped them to make the paintings that you like. The difference or similarity between an artist's drawings and paintings is of great interest to other artists because it is revealing about processes.

In Chapter 3 we looked at the introductory principles to painting which form the basis of the teaching I do. Even while writing this I have made connections and thought new thoughts about control in painting and painting practice. The greater your mental and practical grasp of this control in painting, the freer you will be able to handle the paint. Painting is largely made with confidence or trust, but revision is always necessary, even if it is only in terms of looking. Revisiting the initial principles that I have attempted to structure here should help you familiarize yourself to a greater degree with this aspect of painting which does not change.

In Chapter 4 we discussed composition which, much like drawing, is something continually alive and present in picture making. It is best to experiment as much as you can, early on, so as to find out more exactly what you want. In most aspects of painting, accident can play a positive role. What organizes or controls the accident is within your control, and this is what must be thought about. Work spontaneously and innovatively, but also have something beyond that which you can see or believe in.

The craft of drawing and painting is not something that you can learn and can then do or use; it is something that you can do without any training whatsoever, but that with training, continual effort and renewed concentration, can become more what you want it to be. With practice it can become more within your control to make the pictures that you want. Seeing paintings regularly, and by living artists, is probably the most important contribution to your learning. This is an excellent reason to paint alongside others.

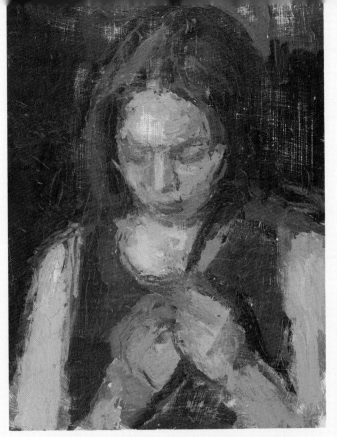

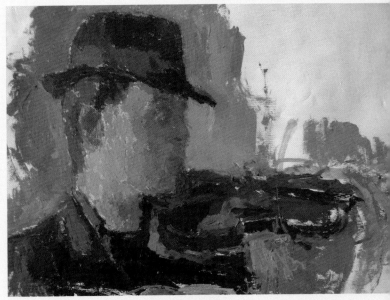

Anne, 2015; pose seen during a break and held for a new painting.

Alan Playing the Violin, 2014.

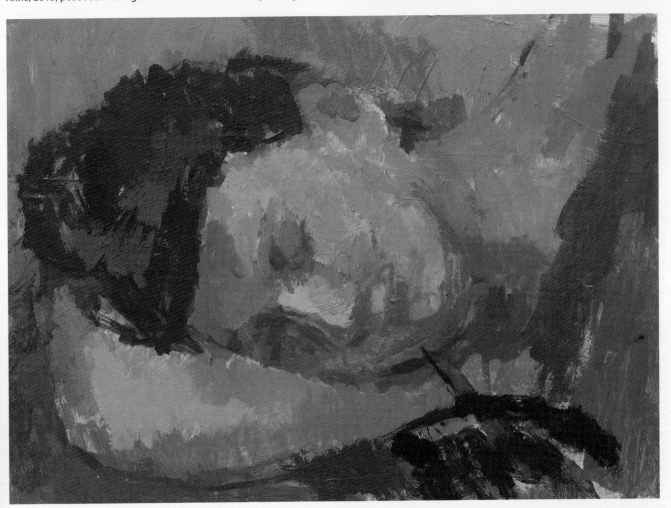

Lucy, 2012; lying down pose.

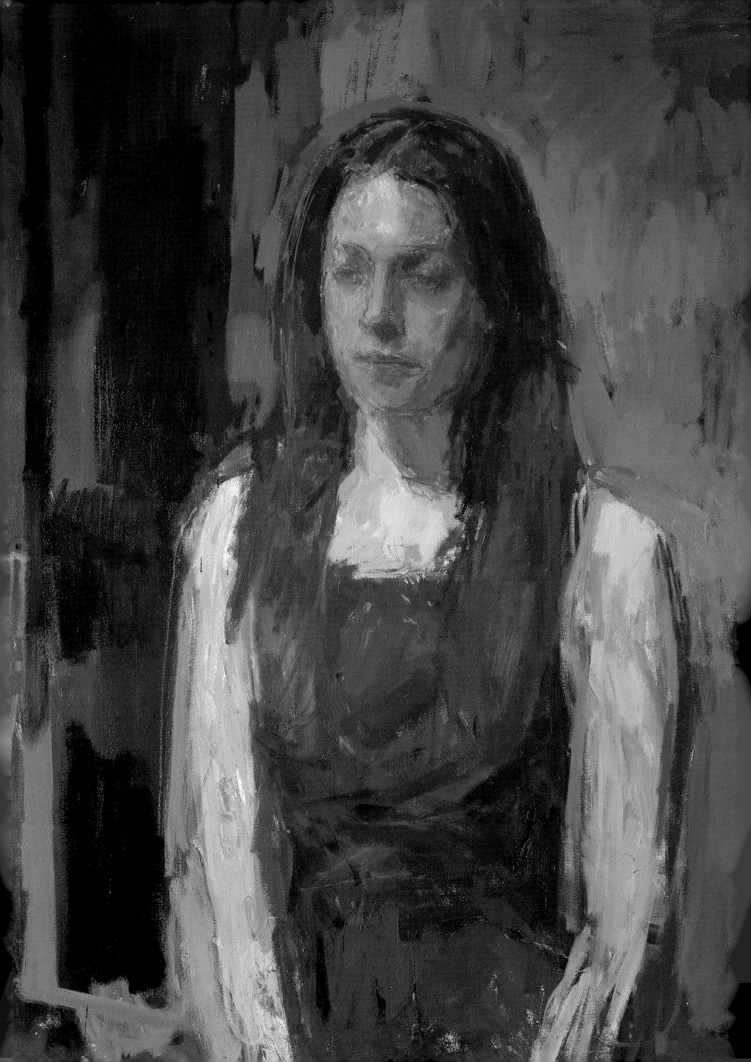

Day I: Bold Beginnings

This section of the book is intended to advise you well throughout five sessions of painting a portrait. A period of five consecutive days spent painting somebody very rarely happens. The more likely time frame will range between three weeks and six months. An average number of sittings will be four to six, although it can go on indefinitely with an understanding sitter or model.

It is my intention to be as specific and helpful as I can, with reference to examples and with instruction for things to look out for. However, the very nature of painting a portrait is unpredictable, and so will mean that there is a chance that what I say will be inapplicable. Combining the unpredictability of how the painting will go, along with the fact that this is a book and I cannot see what you are doing, will make it very difficult for any instruction to be specific and appropriate.

I highly recommend studying painting alongside other people. It may be that you have taken part in classes previously and are now going it alone with your sitter. This decision to concentrate on a portrait individually will give you privacy in your working methods and suggests seriousness in your intention. As with most forms of learning, repetition is essential and the whole process has a cyclical pattern. No painter would say that they have arrived at the end of their learning, or that they have completed what they set out to do. More likely, once one painting comes to its end, another one begins. This new beginning each time is a positive aspect as your next attempt may surpass the previous one. New ideas should be tried out, whether with the composition, pose, or even with the materials you are using.

Jim, 2011; first stage of painting, working into a wet mid-tone ground.

Anne, 2015.

Tom playing Guitar, 2010; a large picture shown here after it was just begun (constructed from a drawing, which was scaled up using a diagonal gridding system).

have a good beginning for planning your composition.

The next step is to look at your sitter, not to focus on any one part of them in particular but to rest your eye in a centralized position. I say this because many portraits will put an eye right in the centre of the picture. While I am not saying that this cannot work compositionally, it may not be the most considered placement of the head. It may stop the viewer's eye from circulating around the picture.

There is a compositional convention in portraiture that places the eye level between two-thirds and three-quarters up the canvas. When the head is placed in a lower position than this, the lower face and neck can begin to shrink in order to fit them into the image, and the appearance of your sitter can be constrained. If the eyes are about halfway up or even lower, then much of the painting will consist of the space above the head. This can work, as Alberto Giacometti has shown, but when you look at your composition ask yourself whether it is a distraction. Also in grander scale portraiture the picture may benefit from having space around the head. Always make sure that the space within a composition is considered.

So having found your central point in your model, begin by drawing out from there. To begin with, thin paint is easily visible on the white canvas so use solvents to make the paint go further. Look and draw in each direction – up, down, left and right – so as to make a balanced view. How fast you paint is entirely up to you. When working from the inside out it may take a long time to get to the edges of the head. This is okay and may even make your painting have a strong quality of concentration. However, beware of slowing down as you go along and coming to a standstill, optically, too soon.

What you should be able to do is look all the way up to the top of your picture. Make sure that you have looked to see what happens when you look all the way down too. The same goes for looking left and right. This visual agility does not mean

Starting a Picture

Painting is instinctive and tactile at every stage, making the process one that is felt more than thought out. It is not a good idea to be too analytical to begin with. Cézanne said that he always tried to start with bold sweeping brushstrokes, making me think of Peter Paul Rubens (1577–1640, one of Cézanne's favourite painters). This looseness is recommended but it is not always possible if you do not feel confident with the drawing. In my experience, I generally use one of two different ways of working and looking: one is from the inside of the form working outwards, and the other is in the opposite direction, working from the outside in.

Working outwards from the inside of the form

Imagine a cross from corner to corner of your canvas. Make a dot where you think the centre is. Now use a long straight edge (a ruler or piece of timber) to actually draw the diagonals onto the canvas. Use pencil or a thin amount of oil paint –anything that will lightly mark where the centre actually is. Is this where you had judged it to be by your eye alone? It is quite rare for somebody to be able to see exactly where the centre is, and this is not the point, but now that you have found the centre you

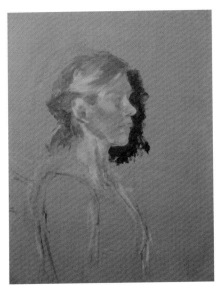

Tara, 2015; first stage of portrait by Rosie Kingston.

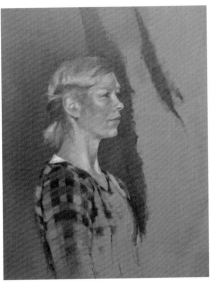

Tara, 2015; second stage of portrait by Rosie Kingston.

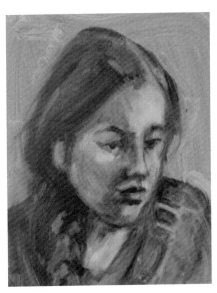

Rosie, 2015; portrait by James Betts.

that you have to have busily sketched in everything that you have seen, but if you have seen it then you will be able to get a clearer idea of what areas of the picture may need more work as the painting progresses.

When Lucian Freud (1922–2011) painted the art critic Martin Gayford, he seemed to work in a small area of the face for a long time. Look across your composition, so as to make yourself aware as soon as is possible of whether or not you will fit the whole head in. You may decide that you want to crop the head. The advantage to working from the inside out is a kind of sensitivity, and a sense of construction of the details. For instance, if you begin with the nose in a frontal view then it is more likely that the eyes and mouth will relate better to the nose.

If your view is three-quarters or a profile then it might help to centre your drawing on the cheek. This may seem like hard work as there is less distinction between the forms. If you work towards the face from the cheek, and then across to the ear or the side of the head, then there is a better chance of achieving a believable sense of volume. With this perspective, watch out for the distance from the ear to the nose, and look for how far the eye is from both the nose and the ear. One danger is that the features of the face are given a disproportionate amount of concentration. This can result in confusion about the space around the features of the face. With every view the difficulty is in getting the relationships right across the composition.

Working from the outside in

This method avoids the detail and attempts to see the whole subject. Look for the bigger shapes and start to be aware of the

Joe, 2008; first stage of painting with ultramarine.

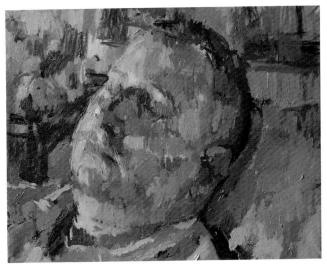

Joe, 2008; several stages later.

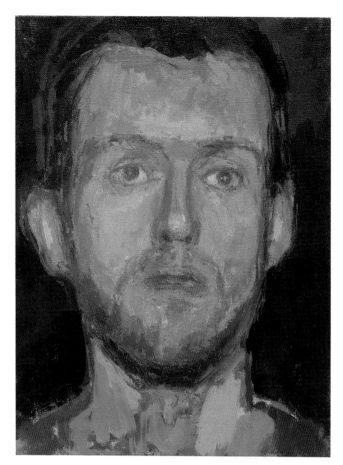

Alan, 2015.

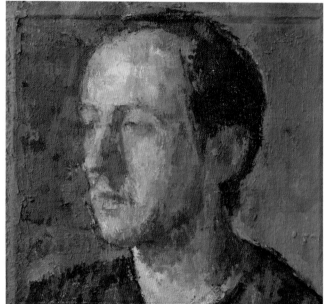

Dan, 2008.

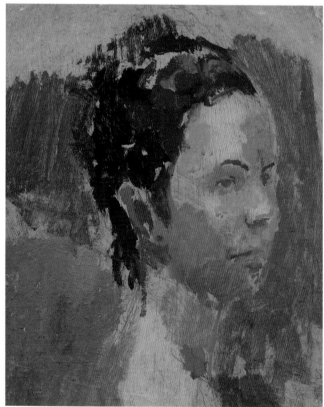

Beth, 2013.

organization of tone across the whole composition. Where are the shoulders in relation to the head? What shape can you make out of the mass of the hair? When you work from the outside in you should train your eye to look for the negative space and the shape of this. For instance with a profile, if the background is understood as a shape then this will simultaneously draw the outline of the face.

This way of looking at your sitter will suit working in layers, putting wash tones in that make distinctions of larger shapes and colours. Some artists will make use of a ground colour to begin with, as this will cover the surface of the canvas quicker and initiate the balancing of tone across the image. How few colours can you reduce your subject into? Henri Matisse (1869–1954) recommended a simplification of colour – that you divide your subject into three or four colours and set about painting those shapes of colour. This bold colour beginning will relate the general contrasts early on. If your model is sat in half-light then divide the skin tones into a few different colours which represent the tones of the skin as clearly as possible. You may mix these few colours with a palette knife on the palette first. This way you can see how they look together before you put them onto the canvas.

Make a colour mixture, using your primary colours, for the area of the skin in shadow. Putting this deeper tone down first will make the picture look right quicker and make it easier to locate the lighter skin tones as colour. Think about the contrast and make as clear a structure of the form of the head as you can, using the light and shade to describe the form. When you are

looking for a colour, look for two or three colours together. It can also be easier to see a colour out of the corner of your eye rather than in the centre of your vision.

This kind of beginning of a picture will be faster, potentially, than working from the inside out, and gives a more immediate impression of what the picture is going to be. The advantage is in the consideration of the overall relationships, that when simplified, colour relationships can be very effective at conveying light and shape. The disadvantage can be if the picture becomes too crude or clumsy and then drawing into the painting will usually be required.

Choice of palette

Starting with a full palette will give the picture as wide a range of colours as you see. Cobalt blue can be very useful to build up the deeper skin tones when mixed with yellows and reds. Earth colours are traditionally used as they can indicate the layout of tone inexpensively. In particular, terre verte, or green earth is highly recommended for this purpose. It has a colour that, on a white ground, is transparent enough to admit a lot of light in the thinner areas, while in the thicker darker areas the tone is sombre but radiant. When dry, new colours can go down particularly well on top of terre verte. Raw umber will deepen the darks, while lighter yellows and reds will bring out the brighter parts of the composition. Somehow the lack of saturation in the colour of green earth lends itself well to harmonizing when other colours are added to it, or more specifically, put down on top of it. With a varied tone of green earth undercoat, you can put a thin wash of a lighter colour on top and the tonal delineation of the undercoat will come through, making one colour, when applied, look like several different colours and tones, in its transparency.

Further into the process

What to concentrate on

Painting is always a case of trying to get something to stick – when it goes well, there is not much of that layer that we would want to remove. When it does not go so well, the wet paint can be removed with solvents and paper towels. With this process in mind, it is worth attempting to paint the whole picture each time we are at work upon it. This method will give less chance for leaving an area out, and also brings into play a session of review which can edit out parts that did not seem to go down right.

Sometimes a portrait can work very rapidly, a whole painting being completed in one hour. It is worth keeping a few

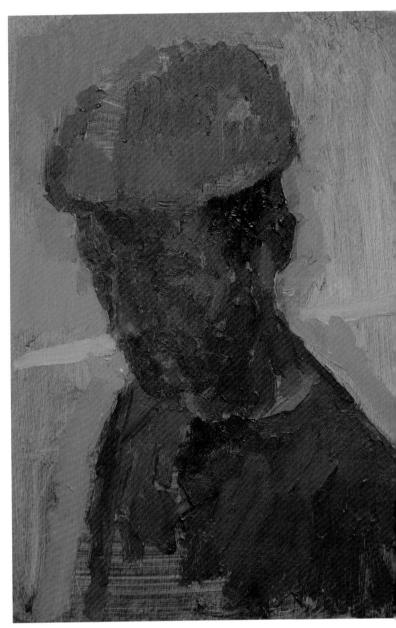

David, 2013; painted on top of a terre verte ground.

pictures that seem to go well in one session, early on, as they may show things that the more sustained painting cannot. Quick paintings very often have a unity in their construction, and can seem clearer in each application of brush mark than more sustained pictures. It is advantageous to be able to return to the set-up and model and to attempt to continue, but not with every picture. This element of revision and how to look at and improve a painting is probably the most important skill to develop as a painter. What to keep and what to change is often a very subjective decision. My main advice is not to be afraid of the deconstruction of a painting as this is very often the part of the process necessary for a picture to improve.

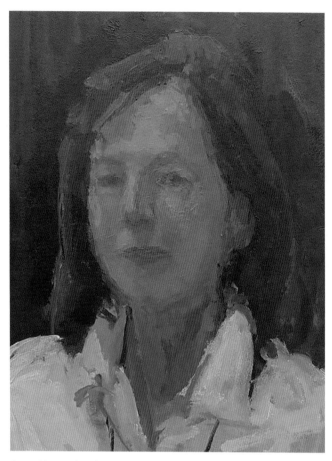

Anne, 2014; painted at Art in Action.

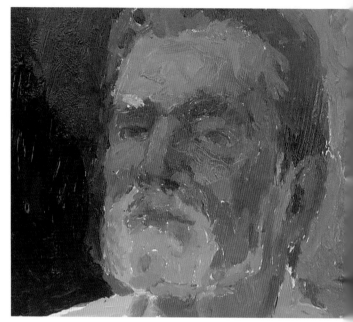

Angus, 2014; painted at Art in Action.

Removing paint

The least damaging method for removing paint is to press a sheet of kitchen towel or any absorbent paper against the wet picture. Do not slide or scrunch up this contact at all. As you peel the paper away, some of the excess paint will come off, making the surface of the painting much more receptive to additional touches of paint.

More severe than this is to add pressure and movement to the pressing of paper, or even to use the palette knife in a scraping movement. This method, it is important to add, is like that of a snow plough, bringing the excess paint upwards and off rather than compressing it downwards. Depending on the kind of picture surface, this still only removes excess paint and will leave an impression of the image which is fast attaching itself to your ground or layer of primer on the painting's surface.

The most extreme method of removing paint is to use clean kitchen towel and solvents to take it all off. Very often a first layer of ground is made out of the initial sketch of the painting. This swoop and deconstruction of the image can turn a drawing that did not do what we wanted it to do into a colour wash that is not at all what we intended but is tonally much more useful to begin the picture with.

Cleaning the palette

When painting, it is extremely important to keep a clean space on the palette for mixing new colours. To do this, scrape off the accumulated colour mixtures that you have made so far for the painting. This can be kept in a watertight container and will stay malleable as wet paint if it is topped up with water, as it is the contact with air that dries oil paint. Do not worry that you will not be able to mix these colours again. With a drop of clean solvent and a wipe of kitchen towel, the palette can once again be used to make fresh new colour mixtures that correspond with what you are seeing.

In order to save time when a model is posing, if you tend to have to clean the palette quite regularly, try preparing several palettes in advance. This will stop you from having too large a palette that gets in the way of you and your model. There is a pleasure and clarity in having a palette that is well organized and freshly prepared. As with most things the opposite can also be true; some artists prefer to build up the colours on the palette and take inspiration from the appearance of the dried colours.

Break time

If you have ever tried sitting for a portrait, you will know that the first thirty minutes is difficult and can seem to last about an hour. By forty-five minutes it can seem a real effort not to move. Rather than prolong a strained pose, short breaks will refresh your model, making their experience a bit less torturous.

Photograph to show the method of scraping excess paint from the canvas.

Washing out the unwanted painting to make a colour ground.

If the picture is a commission and the sitter's opinion is important, then do let them see how the painting is progressing early on. Expectation in a commission can be the most difficult thing to work with, so the earlier the better that they are disappointed, so to speak, with things not looking as they imagined. In a painting, it is up to the painter to control what they want it to be as well as they can. Other people can perhaps point out more easily and objectively what they see or cannot see, and this can be helpful to make your own view more objective. It is very important to remember that you may be seeing not exactly what you want to see, but may be able to see a bit further ahead than other people, who have not been involved in the process as you have. This will be one certain difference in how you and other people will see the progress of the painting.

Taking stock

After the model's first break is a good time to draw and take stock of the essential form. This can range from a layout drawing of the whole image to a smaller unit of study that everything in turn will need to relate to. Identify which direction your method of working has predominantly been and perhaps change your looking to include the alternative way of looking for a while. This initial review should be to check that the direction the picture is moving in will contain successful drawing and is being formed of a coherent arrangement of colours and tones.

Take a photograph if you want to of your model. Your picture

is already more interesting to look at than a photo because of the time you have taken and the sensitivity with which you have seen. Do not see the photographic image as more correct in any way than your picture; it is simply a different thing. If, when you come to compare the two things, one offers you something that you had not noticed so much before, then this may be something to be aware of when painting recommences.

Starting again from the break involves an initial checking procedure. Is the model's chair in the same position? Is their head at the same angle? Are you looking differently in any way? Sometimes we instinctively move closer and even end up turning away from the model. If we can be aware of any of these alterations then we can expect to make progress. Many times it is only after considerable concentration and continued painting that I have realized simply that something was in a very different place and that leads to another decision: do you try to keep things as they were to start with, or do you change everything as it goes along? The second method is probably best to follow for immediate results from painting, and the first method, as long as these things are in your control, will help you to know better how the painting is going.

It is at this point, after some initial thought, that marking can be useful, since it is now conjoined with your intention. Chalk, charcoal or masking tape can be useful for this. So much of the progress of the portrait is dependent on the painter that every consideration should be understood as the painter's responsibility. For instance, in natural light conditions you may want to recreate, as much as possible, the same setting. This, amongst all the other considerations is within your control. Working at the same time of day can help, along with marking the chair positions so that they are in the same place each time.

Be as rational as possible about what conditions will help you. Listening to music for instance can greatly affect the process, putting the model at ease potentially but perhaps distracting ourselves too? Conversation is the most natural

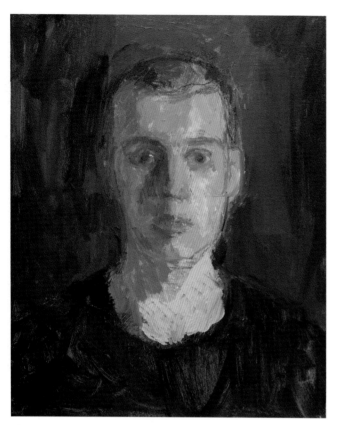

Alan, 2014.

thing for two people sat together but the purpose of the time spent is for the painting. Whether or not the conversation is a help or a hindrance it is hard to say. Generally I advise that you attempt to work in silence but to remain sensitive to the need for speaking and listening. Experiment with cutting out conversation to find out whether you prefer it.

How to check for the biggest differences

Assessing tone

It is very easy to lose the overall sense of basic relationship of tone. To check how the tones are doing, and by this I mean the larger areas, it is helpful to get distance from the painting. To compare as easily as possible it is best to make the scale or size of the head in the painting as close to the size of the head as we see it in real life. Usually this will mean putting the canvas alongside the model, but if the head is painted quite small then you may not need to put it so far back. Depending on the size of the room if you can get as far back as you can now, you are viewing the head and the model with as much objectivity as is possible.

Looking in a mirror simultaneously at your model and the

painting will also increase objectivity. By objectivity I mean the sense of the way something is, rather than the way we are making it or how we would like it to be. When you move back from the painting, and while the model is still there, once the two appear to be the same size in your field of vision you can more easily spot the difference. The biggest differences that you see will make the most immediate improvements to the picture.

Seeing the whole picture

Our eye gets so involved when it is painting that it can be very hard to see the whole of the subject again. Looking at a detail is necessary for the understanding of how to remake it as faithfully as possible. The looking that you are doing can easily start to lose the bigger relations that go across the picture.

One way to reassess the overall relationships of tone is to move back and compare the subject and the picture from the greatest distance in order to see the whole as clearly as possible. Place the picture close to the model, so that the two are similarly sized and start to look across the whole picture. Is there a colour difference that strikes you most vividly? Is there an issue that is immediately apparent in the drawing? Look at the overall structure of light in the picture. Does it match the light relationships in the subject? Keep asking yourself these questions that reassess the larger areas in the picture, and this can give you an idea about what aspect is most important for you to work on.

Use the line in your painting to emphasize the differences in colour. Draw with a colour that matches the tone you can see. Re-drawing is best done with a colour that is visible but which does not cancel out the tonal balance in the picture so far. Do not add contrast in an area that is similarly toned. Keep the thought of how the light affects the form, and use this rationale to help with the tonal structure in the picture. Whether or not your changes to the drawing are slight or dramatic is up to you. Keep an eye on the scale, and the most important thing is to be thorough and consistent. It does not matter if you are only working in a small area. Wanting to get one thing right before starting another will keep your picture on track.

The important thing about moving back at this point, to view the picture in a more overall sense, is just this: to try to see in an instant the whole view, or the whole painting. This is not easy, and will take a lifetime of practice. When we look at the whole picture, a bit like the initial impression we get when we first see a painting, we are not weighed down in a detail. The whole surface we see in an instant (admittedly in less detail): background and foreground, features and forehead, every part of the picture occupies the same two-dimensional surface. We should think about the flatness of the picture a bit like we would

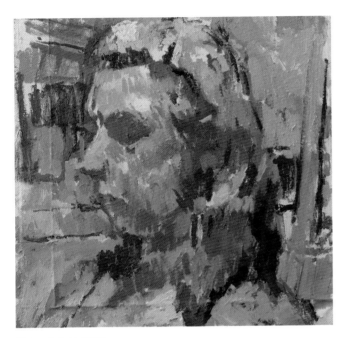

Claire at night, 2008.

have to if we were going to lay a tile mosaic of the same view. If you were to lay a tile mosaic then the necessity is of balancing the impact of each tile, as you choose them, against the whole arrangement of tiles, so that they correspond. Each tile takes up an equal area and has an even importance in the construction of the surface. There is an element of simplification here, but if it is related in tone and colour as a design, then seeing your subject in this way will not harm your painting.

Situate the contrast

If I were to ask you to look for one thing at this point it would be the contrast. Where is the subject darkest? Where and what shape are the shadows? If you sat and watched until the end of the day when the room got dark, what would be the last to disappear? This area will be the brightest part of your subject.

Very often our desire to make contrast will exaggerate one contrast, but then not make enough of another contrast. If the view of the contrast can begin to be consistent across the whole image, then the tone of the picture will come across more forcefully. As a general note the contrasts within the figure or body are not as great as those on the edges or outside of the form of the head or body. Look for the shadows and compare these tones.

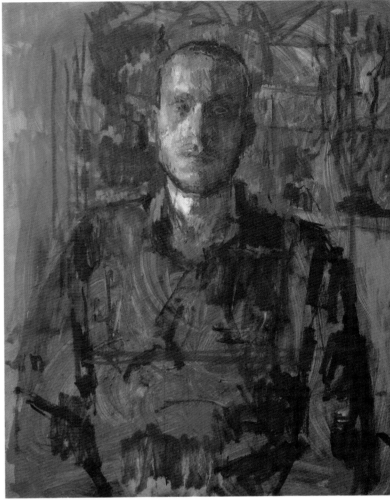

Matt, 2009.

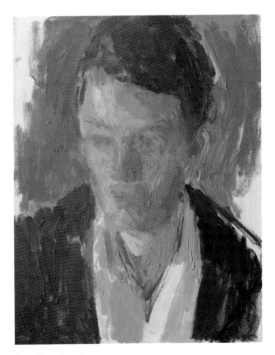

Angelique, 2011.

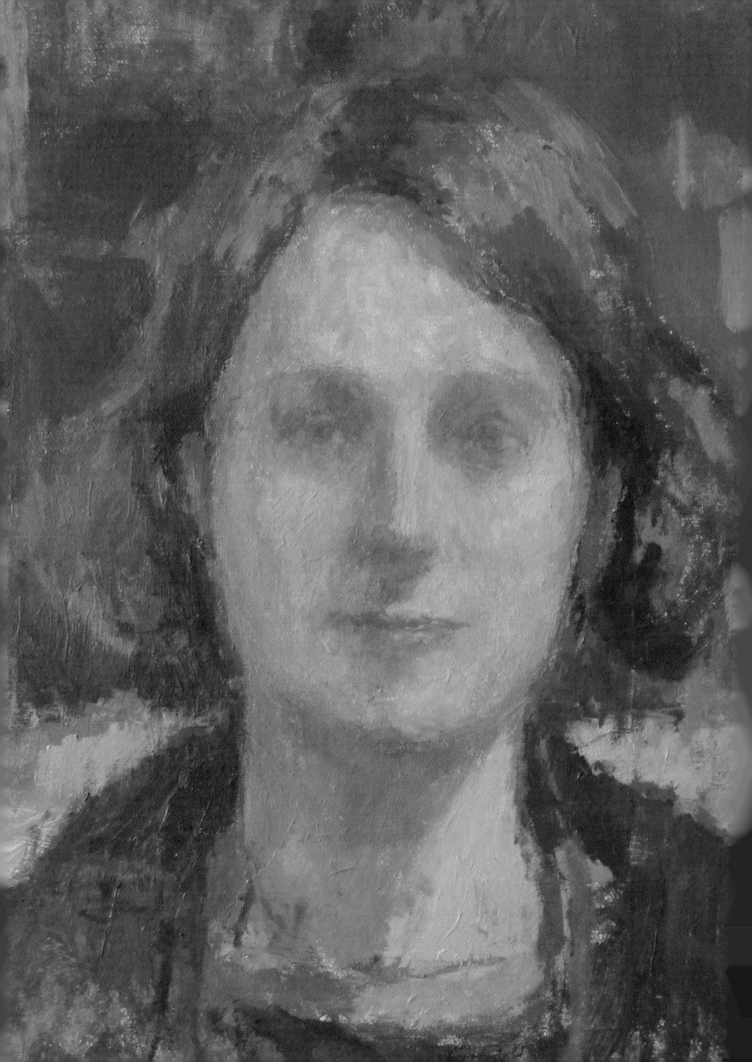

Day 2: Clarity of Tone

This chapter follows on from the end of the previous chapter, where the focus was on contrast. Well, now assess again the contrast and tone of your sitter against the painting. Does one appear darker or lighter than the other? Can we be specific about the head as a structure, behaving in space and light?

As mentioned before, the greatest contrasts are not usually found within the head or human form but outside it. This was taught to me on a day spent drawing and I still remember it and use it as advice. The problem with our looking can be that it becomes localized; it only stays within a certain area. The struggle is to get across visually to what else may end up within the picture. Even if you are not going to paint that part right away, stop and look across the subject now to get a bigger picture of the overall relationships of tone.

Assessing the tonal arrangement

In Chapter 3 I described briefly the way to see tone in a sequence and at the same time. The example was of a form in light interrupting a constant tone: the background. We can apply that way of looking to your subject now. The person that you are painting is the form; their head has been posed in light and the background is, in effect, interrupted by their head in space.

Judge for yourself the tonal arrangement of these large areas. If you are using half-light on the model, so that there are shadows on one side of the face, and in addition if you have used a screen or shadow on a wall as a backdrop – creating a tone that makes a pleasing sequence with the head – then attempt

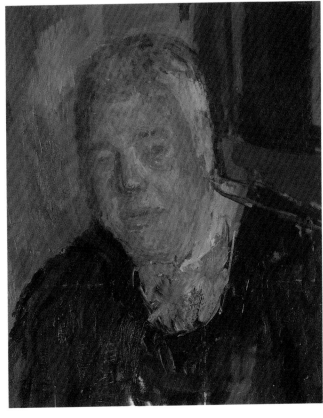

Paul, 2015.

to order this sequence of tones. Which of the tonal areas is the lightest and which is the darkest? Of the closer mid-tones, see if you can differentiate between them and therefore create an order or sequence. Check this ordering, sequence, or way of seeing against the painting you are making. Is there a major difference? Have you reversed any of the tones? Where is the greatest exaggeration in the contrasts that you have made? How does the light correspond to the form? Is the part of the form that is closest to the light source the brightest? Or is there an

Lucy at night, 2013.

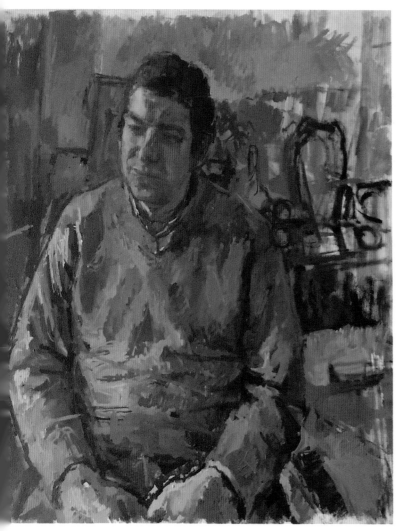

Massimo, 2005.

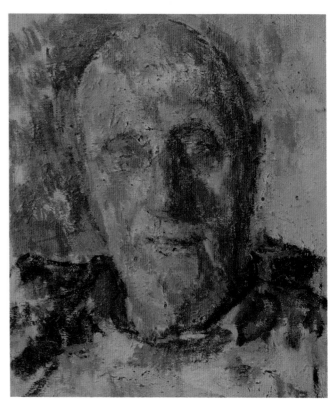

Lawrie (in progress), 2009.

even brighter part of the set-up? Be as strict as possible about your ordering of the tones from light to dark.

After a thorough look at the overall arrangements, the painting, however hard it can be to make changes or even to continue in the way you had been doing, must go on. Do not be afraid of changing anything and everything at this point. What is important is the idea that when you look at your model now, you will see something that you did not see before. Or more specifically, you may see better the same model. The painting that you are doing will always reflect the way you are looking. Because of this pattern it is extremely important to keep your eye alert and your model engaged.

Check the focus on eyes

When a painting is begun, very often the eyes will come to form the point of focus in the picture. Do not focus on this too strongly, too soon. Once a portrait is staring fully out into the world you might say that it was finished, and all of the

additional work that surrounds the sitter, i.e. details in clothing etc. only compete and distract from the gaze. This view might be only a stylistic perspective but in my working methods it has helped to not emphasize the eyes until the rest of the picture is ready for it. Keep the description of the eye simple and about the shape of the eyeball and eye lids and the eye socket. Even though you know the eye is constructed with these delicate forms the overall painting will be more consistent if the eyes aren't treated too differently from the rest of the figure.

Awareness of the skull

The eye socket is the largest cavity in the skull and so naturally creates an area of deep shadow. Always relate the degree of contrast of this shadow to your darkest dark, which I imagine will be on the edge of the head, or on the clothing, where there is the most shadow. This should not be any part of the form receiving light. The temptation when describing the form of the eye is to construct something as three dimensional as possible in effect. This temptation should be avoided, much like the nose, which can project outwards like a sundial and even cast a strong shadow. The effects of these volumes will demand your attention and skill in rendering but please remember that it is a two dimensional image you are making. This will mean in other words that the observations made will need to be seen as

colours or tones or shapes on a flat surface. When the construction of the nose and eyes goes into greater detail, it can upset the balance of the overall painting. Always paint what you are interested in, but do not lose sight of the rest of the picture surface that you are responsible for. It is only through the drawing of this structure as seen two dimensionally that will make the picture space recede and give the head some depth.

Tones of the skin and hair

The use of tone and colour to paint skin are one of the major challenges of any portrait. Every painting is different. There will be many different solutions to painting the skin tones. Each time that you go to paint them they may appear different. The difficulty is in painting the tones as sensitively but at the same time as completely as possible. See the tones for the skin at the same time as you see the tone for the rest of the portrait, including the hair. If you separate one thing from another when you are painting you will potentially confuse the tones. The highlights in the hair can appear very bright when you focus on them. Are they as bright as the highlights on the skin? If you see both at the same time then you will be less likely to lose the overall balance between the tones. This approach may be unsuitable for painters who like to do one bit at a time. If this is the case then just make sure that you look everywhere, to help with continuity.

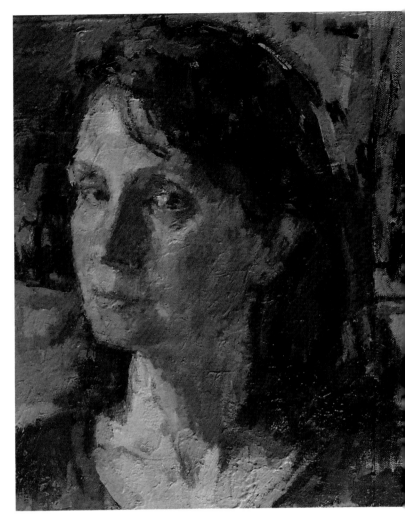

Jenn, 2007.

Creating an under-painting for your second portrait

Reuse palette scrapings

Whilst painting, the palette gets congested with all of the colours you have been mixing. Start to accumulate these mixtures of paint in a tin or jar with a lid. Each time you go to clean the palette, recycle the old paint by scraping it off with a palette knife and put it into the jar. Oil paint will stay fresh and re-useable if it is protected from having contact with the air. This can be done by putting water into the container. As the number of painting sessions increases you will accumulate large quantities of palette scrapings. This minimizes the waste of paint as it can sometimes be re-used.

Penelope, 2008.

Rebecca, 2015; first stage, painting by Harriet Doherty.

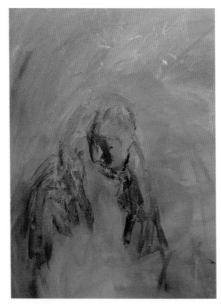

Rebecca, 2015; second stage, painting by Harriet Doherty.

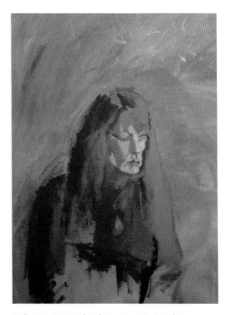

Rebecca, 2015; third stage, painting by Harriet Doherty.

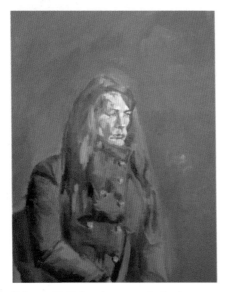

Rebecca, 2015; fourth stage, painting by Harriet Doherty.

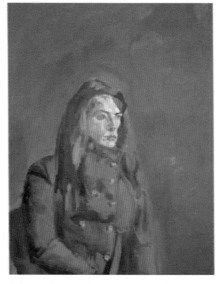

Rebecca, 2015; fifth stage, painting by Harriet Doherty.

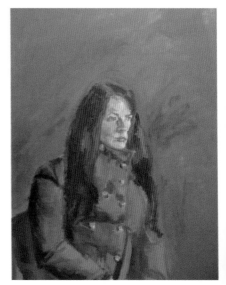

Rebecca, 2015; sixth stage, painting by Harriet Doherty.

Preparing the ground

One use of the palette scrapings is to cover a white canvas with the old paint. Use the palette knife to scoop it out of your jar and onto the canvas. Use kitchen towels and some solvents to thin and spread the paint around, until the whole canvas is covered. If this is thick and messy then it makes sense to thin it a little with some more solvents. Simply pour a little onto the canvas (lay the canvas on the floor to do this, so that it is horizontal) and then use more kitchen towel to wipe it into the sludge. This process gets the paint everywhere so you may want to use rubber gloves to keep your hands clean. The sludge will accumulate onto the paper towel and need to be put into a bin; otherwise the oil paint will stain flooring and clothing and the fumes can also be harmful. Repeat this process with clean paper towels and even another drop of your solvents until the layer of paint is the right consistency.

Remember that the painting should start with thin layers and only get thicker when it really needs to. This is sensible economy, as once the layer of paint is thick, thin paint will not really make any impression on the canvas, meaning that your picture will come to need larger and larger quantities of paint.

This is a rapid and economical way of preparing a ground for your picture.

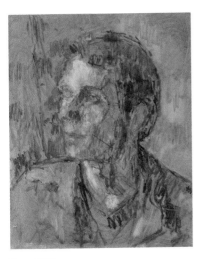

Tom, 2008.

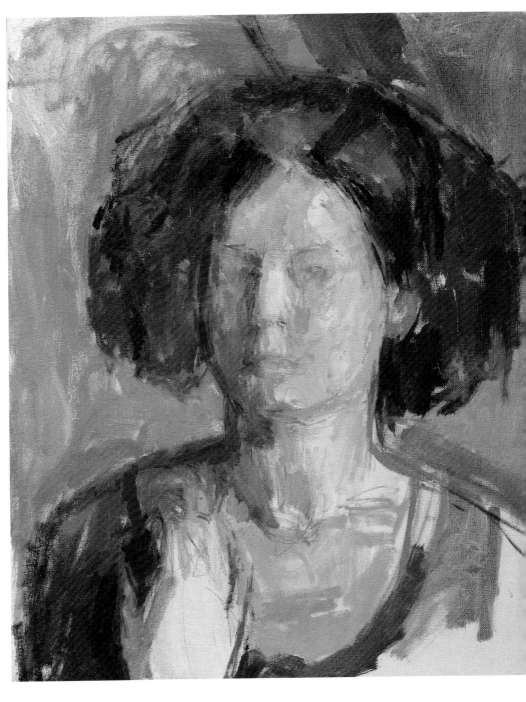

Paulina, 2015.

The thinner the ground becomes the lighter in tone it will be. Working on dark grounds makes for quite tricky painting later, and some people say that a white put on top of a dark colour, even if it is dry, will eventually darken over time, because of the dark paint underneath. Keeping to a mid-tone then, this ground will have knocked the white out of the canvas.

Experiment with this and prepare a few canvases with grounds using this method. After you have done it for the first time, the second time you can vary the tone that you end up with. Have two or three goes at this so that you have a choice of ground to start your second or third picture on.

Working into a wet mid-tone ground

Once you have a colour across the canvas, and you have got it to be the right tone by rubbing it back with paper towels, you have an even tone with which you can begin. This is a good way to start a picture if you want it to be about tonal structure. The first thing to do is to look at your model and try to see an overall impression of the layout of the light. Look to see where the centre of your composition should be, at the same time as looking for the arrangement of light and dark across the form.

The first physical action of painting should be to remove the general light areas. When you are doing this, do not look

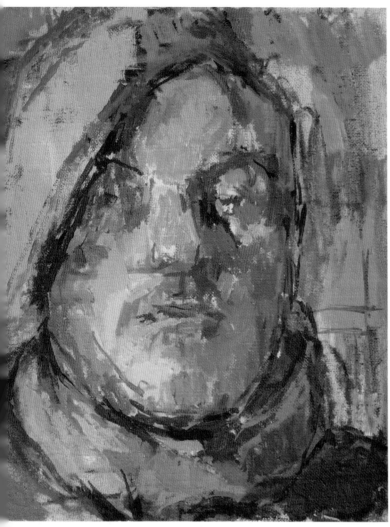

Self-portrait, 2008.

If there is any detail in the composition, such as hair or patterned clothing, it is advisable to attempt to draw it onto the mid-tone ground. Simplify a pattern into areas of light and dark by squinting your eyes nearly shut, or by using a Claude mirror or glass. Persist with the tonal under-painting for as long as possible, especially if there is detail or pattern. It really will help in the next session to have this monochromatic layer, since your observations of colour will seem more accurate as tones when they are applied thinly on top.

Two beginnings

By the end of Day 2 aim to have two different pictures underway. One of the pictures could have a tonal structure, as described, as a layer of under-painting. The kinds of mark will vary for each of these beginnings. There are several reasons for working on two pictures at once that may not be obvious.

One reason is that with two paintings in progress you can potentially feel stronger about one picture rather than the other. This in turn will mean that relatively speaking the picture that you are not so precious about will enable you to paint with the greatest abandon or sense of risk taking. Feeling like you can take a risk with the paint has the advantage of making your picture less tight. Tightness of handling is when it seems incredibly difficult to work at anything but the shortest distance or space on the canvas, resulting ultimately in a poor overall relation. It is desirable that a portrait has good drawing, but drawing can be good and accurate in a broad sense. The whole length of a line can be the right shape rather than only a short section of it. It is likely when drawing that the scale will get smaller as it is worked up, to seem more accurate. This precision in the final working of the picture can be attempted later. For now, and for as long as possible, keep concentrating on the larger forms and try making your relation in the picture about the bigger areas.

If one of the pictures has begun to tighten up and has a density of marks, especially around the eyes and nose, then use the second picture to attempt to work more generally over a bigger area. Alternatively if one painting has the broader aspect as its character then the second painting can be begun with the alternative purpose of making the drawing of detail more dense and interrelated. With two paintings underway either a variation can be sought or the same objective can be attempted. It is surprising how even trying to make a very similar composition will come out altogether different.

for the small extreme highlights, but instead the general larger shapes of light that make up your view of the model. Include the background in this process wherever it appears to be lighter than the figure or face. Draw into the picture with darker paint if it helps to work out what goes where.

These rubbed-off areas will now give an initial look of contrast to your wet mid-tone ground. Now you can work a little initial contrasting dark into the picture to help the drawing. Once this is done, look again at the light areas and attempt to see clearer where it is brightest overall. Now you can try, using solvent and a stiff old paintbrush, to remove all traces of the ground paint in those areas – so that you can get back to the white of the canvas.

Let this tonal beginning dry, to have the full effect of the light study as an under-painting for your second portrait. This will take a few days.

Other checks to make at this point

Scale

Check the scale of the painting. Is the head too large for the size of the painting? Can you make it larger at all without it looking too big? Try to establish the scale with this second session. It will save a lot of re-examination later on if this aspect of the painting can be thought about conclusively. One way of checking this is to foresee if any parts of the head, such as the ears, are going to be outside of the picture's edge. Profiles can tend to lose the back of the head, which is usually a shame. Knowing that you are not going to run out of room gives you more head space free to work on the parts of the drawing that are of interest to you.

Symmetry

In painting a portrait, if you can try not to fall into either eye but keep an even view on both, then you have more chance of painting them at the same scale. Very often, especially with a three-quarter view, the side of the head beyond the nose comes to be painted at a different scale to the other side. It is natural to make an eye the focal point of your gaze, but as you do so, be aware that the other eye will demand as equal an inspection and that you want to arrive at a convincing representation of the whole. If the view you are painting is head-on, then look for the asymmetry of the features: whether one eye is higher than the other for instance. It can be surprising what differences can be found in a subject that at first appears to be symmetrical.

Finding your way back into the drawing

Take a mid-tone colour that will be visible against the colours used in the picture so far, and run it around the features of the face as you see them to be now. Similar to the way of looking with distance, you can improve the drawing by going over it; a small round brush will leave a fine mark and give you a good amount of control. The important thing is to note differences in distances that you can see, that you had not seen before. Anything that you see now – especially if it appears different – should be drawn, as this will make the painting more revealing of how you are seeing. It takes a long time to see your subject, and discovery should be a major part of the process.

Start at the centre

Once underway the biggest challenge to you is to maximize your concentration. How can you keep your eye circulating

THE MODEL'S POSITION

It is sensible to make the pose as similar to the previous session for the sake of continuity. However, please keep your eye open to developments in the pose, as these types of change, sometimes very dramatic, can be improvements to such a degree that they make the painting a success.

The model's pose will generally fall into the same place after fifteen or so minutes of holding the position. Any pose that is too difficult will mean that the breaks will need to be more frequent, and your sitter regularly should have the option to refresh themselves so as to not look too uncomfortable or tired. It is simpler and more important that the model knows how to regulate their pose, as this will mean that there will be less interruption. One way to do this is to fix what it is that they are looking at. I recommend that you sit for another painter as a sure way to gain an insight into understanding what it is like to sit still and concentrate for so long.

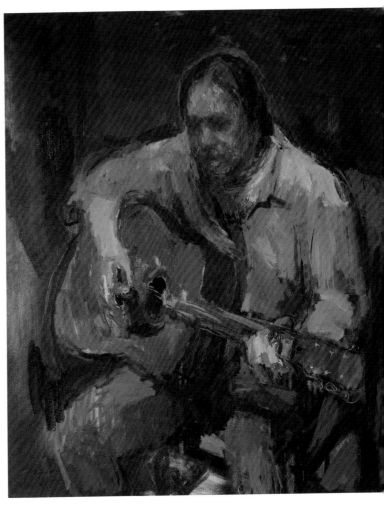

Tony with Guitar, 2015.

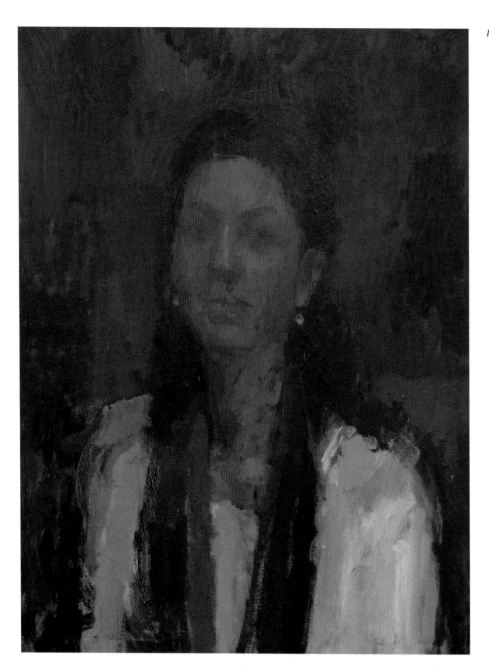

around your subject and keep developing the relationships between what is drawn so far? One thing that will help the drawing is for your eye to follow the central route into the face. By this I mean the centre of the form. In a full-face view this entry point would be the nose; in a three-quarter view it is the cheek; and in a profile it is the ear.

When looking again at the head, start in the centre and check again the distances from that central point to other positions. Picture the central point of your painting as a clock face with 12 at the top, 6 at the bottom, 3 to the right and 9 to the left. Make sure that you have looked well in each direction, that is, to 10 and 11 o'clock as well as to 2 or 4 or 7 o'clock.

Form of the cranium

From the nose take a measurement all the way down to the clavicle or collarbone. There is usually a hollow just above it. This will be a long distance and may not even be within your composition. Check upwards for the connection with the forehead and to the top of the head. Then find the chin. These simple vertical points will help keep a check on the height of your drawing and will also indicate the length of the neck. It is necessary to make the same amount of measurements to the left and the right of the nose, to work out the rest of your composition.

At all points in the painting keep the mark that you make as more of a colour notation, rather than an attempt at specifically describing the form of a wrinkle or a nostril. It is enough to try to get the right colour, and to just put it down flat. This way you give the best chance for the colour to work as space in the picture. Since the position of things will take a few sessions to establish, concentrate first on the bigger areas, making them relate as well as you can in shape and in colour.

Analysing colour difference

Always look for a colour in a sequence – never attempt to see a single colour in isolation.

The sensitivity of your eye is such that small changes will continually alter what you thought the colour was. When you look at two colours at the same time, you can get a better idea of their relationship in the colours that you mix to stand for them. Taking a part of the face or neck and pairing it with the background, look to see not just which is lighter or darker than the other but which is more yellow, which is more red and which is more blue. Deciding this while looking at two or three colours will almost give you direct instruction about how you are going to mix them. Follow this method to improve the colour relationships, and the depth of your image will increase at the same time.

Keeping your balance

One advantage to studying painting in a class will be that the more experienced painter who is teaching will be able to see quicker what part of the head you have not seen so well. If you are painting on your own then you will be wholly responsible for the scrutinizing and checking of your picture against your subject. The eye tends to be habitual in its movements, and so it is important to upset this routine by trying to see differently each time.

Controlling your drawing

One of the hardest things to achieve is an even attention with your drawing and observation. Anatomically, the inner corners of the eyes should relate well, vertically, with the nostrils. The mouth usually follows the nose sooner than you think when you are connecting the eyes, nose and mouth in a vertical pattern. Ears can easily come adrift in space without a believable volume between them and the features of the face. A common issue in a portrait is that the starting point of a drawing is tight and condensed, but as it works outwards from that centre there is a disproportionate extension or drift in the drawing. Distances between things further out from the centre tend to increase of their own accord, and it is your job to rein them in and to make the whole volume of the head more physical and better connected internally.

Measure out from the centre of the head. Find a unit of measurement that can be trusted. This may be the part of your painting in which you consider the drawing to be most accurate. If this is a relatively short distance then you can try repeating it outwards to check if you have drifted in your drawing. If it is a long distance that you believe in the most then it will be wise to check what happens at the halfway point between these points. As always the issue is of relation. Relate something between parts of your subject, and then compare the relationship between the relative parts of your picture.

Deconstructing a painting

It can take a very long time to see clearly enough to bring the drawing into shape. At all times it is the clarity of what you are actually seeing that you should attempt to paint. Paint how you see your subject. An artist who worked late into the night struggling to paint how he saw was Alberto Giacometti. In the process of his painting, the image would be built up, then deconstructed and then built up again.

When you are painting be aware of how you are seeing, to the point where if you can no longer tell where anything should be then it is possibly a good idea to stop. The alternative can be alarming – when you scrub everything out, as it no longer seems right. The advantage however of doing this – deconstructing the painting – is that when you have lost everything it can be clearer to build the picture back up again afterwards. I remember at college being advised to re-prime the area that I intended to re-paint so that it would appear clearer afterwards. Because of drying times this can be a time-consuming process, going back to a white canvas (or I should say, re-painting a part of your canvas with a primer). Under-painting white is good for this since it dries so quickly.

Day 3: Developments, Alterations and New Beginnings

Paintings always become good likenesses in the end.

 – **Pierre Bonnard (1867–1947)**

Prepared ground

By the third session you may have two or three canvases underway. One of your prepared grounds may be dry enough now to paint onto. Take this dry mid-tone ground and notice that from the beginning this prepared surface appears and feels different. The most extreme way of maximizing this difference would be to change the pose that your model is taking. If you have not tried it before, painting a head on its side can be an unusual format for a portrait. Put your canvas on the easel in a horizontal or landscape orientation so as to emphasize the horizontality of the head.

The initial difficulty when changing the pose is in making your sitter comfortable. A bed, or raised platform with a number of cushions would be advisable. A simple pillow on the floor is the most minimal set up for this pose, but it will mean that you also have to work from the floor level. The most comfortable would be a *chaise longue* or low-level armchair with a head rest, where your model can position themselves into a more horizontal aspect. Watch out for creating an unflattering pose with double chins, but look also for what will be the most comfortable pose to hold.

Working onto a dry mid-tone ground

The initial touch of paint onto this ground will appear immediately different to the first touch on a white ground or on a wet mid-tone ground. The dry mid-tone ground is as easy to mark as the white canvas, but the tone will change the impression your painting makes. Many artists use this method of ground, as it makes their painting more efficient in its tonal structure. This is because on a white ground, every colour put onto it will appear darker – and the countering tendency to this is to make the painting too pale. The mid-tone can come to stand for some of what it is you are trying to describe.

The initial reason for using a ground is to take the glare off the white canvas. Further than this, the tone that you choose to work onto influences the way that the picture looks. For this reason most people will opt for a light tone, but sometimes it can be advantageous to paint onto a mid or dark ground. The sensitivity of your eye will easily be able to differentiate between tones, whether you are using a colour that is lighter or darker than the ground. This will change the way that the tone of the subject is handled in the picture. If the subject is generally dark then it is quicker to start with a darker ground, since tonally the picture will resemble the majority of the subject more easily.

The advantage of drawing onto a mid-tone ground is much like drawing into a painting that you have already been working on for a few sessions. The surface of the picture can become pleasant to work onto, when enough paint is on it for the application of more paint to become smoother. Resist the temptation to draw in with too dark a colour, but use a colour that is visible – perhaps a similar tone to the ground but a different colour. This will mean that the drawing does not interfere too much with the overall tone of your painting.

Nicholas, 2012.

Lucy, 2013.

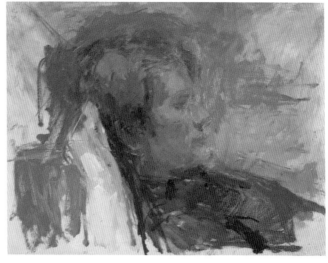

Will, 2014.

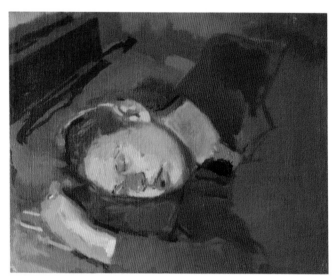

Claire, 2005.

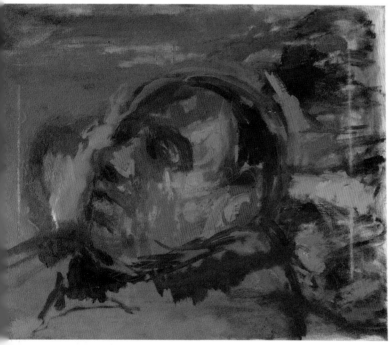

Nicholas, 2015.

Drawing a head on its side

The head on its side is a fascinating thing to draw as things will no doubt end up in unusual places. From a young age we are accustomed to drawing faces in an upright position. When you find that the ear is the feature that is highest in your composition the order that normally arranges the features of the face is upset. This is a challenge; and as a result our looking is tested. Look at a good book of reproductions of heads painted by El Greco (1541–1614). What was familiar is now unfamiliar. How do you paint a mouth on its side? Even more than before the answer is simply to put lines and colour where we see them, and in order to keep our drawing and perspective consistent we have to avoid the temptation to lean our head to one side whilst drawing. Lucian Freud also painted heads at these unusual angles.

Think about the things you haven't yet thought about

By Day 3 on a portrait you should have had enough time to develop the things that were of the most importance to you in the painting. Whether or not you have done this, the third session with a sitter is about time for things that have not had enough consideration to come to the fore.

Look beyond the head

It may be that the colour and tone of the clothing has not been pitched accurately enough, or at least has not been painted enough to show the contrast against the face. It may be that the background has not quite been covered as an area and this can now be given enough attention to help the picture to proceed. I think of it a bit like this: the face may be the most interesting part of the painting, yet in order for this to be developed as well as it is possible, very often there is something to be said for painting something against the head with as much attention as you are giving the head. This concentration away from the head can show up things that had not yet been considered.

Look at Paul Cézanne's *Old Woman with a Rosary* that hangs in the National Gallery in London. Cézanne concentrated on painting the lady's bonnet and the background as a colour and tone, just as much as he has painted her face. In fact when you get up close to this painting, look and see just how thick

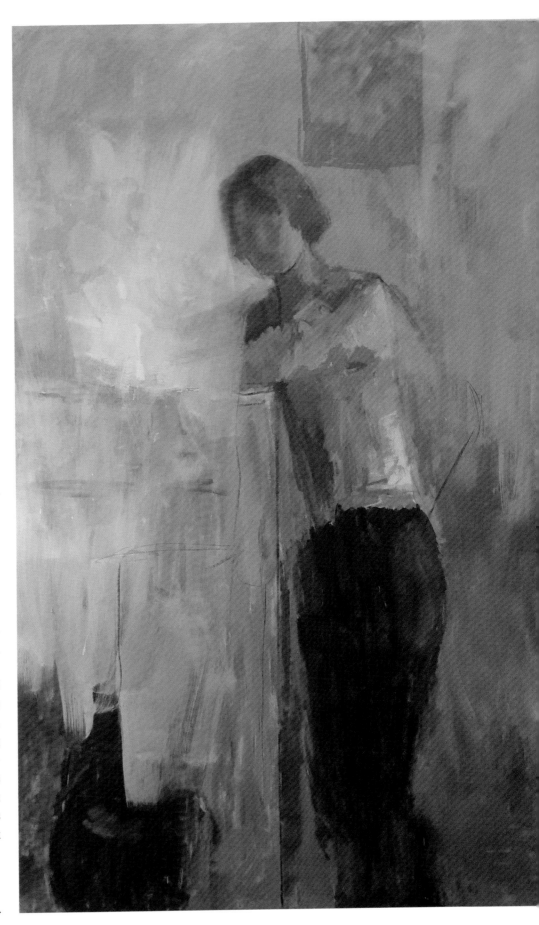

Lucy standing, 2014.

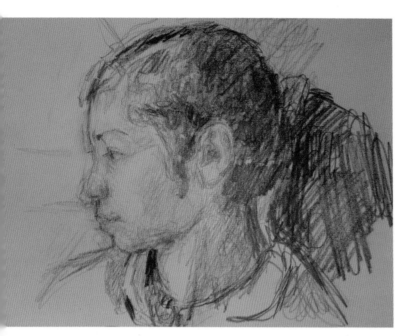

Dominique, 2015.

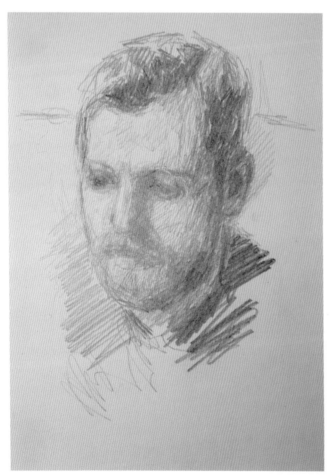

Kit, 2014.

the paint application is around the side of the face. Time and again he has painted the background where it meets the head so that it forms a thick ridge. Strangely this evenness of concentration makes the head in turn look more real, and really as if it is in space, leaning out of the picture. It may be worth bearing in mind at this point how many sessions it is known that Cézanne would work on a painting; the portrait of Vollard took reportedly 100 sittings, although this may be an exaggeration. Looking at this portrait with even a small experience of painting, one can see that he has built it up over time. The brilliance of his method was that he could sustain his concentration for that long and could construct the picture very patiently.

It is worth looking at other artist's pictures very closely to try to learn from their techniques. For instance, look at Poussin (1594–1665), who was much admired by Cézanne. The slow and deliberate construction of these paintings, as a method, is imaginative and satisfying. We should look at paintings to see how they were made, if we claim to be painters ourselves. Learn to trust only the paint that you see, and see as much of it as possible.

See the whole picture

With all this in mind, think about the construction of your painting. Is the background the right tone for the impact you want the picture to have? Give the whole picture your attention and especially look to see if there is something you had not noticed yet. This does not have to be a detail, although it may be. Hang the picture on a white wall so as to see it more clearly. It could be something as simple and large as the tone that surrounds the head: is this dark enough to show up the light on the head? Think of the whole of your picture's surface as something that you are responsible for arranging. Seeing it exposed on the white wall may well give you an idea for an alteration to the image. It is said that the artist must put their picture on to the easel twenty times, before knowing whether or not it is finished.

Including the hands?

Depending on the scale you are working on, the structure of your composition and the pose your model takes, it may be worth considering if the hands or a hand could come into the picture. Traditionally, the hands are the most interesting part of the body to paint, after the head. The visual impact of this can really alter a picture as the hands will give another point of interest. This effect really can vary from that of being harmonious and complimentary to something more expressive.

Try asking the sitter to do something with their hands that would fit into the composition you have already begun. Avoid covering up too much of the head with the hand. The holding up of the hand will alter the circulation, and the model will need to move it quite regularly. Fingers and hand shape are just as individual as somebody's face, and especially when seen together.

It can be a good idea to do pencil drawings of the hand, remembering to connect a part of the face to the drawing so as to make a comparative note of the scale. Look at the drawings of hands made by Leonardo da Vinci (1452–1519). A drawing will be able to inform your painting with the right amount of seen information. Photographs usually contain too much information, which can be distracting.

Drawing alongside painting

Because a painting is made up with so many hundreds if not thousands of touches, it can be very hard to know what impact a brushstroke is having. Sometimes what will seem like the right alteration to make will hardly be visible when looked at after a break. When you are working from observation it is so difficult to actually see, and to see what you are doing. It could be understood that each brush mark is in competition with the previous brushstrokes. Although the wet touch of paint will stand out as it is made, technically the effect of drying will usually make it recede or fade. I will regularly add linseed oil into the paint, undiluted with any solvent, after a painting is worked up into layers over several sessions. The oil may eventually come out of the paint through drying, but in the short term it seems to help bind the layers, and maintains gloss.

Because of the difficulty of seeing cumulative effects of the painting, it can be very refreshing visually to take a clean sheet of paper and to try to draw the thing that is absorbing you most about your subject. Think of this as an independent enquiry to the painting, where something new can be seen. As you are drawing, forget the painting, and make a new observation of your subject.

When the person you are painting has to leave (you may be paying them for their time, and this can become expensive) it will be possible for you to compare the drawing with the painting. Each drawing may or may not relate to the painting but at least it is something else that can inform it. Because of the limitation of information in a drawing, it can be less likely that you will overwork the painting, while the model is away.

If you were to use a photograph as a reminder, the very real danger is that your painting will lose all individuality and particularity by looking more like a photograph. This can be admirable when done by some painters, and there are some advantages to using a photograph with its stillness, which is extremely desirable as a stable, reliable and cheap source from which to work. However, it is very different from having a live model in front of us to look at. Our eye is so much more sensitive to what it sees than the camera that a photograph becomes deceptively simple.

It can be very interesting to involve the movement we constantly see in working from life, in the drawing or painting that we make. Likeness in painting very often contains a slight distortion, which, perhaps like a filter, helps the appearance to be seen. In drawing and painting there is constantly room for change, and the history of art tells us that there is certainly not only one way of doing things. Look at the paintings by Matthew Smith (1879–1959) to see how he relates colour and how fluid his drawing is.

Whether a drawing made tells you something that may help the painting or not is another thing that only you can decide. It can be useful for your vision to zoom in onto a detail in order to explain that feature more fully in a drawing. A drawing will be much more 'you' than a photograph, and this may give the painting more individuality. Always spend time making yourself look at the painting in order to question what it is that you have not seen as well as you would like to. Make a note of this so as to remember what to look out for when the model returns.

The human aspect

Keeping your model engaged

By the third day, the regularity of the sitting can have its effect on the model. They may, if unoccupied, look sad or tired and this is not necessarily what you want to bring out in a painting. Engaging your model in conversation does make them move more than they would if they were silent, but it can also have the positive effect of waking them up, making their eyes sparkle, and animating their expression. If it is a person's face and expression that you are painting, it is better if that expression engages with you in some way.

As always the alternative can also be true where a dis-engagement is painted effectively. As I mentioned in Chapter 1, if the model can self-regulate their pose, and if the chair has marks for its position and there is a mark also for what they

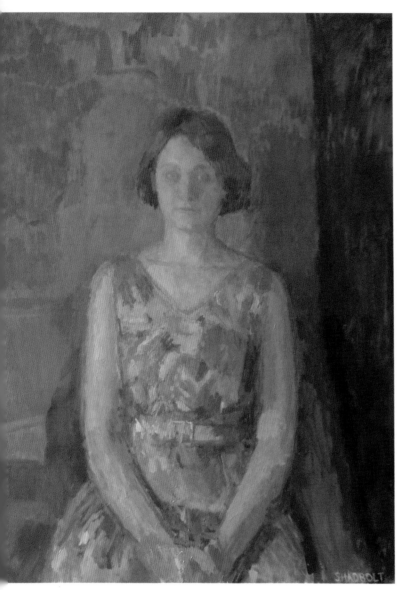

Lucy, 2012.

Although the process can be considered as building or continually additive – as I have written about earlier – there is usually the need for reconstruction within an image. This can be as dramatic as a re-painting of a whole section, using primer as a white undercoat, and a change of composition will most frequently be an improvement. It is hard sometimes to know what to do next. At this point taking a break can be the best thing to do.

What is challenging is to see the sitter as if it is the first time that you have seen them. If the picture has been up until this point mainly about the face then it can be useful to reverse this focus or hierarchy of content and to look instead at the hair or the clothing or even the background. You have to look at the subject in as many different ways as possible so as to develop fully the potential of your image. It can happen that highlights in the hair have been painted with a tone so light that it is equivalent to the tone in the face. Look again to see how objective you can be about the overall tonality of the subject. When one element has been misjudged (sometimes by focusing on each thing in isolation rather than by relating to the whole) the thing to do is to put down a glaze over that particular area, so as to bring it more in line with an overall tonality.

Facing difficulties

Viewing the whole

As the painting progresses the usual difficulty is to not ignore a part of your composition. The nature of visual sensitivity can lead to contradictory effects, and reversals of tone can occur, for instance where one thing should be lighter than another it is painted darker.

The best method of combating these discrepancies is to make sure you can see the entire subject. Sometimes the easel and canvas is in a position which blocks the view of the sitter. Try using a Claude glass to check the effect of tone. Use a mirror to refresh the habitual movement of your eye across the picture. Get back from the picture to have a look with greater distance to check the overall progress of the painting. It can help the vision of your picture to photograph it, and to then view the photograph. This is similar to the method of getting distance from the picture. Also the effect that time has on the way that you see the picture should be taken into account.

are looking at, then there will be less interruption along the lines of 'up a bit, down a bit, left a bit, right a bit'. In the case of a commission, the comfort of the model and their level of satisfaction with the work is very important. Sometimes listening to music is a good idea, provided that it is not too interruptive to your painting. Most people will come to find something positive about the process as long as they are treated well. Remember that regular breaks and drinks or snacks can add to this routine in a good way, even if the sitter is keen to sit well and not take breaks.

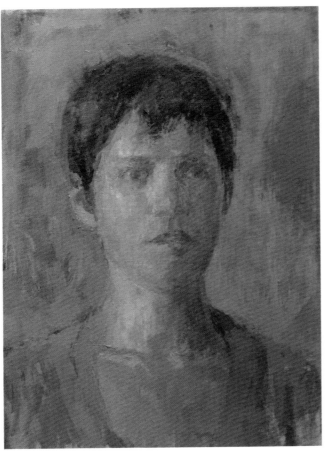

Hannah, 2010.

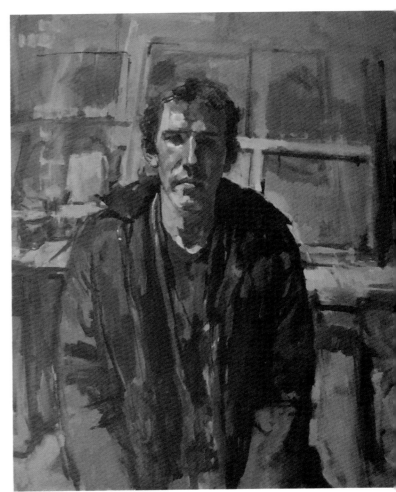

David, 2004.

Avoiding caricature

When we look at and paint the features of the face directly, with only a slight regard for the side and top of the head there is a tendency to enlarge the eyes, nose and mouth. When the features of the face are painted at a different scale to the rest of the head the portrait can resemble a caricature. This is because the artists that draw cartoons will seize on the expressive potential of a big nose, lips, eyes or eyelashes. Some painters in the past have worked in this way and succeeded in making good paintings, for instance Oskar Kokoschka (1886–1980). Depending on what you want to achieve in your painting, an objective awareness will help you to recognize and control the direction of your picture.

If you can see that some of the features in the head you are painting are oversized then scrape back the picture. No doubt some of the colour that has gone down will be helpful. Scraping back the picture only removes the excess paint that has not been absorbed, making it easier to draw back into again. You may want to let the paint dry a bit before scraping, especially if you want to preserve some of the drawing that you have already made. Let it dry for a day before scraping and the image should remain. If you are worried about losing some of the painting

when you scrape, you should think about how the paint needs to look. Scraping a canvas can be the most immediate way of being able to remake the image with a developed drawing. The reasoning for this is so that when you can already see a face in the painting it is harder to feel the urgency in the re-making of the image. When the face is gone or partially removed, there is a greater sense of urgency about the rebuilding of the image.

Consistency of light

In drawing and painting the essential nature of what we do is exaggerate. Whatever we notice, or are thinking about, we tend to overdo. Since by this point you will probably be using a full palette with light and dark pigments in all sorts of colours, the danger in the picture is of confusion and lack of organization.

Very often it happens that when painting in the shadowy side of the face, a highlight is seen, such as the light on the cheek that travels across the face. Because of the darker surroundings, if this is painted with too much contrast it can no longer seem to be consistent as a reading of light on form. Just

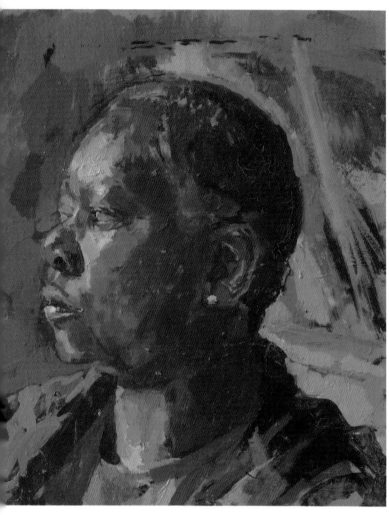

Vida, 2005.

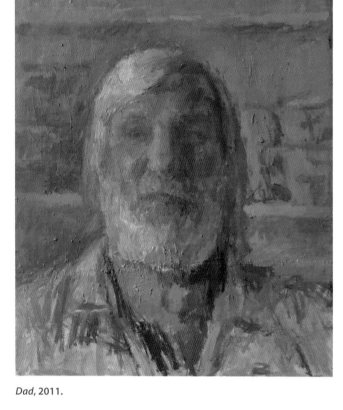

Dad, 2011.

as you should look across the whole head to stabilize and mini-mize the exaggeration in the drawing of the features, looking at the arrangement of light across the whole head will help you to minimize exaggerations of lights, which can confuse the source and strength of light on the form.

One system for viewing the tone consistently is to use a Claude glass or to try squinting your eyes. Reducing either the amount of light or your sensitivity to the light will have the same effect of making the tonal arrangement clearer to see. It is for this reason that the last hour of sunlight in the day will be the best for painting. As the light begins to fade, the subject is easier to observe in terms of the lighting. It is a good idea to sit with your model until the daylight is almost completely gone. This way the arrangement of the light will appear simpler and simpler until the last highlight disappears.

Treating the eyes

By this point whether or not you have been painting the eyes is of no great concern. They are the most exciting thing to paint and can dominate a portrait completely. For this reason it may be worth hiding them from your attention while the rest of the picture is being developed. If the paint is dry put some masking tape across them on the picture. This will help you to see the rest of the picture. Alternatively, you can indicate their position but try not to use too strong a contrast. Keep the direction of the gaze central. Sideways glances in the portrait can be experimented with later.

Eye contact can be wonderful in a picture, but keep it in check as it can also prevent you from seeing parts of your picture for what they are. Concentrate for now on the structure and form of the head in the portrait. Until you wish to be specific about where the eyes are looking, keep them centralized within the eye socket, occupying a middle space, and facing the same way that the nose is pointing.

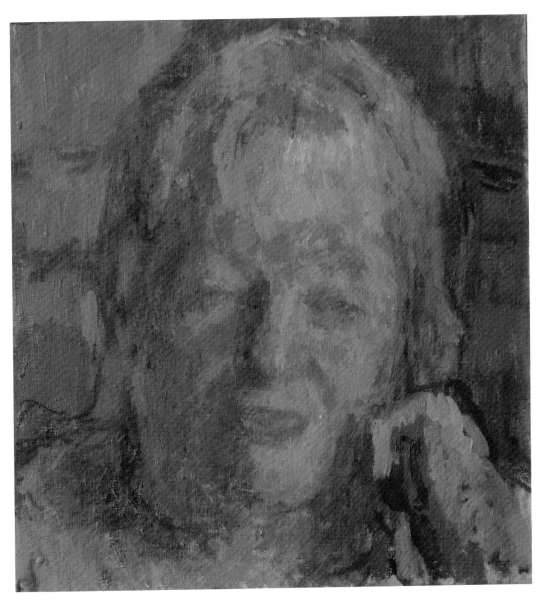

Mum, 2011.

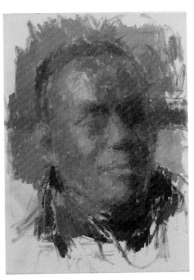

Nicholas, 2010.

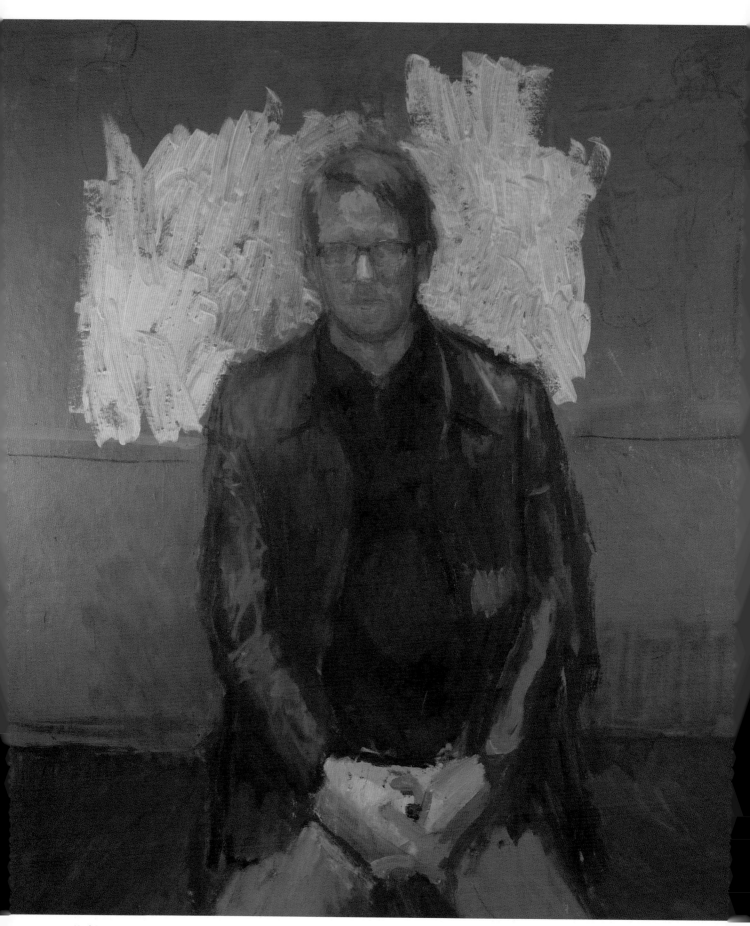

Karl-Peter, 2014.

Day 4: Evaluate the Composition and Scale

Anticipate the work that needs to be done. This will help to organize your looking when the model returns. Look at all the drawing and painting that you have made of your model before they arrive. Assess what the strengths and weaknesses are. If you have more than one painting under-way then it may be best to begin work on the picture that you like the least, since you will feel freer to reconstruct it. While reviewing the pictures try to list what you need to look at in better detail.

It may help to try to remember what your sitter looks like. Attempt to make a sketch of them from memory. The parts of them that you remember least should be the parts that you look for first when they return. If any part of your picture appears constricted by the shape of the composition then you may consider extending the canvas to make more room to include what is needed. Ask people who know the sitter well to look at the paintings; this may provide suggestions about what aspect of their physical appearance can be improved in the painting. However, only consider revising the portrait when you know that the model is going to return.

Techniques that can help improve tone

Grisaille

A grisaille is a layer of paint, usually a grey colour that goes over the whole of the painting; for example a wet ground that you may already have worked into, removing paint for the high-lights, is technically a grisaille. A grisaille can also be used as a technique later on in the progress of the painting to unify the surface, and it can be made over only a part of the picture. It works best when the paint underneath has had a few days

to dry, as the dry paint will have a better chance of not being lost during the application of the grisaille. Usually the aim is to preserve the drawing but also to have an overall control of tone and strength of colour.

The purpose of a layer of grisaille is to make a clear statement and re-organization of what the dominant mid-tone is. It is effective in re-balancing the light and dark areas of tone. It is by no means necessary for every picture, but it is worth trying so as to expand your use of the oils and to get a firm grasp of the whole surface of the painting.

The process works by applying an oily mid-tone grey, and then using clean rags or paper towels to remove paint in the areas where you want it to be lighter or darker than the mid-tone of the grisaille. Start by mixing a quantity of grey paint with oil and some solvent. The paint should not be too thick as most of it will be taken off anyway. The aim is for an even coverage of the picture, suppressing the highlights and making lighter the extreme darks.

How do you decide whether or not it is a good idea to try this method? If the painting has become too extreme in its con-trasts, and you are no longer sure that the tones relate to each other very well, then it may help to see the subject in a simpler way. If you are stuck at all in deciding what to do at this point in your painting then taking a new canvas, you can begin a new picture with a process that is similar to the grisaille technique already described. Remember that a painted study made in an hour can sometimes be more pleasing to look at than a painting that you have laboured over during several sittings.

Terre verte under-painting

Terre verte or green earth is a wonderful and unique oil col-our. Its consistency is spongy and it is extremely transparent. Because of these physical qualities it is perfect for under-paint-ing the reflective nature of human flesh. It was used in Italy in

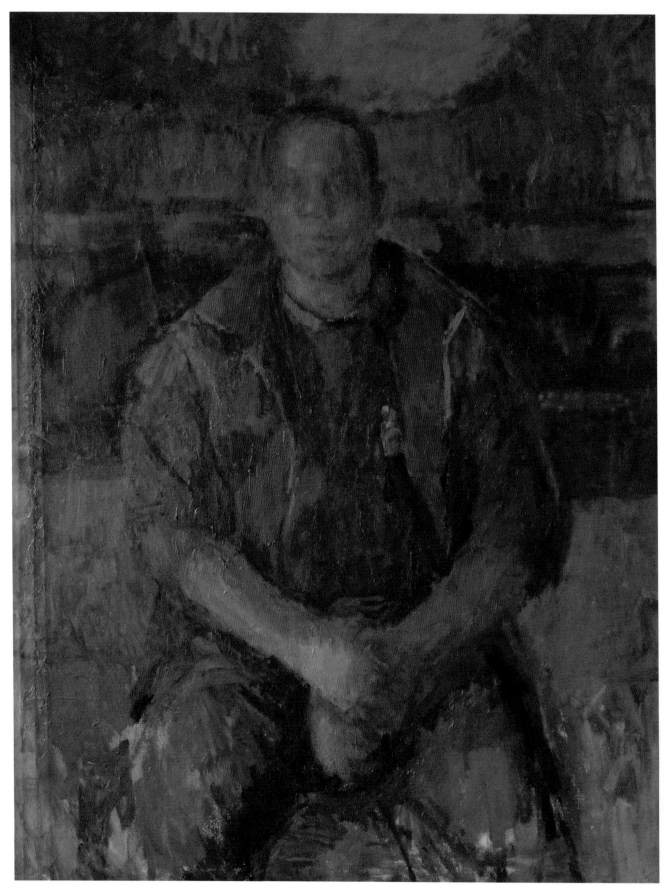

Nicholas, 2011.

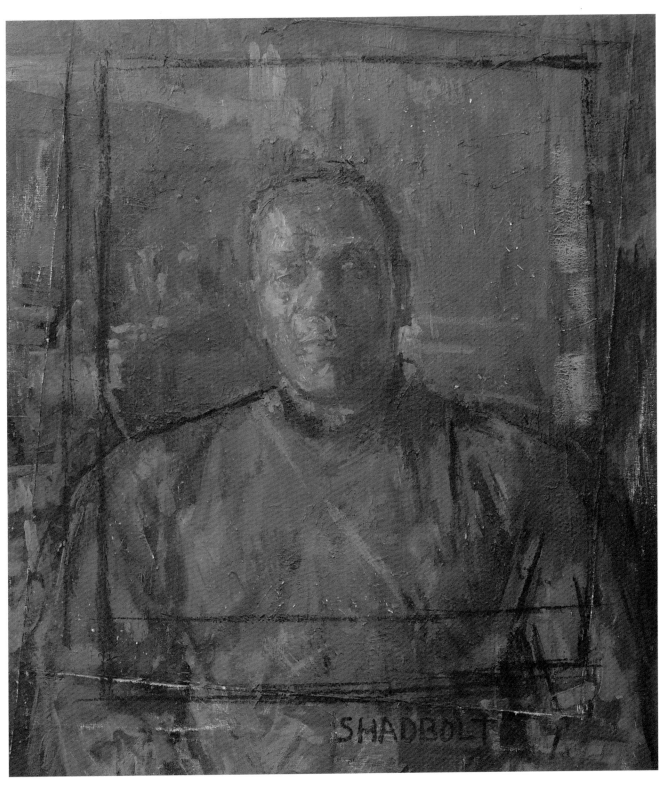

Nicholas, 2008.

EXTENDING A CANVAS

It is no surprise to me to see how many pictures in the National Gallery have been extended. It is a testament to the commitment and patience of artists of the past. Look across a painting for the almost invisible line where a canvas has been joined and the picture's scope enlarged. The reason for doing this is quite simple; it very often happens that we run out of space in a picture. In some cases the larger canvases must, out of necessity, have been joined up out of canvases which in themselves would not be wide enough for the whole picture. Apart from these cases where the join is more central, I think it is logical to assume that alterations in a picture's dimensions are arrived at after lengthy consideration during a picture's construction. Rubens must have constructed some of his larger pictures in this fashion, since some of them appear to have been begun as simpler arrangements. It is possible that a single portrait or double portrait became enlarged so as to include a whole group of figures.

It can seem like failure at composition to have not included enough space around a head or figure in a picture. If you see that the composition could be improved by a shift in drawing at an early stage in the picture then it makes sense to wipe it out and start again. The actual reality of making a painting can mean that so much work has gone into the picture that adding a strip of canvas is really the simplest and best way of improving the composition. If you suspect that this may be the case with your picture then follow these instructions.

1. Place the canvas on a nail on a clear studio wall. Use charcoal to draw onto the wall, or stick some masking tape indicating to what point the extension could be made. Then make a line to represent the whole new edge of this proposed extension, making sure to keep it parallel to the picture edge. If you think you might like to extend in two directions then use two lines to re-draw the boundary of the composition.

2. Measure the new dimensions of your canvas shape. Be careful not to over-estimate how much extra space the picture needs. Do not order the new stretcher until you have glued the canvas extension and re-drawn the boundary line on the extension.

3. Either use offcuts of canvas, or buy some pre-primed canvas for the extension. Measure out the lengths you will need. To do this accurately, unpick the canvas you have been using with a staple remover or small flat-headed screwdriver and

pliers. Once the canvas is un-stretched, lay it flat. Depending on how resistant to flattening the canvas is, you may need to weigh it down with a board. The size of canvas you will need to attach should include enough room around the edges to go around the new stretcher. What was the depth of the old stretcher? Will the new stretcher be the same?

4. Once you have the measurement required, cut the new canvas strip to be joined. Use a scalpel, a metal ruler, and a cutting mat to make this edge as clean and straight as is possible. The finer the cut, the less noticeable the join will be.

5. Now you are ready to glue. You will need some PVA glue or wood glue, some tin foil or plastic sheeting which will not stick to that glue, and boards big and flat enough to cover the area to be glued. Arrange the materials in the following order: board to provide a flat base, a coverage of tin foil to prevent sticking, the old canvas edge laid flat which is to be extended, then have the extending piece of canvas ready next to this with another strip of tin foil and the board ready to go on top. When you are sure that you have everything in place, proceed to Step 6.

6. Cover the area to be glued with the wood glue, and even out the layer of glue with a plastic palette knife. Then place the new strip with the clean straight edge on top and right up against the old edge of the painted canvas. Once this is aligned, cover with tin foil all along where the glue is. Then put the board on top, being careful not to slide the canvas out of position. Weigh this down with the heaviest thing you can find and leave for two or three days to ensure it is fully dry.

7. After this time, remove the weight, the board and the protective foil. The canvas should now be glued and dry. Let this air for a bit before pinning the extended canvas to the wall to check the new dimensions of the extension. To do this draw freehand the mark which indicates the amount of the new canvas extension that you wish to use. Use a metre stick or long straight edge and set square to make sure that the rectangle you draw is square (90 degrees at each corner). Is this the same measurement that you estimated in Step 2? If so then you are ready to order the new stretcher.

Once you have re-stretched the extended canvas, painting may begin by filling the ridge left by the join. This can be done repeatedly with palette scrapings and sanded back when it is dry so as to make it less visible.

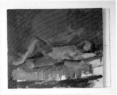

Photograph of painting with drawing for extension.

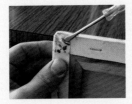

Levering out staples.

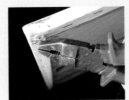

Removing staples with pliers.

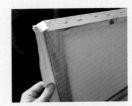

Photograph to show the undone canvas edge.

Canvas un-stretched flat on the floor.

Cutting the extension strip of pre-primed canvas.

Getting a layout for the extension.

Extension piece cut to size.

Photograph to show the wood placed under the area of canvas to be joined.

Tin foil under canvas to prevent sticking.

Glue for the join.

Spreading the glue evenly.

Arranging the extension into position.

Wiping clean and applying initial pressure.

Positioning foil on top of join to prevent sticking, and a flat piece of timber to apply pressure evenly.

Weights in place to keep pressure constant during drying time (approximately twenty-four to forty-eight hours).

Having removed the weights, carefully peeling away the foil.

Showing the underside of the join, peeling away the foil gently.

Viewing the extension.

Extending the painting by adding oil colour.

The extended painting (full view in black and white).

The extended painting (full view in colour).

the fifteenth century for this purpose. Use it thick to represent the darker parts of your subject and thin for the lighter, creating a monochromatic study of what you are seeing.

Improving composition

The way a portrait or painting of a head looks when it is on the easel in front of the subject is very different to when it is hung on the wall. At this point it can be informative to do just that and to spend time looking to see what you think the picture needs.

Composition can be understood as the control of how your eye moves around the picture. Where do you end up looking when you look at the painting? Also, how long is it before you turn your eyes away? If, on repeated occasions you find that your eye hits or leaves the picture along a particular point or edge then it is probably the part to attempt to rethink, or re-draw. Many compositions benefit from having something enter the picture at the edge, which will send the eye back towards the head.

Without an obvious and logical form that you can introduce, the next option is to give the central form a little more room. It is surprising what a difference a thin strip of extension can make to a composition. Extending a canvas seems to me like drawing, since there is an effect in the framing of the subject which should not be accidental. With your painting on the wall, using a ruler and charcoal or masking tape, give yourself a visual indication of what an extension may look like. This can offer surprising results, and can sensibly give more room for the inclusion of other elements.

The great advantage of using a monochromatic under-painting is that it provides a template, with a clear structure of tonality to work upon. The grisaille will inform your composition and handling. It is easiest to paint onto when it is dry, and if you have had a break from the painting and it is now dry then use this moment of re-assessment to check if the composition is as you want it to be. Simply having a thought like 'everything should be a bit more to the left' will inform the painting, and will improve it in time. Think of the alterations that you have in mind as improvements to the idea of your picture. Follow every idea that you have about the painting so that possibilities can be explored. Otherwise, you will not know what might have been.

Tone informs colour

If you were to mix one colour for the skin, then this colour should be made transparent with solvents before being put on to the canvas. The colour as it is applied should be visible, but not so opaque that it blocks the under-painting completely. This way the tone of the dry layer underneath can inform or affect the colour that goes on top.

Do not rely too much on the drawing that you made in the monochromatic under-painting. The tone that is established should only be considered as an indication and not as a fixed certainty. The difficulty in painting is in constantly re-evaluating everything that you see, and in countering the tendency to focus into details too soon.

When continuing a painting with the subject in front of you, after you have reconstructed the set-up the way that you want it to be, the thing to do is to look again at the decisions you made previously. Do you agree with the tones as you have described them so far? It may be that having had a break or interval in the painting you can now see clearer something that you could not before. Remembering that all painting and drawing is an exaggeration of one form or another, it may be that something was made to seem too dark or too light.

If you start to use colour at this point then keeping the consistency of the paint fairly transparent will mean that the tone of the under-painting will be visible still. It can help a painting to reverse the direction of light on your subject so as to have to fully engage and re-paint the whole image. This is a dramatic alteration and will require an energetic approach.

Initial colour arrangement

Make sure that your palette layout includes yellow, red, blue and white. Use a palette knife to start making mixtures on your palette of the dominant two or three colours. At this point it is helpful not to use too much white, since the whites are generally opaque and using too much will reduce the painting's transparency. Keep mixing these initial colours on the palette until they begin to look good together.

When they start to relate well you can begin applying the paint in a broad manner. At this point the detail can be left out in favour of arranging the general dominant colours. Do not mix up the colours too much on the painting, so that the colour keeps its clarity. Remember the colour wheel and the advice of using the complementary colour in the mixture to make the colour less saturated; for instance if you wanted to make a red less red then you would add a little of its complementary colour (green).

The painting of Nicholas seen in mid-extension, with the bare canvas around the painting.

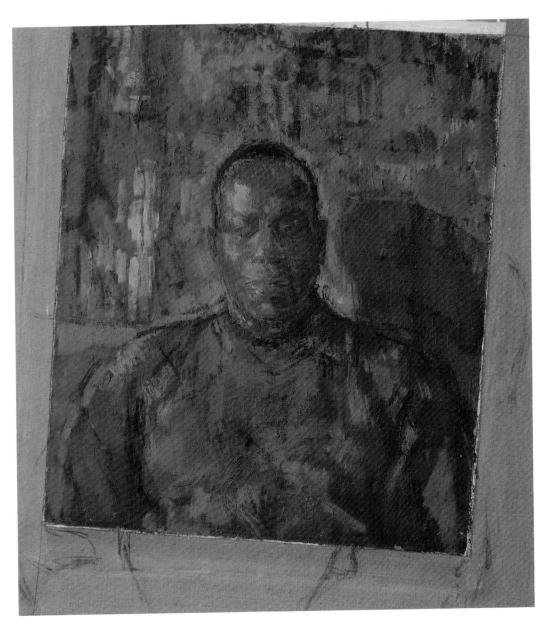

Getting distance from the portrait

If you have been painting your portrait now for a few sessions then it is probably a good idea to get as far back from it as you can. Push your easel forward so that the painting is closer to your model. Check the scale of the picture and question yourself: is the head life size, larger than life, or three-quarters life size? Find out the scale at which you are painting, for future reference. The further back you have to put the painting (to make it sight size) then the larger the scale you are working on.

Put the canvas at a distance so that it is easier to compare your subject and the picture. This is similar to playing spot the difference, where it can take a very long time to see something. Look as generally as you can to begin with, taking in the view of the whole canvas. Compare the structure of the biggest

shapes: whether they are the shadows or the mid-tones or the highlights. Treat the area of the picture as evenly as possible and keep looking for things you might have missed. This kind of checking cannot be done too much. Repeat the process time and time again.

Find your scale

Scale is related to emotion; you paint something the size that is related to your level of interest. This can explain why many portraits have the features painted at a larger size than the rest of the face, since it is predominantly at the eyes that we look or are most interested in.

A composition is what is within the edges of your picture; therefore include more of your surroundings in order to make the scale smaller. If you had already been painting at a smaller

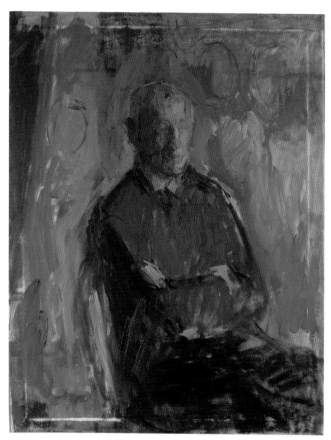

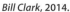

Bill Clark, 2014.

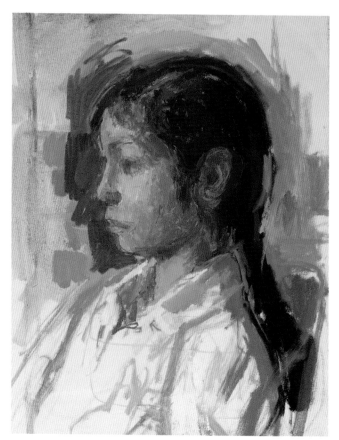

Dominique, 2015.

scale, with lots of room around the head, try the alternative of painting the head with very little room around it. It is good to experiment with composition in order to see the results.

All the time the thing to concentrate upon is on making the painting look like your experience of seeing the subject. To do this it is a matter of relating, and relating again, as many parts of the head that are in your composition and that are of interest to you. You may have to force yourself to look at some part of the head that until now you have avoided, for whatever reason. The aim of your attention should be consistency and an even observation of the whole head or form that is in your composition.

There are many ways to improve the objectivity of your observation. One thing that can help is to look into a mirror so that the image is reversed. When you do this does the image surprise you? The construction of a picture can break anatomical rules and still be a good picture; for an example of this look at paintings by El Greco. Heads that he painted at different angles all have a peculiarity of drawing that is nothing at all like a photograph of the same subject would be. Antoine Watteau represented the head from several angles and his pictures have

a similarly un-photographic feel. Does this make his paintings any less true?

Sustaining observation

If this is Day 4 of your painting and you have managed to maintain the pose of the model all this time and have not yet lost interest, then congratulations; the work that you have put into the head will surely be visible. When you sustain the observation of the same subject, the time spent painting becomes the thing to manage. If you are to reflect on that time spent painting, then what area of the painting do you identify as being the most important? Which part is the weakest or which part do you remember as having been the least observed?

Once the drawing is established in the painting it can be difficult to deconstruct it again, allowing for development in the drawing. When I say drawing here I am referring to the placement of things on the picture. So the drawing of the head, if understood diagrammatically, could mean the position of the eyes, nose and mouth in relation to the ears, chin, forehead,

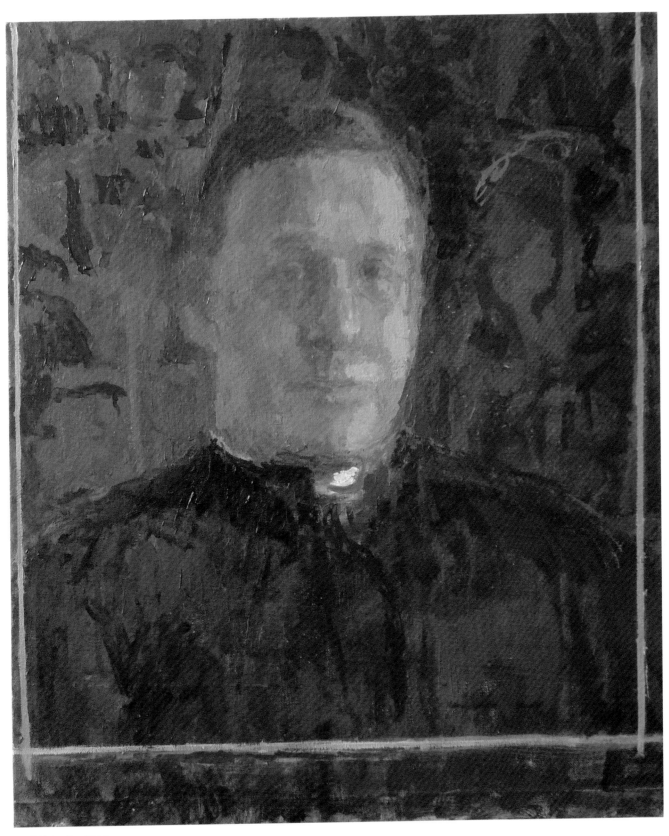

Hugh Valentine, 2010.

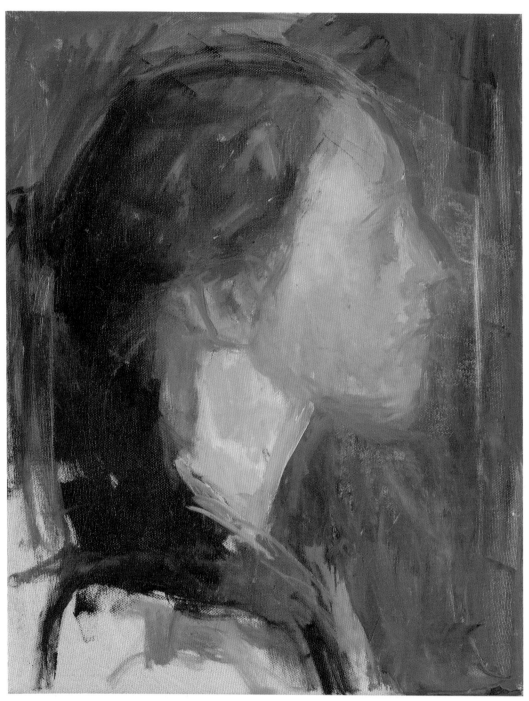

Berni, 2014.

neck and shoulders. If all of these points have been considered in the picture, and seen in relation to each other, then it can be difficult to know what to do next. My advice in this circumstance is to keep painting something you have not yet seen. It may be that the painting lacks detail and that is what you want to start to deal with. If you do this, then remember to keep an awareness of the whole image.

Time for review

Since I cannot respond to the picture you are painting as I could if we were in a class together, the skill that you must apply is honest self-criticism. Have you got the essential qualities or relationships of the features of your sitter? How are they visually different in real life from the representation you are making of them in your picture? Is their head any wider or

longer in a certain direction? Do they have a narrow or broad neck? Keep a distinction between how you see them now, in looking at them, and the image you are building of them, which can always be re-developed.

It is when you can no longer see something new to paint, or if the whole head looks completely different to you, that it is time to start a new picture. If you are at all unsure then make a drawing on some paper. Paintings are made over a duration of time. The time spent building the image is used more or less wisely. When you have experience of employing your own models for this purpose the chief pleasure and excitement is that of doing your best within the time available. What can you see in your model that you wish to paint? How can you see them differently? Ask them how they would like to be shown in a picture? Drawing can help to generate these possibilities without the commitment and longer process of making a painting.

Alterations

It can be your perspective that changes. Perhaps what alters the composition is a new focus or direction for the head to look in. By this point, try to always be aware of what they look like and to think how it may be possible to portray them differently.

Clothing and hats can alter a person's image beyond recognition. Enjoy the variation that you may at first view as a distraction, but which may yet tell you something about the subject that you did not at first previously see. Because of how we see, all elements of our vision inform each other. A new earring in a profile view can refocus the image much more than you would think. Imagine at least one other possible composition, even if you simply wish to return to the first idea and continue painting. The main thing is to keep seeing your subject as if you are seeing it for the first time.

Distortion

Some people say that it is good to have an element of distortion in a painting. It is one way in which a picture can be interesting in its own right. Some distortions in the method of painting can even make the portrait seem true to life. Distortion in sculpture can be what captures the eye of the viewer, and in painting, as in drawing, exaggeration plays a part in the construction of a powerful image. Painting from life is different to painting from a photograph; they are not the same thing.

Working across different pictures

When painting more than one picture of the same model, there is a simple way to choose which picture to work on. Put all the portraits side by side so that you can view them together, and decide which one you are least pleased with. This picture may well be the one that you will be most likely to take risks with, and being prepared to take risks will change the way that you paint. The painting has less likelihood of tightening up too early when it is not your favourite. Working on a picture that we consider our best work is going to be inhibiting, even if the work is improved. As a rule I think the best thing to do is to work in whichever way gives you the greater sense of abandonment or liberation, although painting also needs to be focused, deliberate and exact. Your drawing will improve with practice.

When you don't know what to do

The best thing you can possibly do when any uncertainty begins to creep into the process of painting is to draw. Taking a fresh sheet of paper takes all of the weight of the paint out of your mind, and the habitual movement of your eye from the model to the canvas now has a clean look of the page. You can now make your mark with as deliberate and clear a touch as you can.

The process of drawing can very often reveal something in the subject that has not yet been seen. When drawings are made as studies, during a painting, they can be made with a variety of media depending on the purpose of the drawing. What are you trying to find out? For instance, a Conté drawing will give a line more strength than if you were to use pencil, and watercolour will be more suggestive of tone.

Think of the drawing made at this point as a clarification or a form of research into your subject and image. What do you wish to understand better? The decision of what to draw can be about which part of the head is the least understood so far in the painting. More simply, what part of your subject have you looked at least? The drawings of Raphael (1483–1520) show us what he was most interested in within the female portrait: where the neck and shoulders reveal the angle and turn of the head. His perspective was usually that of looking up towards her head. The model's head would be turned to one side, making the view a three-quarter angle but also seen from below. This viewpoint is a terrific challenge to draw.

Scumbles and glazes

A scumble is a thin layer of paint that is lighter in tone than the layer of paint beneath it, and a glaze is a thin layer of paint that is darker. These terms usually refer to a broad area of the picture.

Think for instance of the background: if it is darker than your subject which is light, then dark glazes across the background will help to make that contrast greater and greater. Titian (1485–1576) was supposed to have painted forty glazes on a painting to achieve this effect as well as he did.

Scumbles can be used to lighten an area of darker and dry paint. Clothing in Rembrandt's paintings is sometimes an example of scumbling, although it is often *impasto* (where the paint is thickly applied). Where an area of the painting is dark, and you wish to lighten it with a thin colour, then this is a scumble. Turner (1775–1851) is a good example of an artist who made very effective uses of scumbles.

Generally speaking if you are to put a thin layer of paint over a thicker layer then there is a chance that it will crack over time. It is advisable to use linseed oil when doing this to help the layers of paint to bind. This knowledge should inform the practice of keeping your paint application in layers as thin as you can for as long as possible. Although it is not good to have too transparent an image, it means that the painting can be continually worked upon without getting too thick and unmanageable.

When is it finished?

Saturation of colour

Cézanne said, when asked how he knew when a painting was finished, that it was when the colour reaches its plenitude. My dictionary defines plenitude as fullness, completeness or abundance. This is a good way to understand colour in terms of its application in painting. When the greatest range and depth of colour is reached in the picture it may be wise to stop.

When you notice a colour and go to mix it on the palette, be mindful of the other colours. Let us say that the shadow side of the face appears to have a lot of red in it. Look around the rest of the subject; compare the amounts of red that would go into mixing the other colours. The surprising thing is the difference in looking and thinking about colour and the actual physical content of colour in the painting. If we noticed the red in the shadow side of the face, but the surrounding background was darker, then there may be a greater content of red in that dark background than there is in the face, since the face in shadow is lighter. Always look at the very least at two colours at one time, since the effect of colour is relative. Saturation of colour is how red a red is. The more red it is then the more saturated we call that red.

Working with the primary colours, the complementary colour will help to de-saturate a colour. Many people use white to de-saturate a colour, but it will make a picture very pale if this is done too much. Think of every colour that you look at as a mixture of yellow, red, blue and only then add the white that is necessary. Look at your subject with a view to locating the most saturated parts and de-saturated parts. Grey is the opposite of saturation, yet in a painting it can offer a pleasing muted effect. Study the paintings of Gwen John (1876–1939) to see how well she manages and experiments with the saturation of colour.

Check the tone of the whole

Getting distance from the canvas can be the best way to see tone. Put the picture on the wall where you can get back as far as you can to look. Once at this maximum distance, use a mirror to look at your painting in the reflection. With this visual aid, the further you get the more objective you should be able to be about the painting.

Think solely of the arrangement of light in the picture and what that suggests about the form, and the source and direction of the light. Is the shadow area of the volume of the head the darkest part of your subject? If not then where is it darker? Can you see the different value in tone for the areas which have direct light, and then reflected light? If anything looks strange at this point and from this distance then that may be the part of the subject to look at first when you return to paint. The more drastic the change at this point then the more vivid the painting.

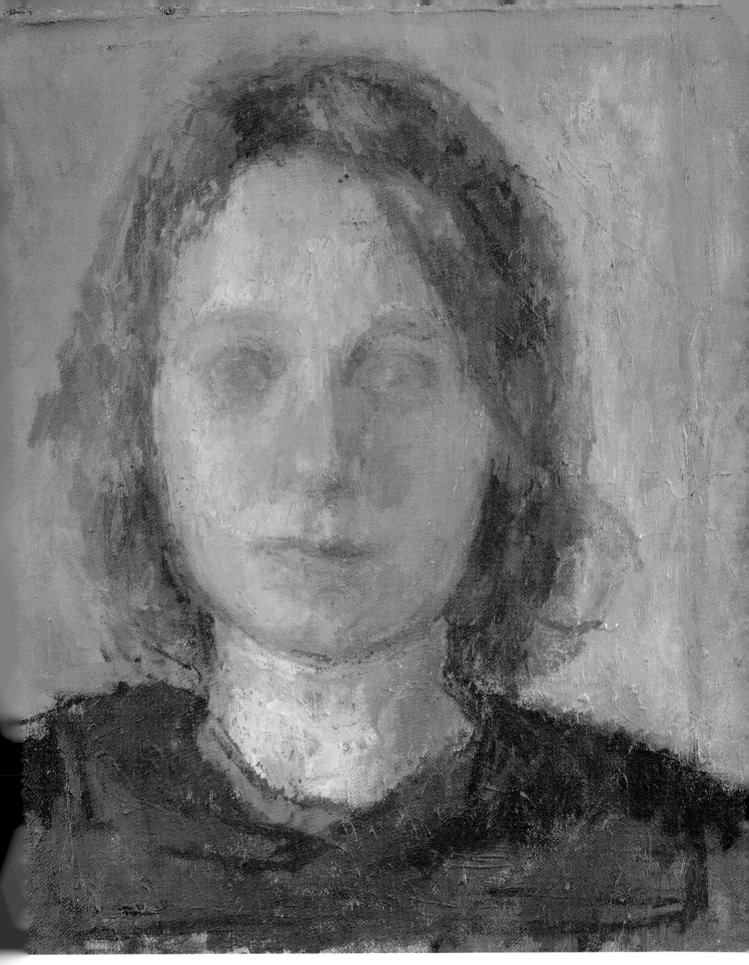

ucy, 2012.

Day 5: Look More Than You Paint

If this is the last day with your model then it is very likely that panic and dissatisfaction will begin to set in. Try not to let these negative considerations cloud your judgement. The thing to do is to continue working in the same way that you have done, but to be aware of the impact of what you are doing.

It may be that the kind of painting you do is along the lines of what has been written about in previous chapters. Now this is a case of going over the various stages but with a view to making each aspect of study as strong as it can be. Some painters have likened the process to a tightrope walk; you have to keep going and not fall off. This might mean that although you want to increase the contrast, you must take great care not to put that contrast in the wrong place. It might be that the detail is what is of most importance to you; here the danger would be that you do not lose sight of the whole. You can see from these two instances that it is about balancing what you want to achieve with what you have already achieved. As I have said before it is only right really to paint what you have not yet seen, and this can mean that you spend a lot more time looking for the things to paint than actually painting.

This chapter takes stock of the important things to consider, or reconsider, at this point in the painting. Although an artist constructs a painting by building up line, tone, colour and contrast, sometimes it is also a necessity to deconstruct a picture. This can be partial or complete, but it helps to control the picture. Giacometti worked so quickly that in some sessions he would build up the drawing in a picture, knock it down and build it up again two or three times.

Colour

Making colour relate

Having made the tone relate well across the image over a monochromatic under painting, or grisaille, the next step is to develop the colour relationships. The simplest way to do this is to try to narrow the number of colours down to three or four, or even two colours. Simplifying the relationship between the colours, rather than looking at the variety and complexity of colour, will make those colours easier to mix on the palette. The choice of colour you put onto the palette can even be informed by what colours you see in the set-up. It is more important to get the overall relationships of colour right than it is to aim to capture the nuances and smaller differences. Reducing the number of colours increases the chances of effective use of the colour mixtures or modulations.

Often I have seen examples where only one large colour area in the picture seems to be considered, and the work in the painting begins to be about the variety in that one colour area. The problem with this level of sensitivity is that it is very difficult to control those variations without reference to the whole. Always remember that when painting or drawing we exaggerate what it is we are interested in. Countering this focus with a view of the whole is difficult, probably impossible, but it will help your composition retain balance and gain subtlety.

Michael, 2013.

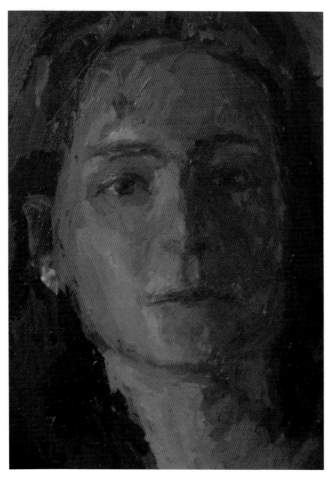

Helen, 2015.

Organization of colour

Keeping a view of the whole picture, in your mind create a layout or distribution of colour across the image. Keep thinking of the primary colours, since they will give you the easiest form of colour control. Decide if the head is the most red, or yellow, or blue part of your picture. The same kind of observation should apply to the background. Care will need to be taken when the colours are closest, since this may create interchange between those colour areas. A saturated background colour can be substituted for a less distracting muted colour that is a similar tone.

Bear in mind that the most interesting thing in the picture should be the head so experiment with backdrops to find one that is the most complimentary to the head. By this I do not mean complimentary as in the colour wheel, but just whichever colour seems to show the head to its best advantage. At the beginning of every painting session it is a good idea to use the palette knife to make the basic colours for the large areas in the picture. This will refresh your perception and help in terms of the mixtures that you go on to create.

Structure

Improving structure and form: Re-drawing

If the painting begins to lose its three-dimensionality, or appearance of depth, then the thing to focus on is colour and light. Make sure that the drawing of these areas relates well. When drawing, it is most useful to use the line to emphasize the differences in colour. Draw with a colour that matches the tone you can see.

It is important at this point to not add contrast in an area that is similarly toned. The whites of an eye in shadow are rarely white. If you use contrast in an area which is not the most contrasted in the subject then the work that you do in the drawing will not be as helpful as it could be. Frequently the area that we are most interested in becomes the most contrasted through the repeated work or re-drawing.

If the picture contains more of the figure then look to see that the darkest tones most probably happen outside of the head. Clothing, hair, and shadow will usually be the darkest areas, while the face in relation to these areas is only a mid-tone. Within the head the drawing should correspond well with the form, keeping in the front of your mind the thought of the light on that form. It can help to look at the picture and ask what direction is the light coming from?

Deconstruction

When an area of the drawing gets convoluted, it can help to make it simpler. Simplify the image by getting a general tone to be more accurate rather than by accumulating detail. If an area of the painting is not what you want it to be, you can either take off as much paint in that area as stiff brushes and clean solvent will allow, or alternatively, if the paint is dry you can use sandpaper to remove any lumps before re-painting with an underpainting white to block out that area. Re-painting will be easier technically if the canvas gets back to white before being painted again. With experience the deconstructive element of picture making can happen quickly, enabling the concentration to focus again on building up the form, tone and colour that you want.

Commitment and perseverance

It is surprising how each time you go to paint somebody you can see something that you have not seen before. Giacometti, who said he had painted his brother Diego 10,000 times, remarked that each time he went to paint him he no longer recognized him. On this fifth day with your subject, reflect on

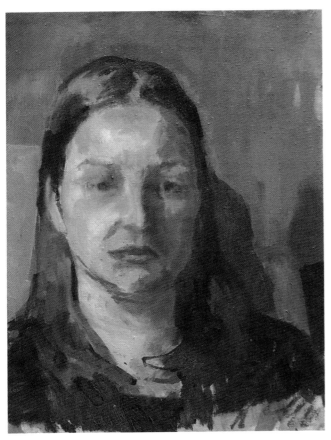

Mel, 2004.

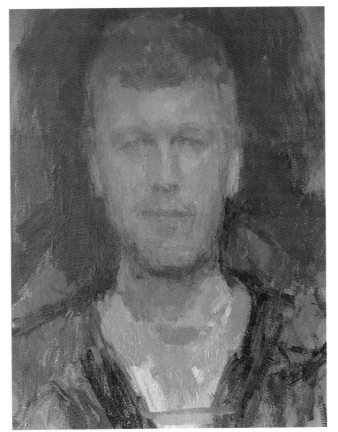

Max, 2012.

what it is that you have not yet seen. Anything that you can now see will be worth including in the picture as it will extend your research and deepen your representation.

It can take a lot of experience before a painting either does what it initially wanted it to do or that it can be considered a success. Avoid judging what you do too soon, but turn an image away for a while before re-examining it. Renoir's advice to artists was to turn the picture to the wall for three months and then to see it again. This is one way to know whether or not you consider a picture to be finished. With the portrait you may not have this extent of time, but still you can vary your work and not be too hasty with the evaluation of a picture. I once overheard Karn Holly as she told a group of students at Heatherley's that the success ratio that seemed accurate to her was about one in twenty pictures.

Overhaul – not a disaster!

The concentration that goes into a painting can have extreme effects. When you look at something for a long time, sudden changes can occur in how that thing is seen. When painting, and following what is being looked at, it can be difficult when this happens. If you do get to a point when what you have been

painting now looks very different to what you see, the next step is to try making a change to the painting that will make it more like what you are looking at. It can be hard to control things at this point, but do your best. Usually the result will be more interesting to you at least, as it can become a bit of a breakthrough zone, where the picture becomes more ambitious.

It takes courage to deconstruct something that you have been labouring over, but if the result is something which could not have been arrived at otherwise then last-minute transformations of the image can be extremely worthwhile. This can be as simple as repainting the background and it can be as complicated as changing the whole head. The most important thing is to follow what you see, and to keep discovering the image anew in your painting.

Remember, as Cézanne said, that perception can be a very long time in coming. Do not give up hope that the image can be improved by re-working. It will happen that paintings get lost in this way as they have been taken too far, but this is better than to reluctantly hang on to a painting that is not as good as the one that you began to see or to imagine. It is a case of chasing the image until you really cannot do any more. If you play it safe and accept an image as what you can do, without

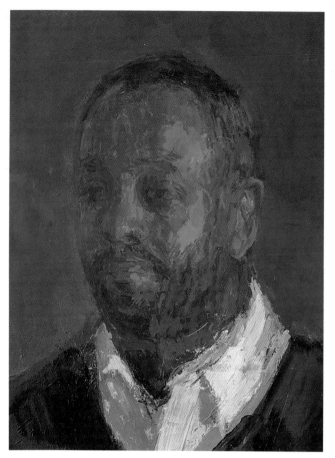

Lawrence, 2014.

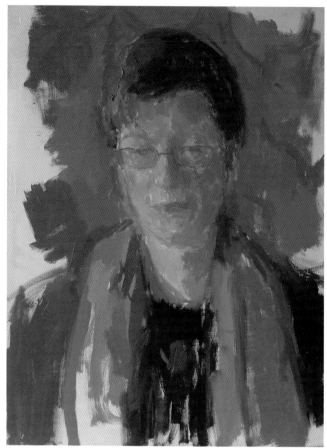

Anya, 2013.

actually challenging yourself further than that, then you may not improve. Being too cautious in a painting is harmful since there will be little sense of discovery within the picture itself. This reminds me of Lucian Freud who said that painting should have something revelatory about it. You should want your way of seeing to stand out in the picture.

What else to do?

The advice to look more than paint is vital if it is the last sitting, and can be useful at other times too. When you know that there will be no more chances of painting this person from life, the difficulty becomes that of really seeing the subject as a whole – so that the painting does not get worse. The danger with painting is that the painter looks increasingly at the picture and less and less at the subject, until these two things really become very different. This can be a hard thing to reconcile, as the stubborn instinct of a painter will be to dig in their heels and defend what it is they are doing. This standpoint can be useful and even necessary for a time, but as long as you want to keep a

picture progressing you should remain open to the suggestions made by the continually new appearance of the subject.

Look at the model more than at your work

I was advised to keep concentrating on the model rather than my painting or drawing when I was a student, drawing in the life room, but its application does not stop there. The average person does not question what they see, in the same way that a painter must if they are going to have their way of seeing make an impression to other people. The thing to attempt is to see something clearer and more completely than you did before.

Giacometti used to say that if he could see something better through the process of drawing then it would have been worthwhile. What does it mean to see better? How can you judge if you have seen something better? Again, this is difficult to write about, but as long as you question yourself and remain positive it will help the picture. I think it is to see as much of your subject simultaneously, and as clearly as possible, but equally I may feel satisfied if I have studied one part of the picture better than I had done before. This qualification is by no means fixed, since the results will vary as much as we do, and since each painting session is different.

Only paint if you actually see something more

The logical development now is for the painting's progress to grind to a halt, and for this particular attempt at painting the head to come to an end. The artist Bill Clark advised that you save the best bit until last, as a way of making the end of the painting more interesting for you to do, and at the same time making the painting more interesting for the viewer (he learned this from William Coldstream, his teacher).

Many paintings lose their initial excitement and then gradually get worse before they are left, or finished. You can work against doing this by remaining increasingly attentive until the end. One way of gearing up to this excitement is by keeping the bit that is most interesting to you as the last thing to paint. If this is the eyes, then once everything else has been painted it should be easier to see where they should be and what direction they should be looking in. Think of the antique casts: sometimes the eyes are only an outline of the iris, yet it is enough to suggest the gaze. Theoretically it is equivalent to drawing what you can grasp but not more than that. Keep your painting and drawing connected to the sense that you make of the subject. It can be hard to stop at this point but in the end the result will be more satisfactory. When we draw or paint without regard to the whole picture this is usually when things go out of balance.

Checking with a mirror

Paintings have a knack of looking different each time that we look at them. The eye takes a route through the image. Because paintings are built up over time they are constructed with a variety of relationships. Very often a viewer will see something that the artist had not seen.

When you construct a painting you should be conscious of as many relationships as possible; in other words view your subject from all angles and try to cover every view. The mirror can help to unravel aspects of how you saw the subject, and since it reverses the image from left to right the reflection offers a view or direction in seeing that you are not used to. It is a way of seeing the work un-habitually. This can be unsettling but it offers an objectivity in the view of the image that otherwise may take a long time in achieving. Anything that stands out to you as something which you had not noticed before will be helpful in seeing the view of your subject in your picture as well as possible.

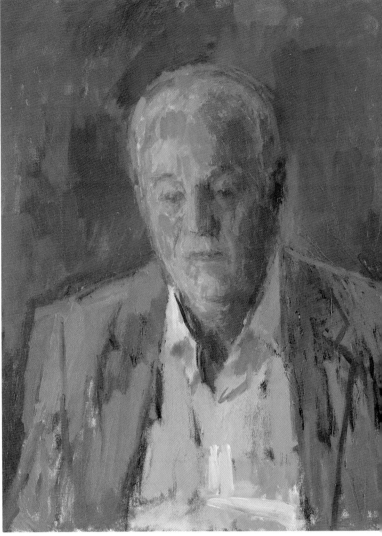

Uncle Tim, 2014.

Seeing the eyes

Portraying eye contact can be the most rewarding and also the most frustrating part of painting the head. It can be a challenge to meet a person's gaze at the same time as concentrating well enough to keep a painting on track. Eye contact is probably the most expressive aspect of a portrait, and can make the difference between an average picture and a powerful one. It can seem that a portrait is not really complete until the gaze, or communication of the eye, is painted as well as it is possible. Practise this as much as you can by drawing yourself in the mirror. You should be prepared to repaint the whole head outwards again from the centre of the picture, once the eyes are at their strongest. If you find you need more time with the model, use your own judgement to consider asking whether the sitter may be able to give you an appointment at a later date.

Jade Elouise, 2011.

SUMMARY OF PART II

This section of the book (Chapters 5–9) attempts to accompany your painting of the sitter: from the choice of ground for the picture, through the set-up, the structure of the sessions, guidance on how to compose and what palette to use, all the way to the later stages of developing a portrait over time.

Some portraits take years to complete. Many of the aspects in this section may be applicable in different orders, or not at all. Each picture is different and one will give you a different challenge to another. Attempt to keep a momentum going throughout the process, and this itself can become the biggest challenge over time. Matisse said that he found it hard to be the same person on different days, in respect to being the person painting the picture.

Document your progress with photographs so that an earlier stage in the picture is still visible. Also try painting another person, since this may well change your approach in another way. Keep an awareness of your own engagement with the picture and make sure that the picture that you choose to work on really is what you want to be concentrating on most of all.

Toby (in progress), 2008.

ALWAYS A FRESH START

The beginning of every painting requires seeing anew and considering your options.

Each time (one) begins a picture…(one) plunges headlong into it, and feels like a man who knows that his surest plan to learn to swim safely is, dangerous as it may seem, to throw himself into the water… No one should paint a landscape and a figure by the same process, with the same knowledge, or in the same fashion; nor, what is more, even two landscapes or two figures. Each work should be a new creation of the mind. The hand, if it is true, will conserve some of its acquired secrets of manipulation, but the eye should forget all else it has seen, and learn anew from the lessons before it. It should abstract itself from memory, seeing only that which it looks upon, and that as if for the first time; and the hand should become an impersonal abstraction guided only by the will, oblivious of all previous cunning.

– Edouard Manet (1832–83)

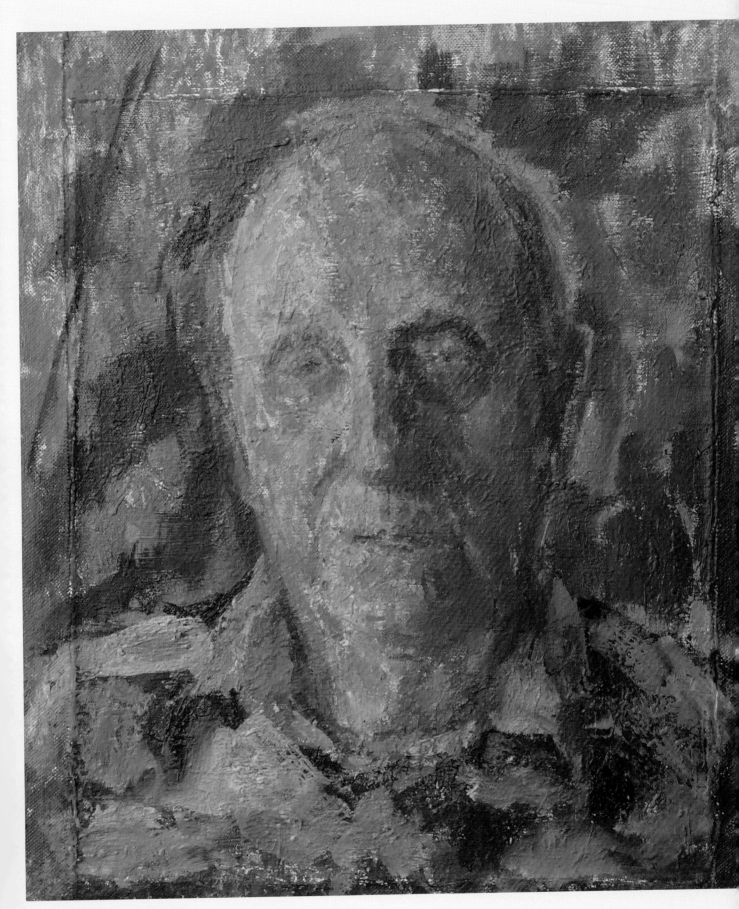

Lawrie (the finished painting), 2009.

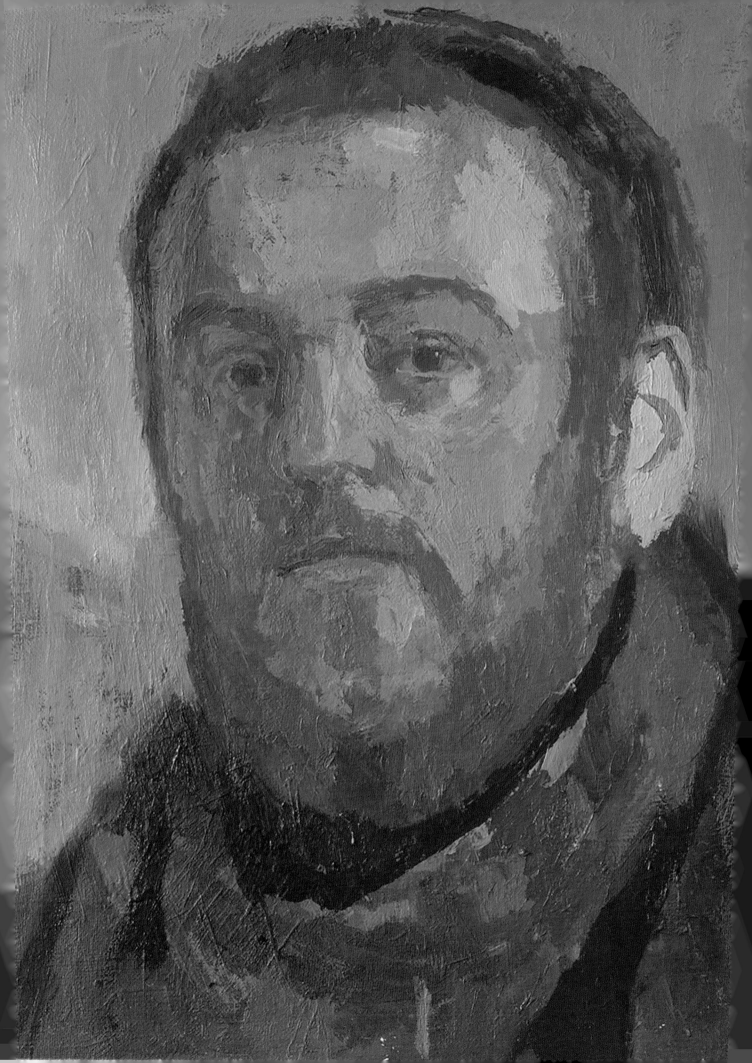

Self-portraits

The self-portrait offers a painter the most control of a painted portrait from life. Every decision within a self-portrait is made without the involvement of another person. This is not to say that these decisions are not affected by outside influence, but that they do have a particular interest in themselves. There is nothing to stop you doing it, other than issues of time management and motivation. Not being reliant upon another person for the construction of a picture can be liberating. Saying this, it is clear that no idea exists in isolation; in other words, things that you may have seen and thought will take root if you give them a chance to in the time that you spend painting yourself.

Beginning with drawings made in the mirror, usually the appearance of eye contact is the dominant characteristic of the self-portrait. Drawing a reflection, wherever it is seen, traces a moment in time, and a distance specific to that time and place. In a controlled environment, the continuous presence of this model offers the relation to the human figure that can be a valuable impetus to making art. At its worst, the vanity that is present in most forms of art making is laid bare at its most vulnerable state – the image that we have of ourselves. A face, any face, will betray a feeling however unintended, and this can give a picture its content. The self-portrait is usually seen to reveal, on some levels, the person who painted it.

In practical terms, you are always available to yourself as a model. If no mirror is available you can draw your hands. You might also try to draw yourself from memory. With the mirror, any conceivable angle or expression can be studied. I strongly recommend the use of two mirrors for the most objective view

Eyes, 2012.

that you can get of yourself. With two mirrors the reversed image of a single mirror is reversed again so that the left-to-right order is re-established and you see yourself the way that other people see you. This is important as it gives you access to more of a variety of image, and usually the greater distance of the two-mirror set-up creates a less distorted perspective. It will however mean that the size of the reflection seen is smaller, which may affect the scale of the picture.

Self-portrait, 2014.

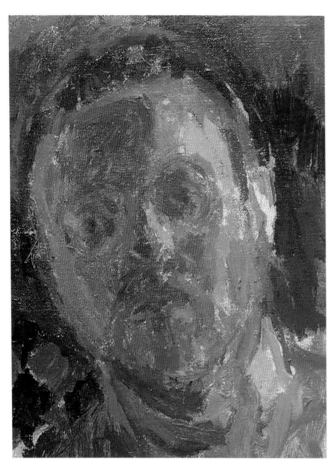

Self-portrait in Italy, 2014.

Choice of light

Using a small and lightweight mirror that you can comfortably hold at arms-length, and which will reflect the whole of your head, try standing in the centre of the room and hold the mirror out in front of you. Looking at your reflection in the mirror, begin by studying the effect of light on your face in the reflection. As you are observing the reflection, rotate the direction you are facing with your body whilst keeping your arms and the mirror in the same position. What you will observe whilst doing this is the fall of light across your face. As you turn or rotate, study the changes in the contour of light across your face. If we call this rotation a cycle, get to know the positions at which the face is in shadow (with the window behind you) and in full light, (with the window in front of you).

As described in Chapter 4, the initial choice of position in the studio in which you decide to work will determine much about the appearance of the head. The more times you attempt to paint a self-portrait, the more you can experiment with different positions and different arrangements of the light. Each potential view will offer its own challenges in the painting.

The paint

Make the colour mixture for the area of skin in shadow. This way of starting is especially helpful if you are painting on to a light-toned ground. Putting this down first makes the colour mixtures for the lighter skin tones appear closer in tonal contrast to the colours of the subject seen as a whole. This method of beginning makes a clear structure of the form as it is seen in space and as it is described by light. Painting in this way may inform the set-up that you choose to work with.

It is a good idea to indicate as many surrounding colours as possible at an early stage. When you look to find out what colour something is, the surest method is to look at the colour that sits next to the colour you are trying to see. Work out the two colours in tandem, or together, so as to make the colours in the picture harmonize. The colours may be similar but yet different in tone – this is fairly simple to work out on the palette – or they may be two very different colours.

Stronger differences in colour can be harder to harmonize overall, but keep on adjusting the colours together in your painting, and constantly look back at the two colours in your subject. Also look at how these colours relate to the rest of the composition. Modulate the painting with these thoughts in mind, as you continue to draw with the paint. Over time the depth of the colour in the picture will be improved by exactly this method across the painting.

Composition

How do other people see you? This is practically impossible to answer, but it may feed into your choice of composition. You may try a frontal direct drawing to convey the immediacy of being in conversation with somebody. Alternatively you might construct a view that nears a profile. It may be that your profile has a more distinct characteristic, and this will help those that know you to recognize you in the picture.

Very often, these considerations will only take place late in the picture making. In my experience of painting, the pictures follow one another fairly rationally. It is hard enough to make a picture begin to work, without complicating the process with an extra difficulty. For example a hat will transform the whole image.

Try drawing several ideas for a composition, looking at your reflection from a variety of distances. Francis Bacon (1909–92) once said that the great thing about Rembrandt's self-portraits was that each time he painted himself his face had a different

contour. Rembrandt (1606–69) often wore costumes, including a white cloth wrapped around his head. Having white at the top of the head creates an interesting tonal challenge to paint. Cézanne also painted himself with this choice of head wear.

Mirrors

Vary the kind of mirror you use so as to get the view that you want. A large mirror gives the best overall view and is one of the only ways to paint a large self-portrait that includes a lot of the figure. But take into consideration that the bigger the mirror you use the heavier the weight. For a larger mirror an A-frame easel with a locking mechanism works best, as radial easels carrying a heavy load can slip under the weight and can increase the chances of accidentally breaking the mirror. Smaller mirrors are best for a smaller picture that concentrates on the head. A small mirror will enable you to be physically closer and will interfere less with the space around you, which you will need for your equipment, including palette, brush, cleaning cloths and solvent.

It is a good idea to draw the view that you intend to paint. Make small studies on paper; these do not need to be exhaustive in detail but do make sure that you draw everything that would fit into the composition. When you start a drawing, be conscious of whether or not you become bored before you get to the end. If this happens then this particular composition may not be the most interesting one that you could attempt. Alternatively it may mean that you are ready to begin painting. It will not take very long to make a few variations as pencil studies. Once they are on paper, you will be able to judge them later. It is important to generate as many ideas as you can so as to be surer about the one you eventually choose to paint.

Are you able to see what you are doing?

The set up for painting a self-portrait is a bit trickier than for painting somebody else. The mirror position will determine much of what the painting will look like, so this can claim the priority.

Second to this is where you put your canvas. For a right-handed person it usually follows that the canvas goes beside the mirror, on the right-hand side, so that movement is minimized, and you do not have to look over your painting arm. This can be problematic if there is not enough light on the canvas to see what you are doing. It is possible to paint under very dim conditions because the eye is so sensitive, but it is also worthwhile to minimize these difficulties.

If you are at all unsure about this, and your picture is painted in low light, then the thing to do is to regularly put the painting in good light so that you can see how the picture is going. Other

Self-portrait drawing, 2015.

mirrors can be angled to reflect light in the room. You may find that over time it is beneficial to find a position in the light that works well and to return to this. Each time you go to paint the result will be different even if all of the variables of set-up are kept constant.

Research the subject

Look at as many self-portraits as you can by other painters. Especially look at the variety of self-portraits painted by artists over their whole lifetime. It might give you an idea that may well be worth trying. See the paintings first hand if you can; this will give you the clearest idea of the artist's method since you are looking at the real surface that they had contact with. Try to absorb as much as possible about the touch and handling in the paintings that you admire. William Coldstream, when asked, said that he thought that 'touch' was the most important thing in a painting. Imitation can be a very good way to learn.

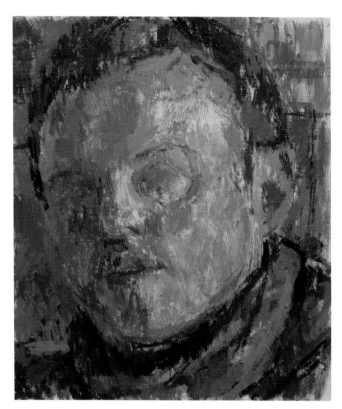

Self-portrait (in progress), 2009.

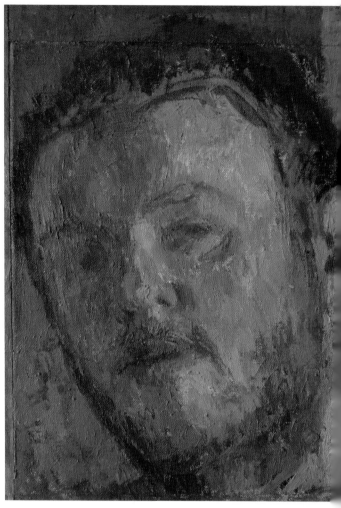

Self-portrait, 2009.

The real reason why self-training is all important for the artist, and must always be far more important than the best teaching the best teacher can give him, is a simple one. Ultimately the painter depends for his fame upon his own personal message, upon the strength and the sweetness of the things he has to say. Training of any kind is only the process of learning how to deliver that message in the most exactly appropriate words – appropriate not only to the subject-matter but to the habits and conditions of the time. No man can see to the bottom of the painter's heart so well as he can himself, if he chooses to try. And it is only the man who knows the message for every month, for every day of his life; who can have a chance of finding the perfect phrase for each occasion. A clever teacher may make a good guess now and then, but can do no more than that, and the guess that is right one day will be wrong the next. So the painter must train himself willy-nilly, or he will never be trained at all.

 – C.J. Holmes (1911)

Considerations

Choice of canvas

Think about the intentions for the picture. Do you want to paint yourself with as much detail and fine brush work as is possible? Is it a more physical painting with broad strokes and larger areas of colour that you want? It is hard for fine brush work to show up on a canvas that is rough in texture such as coarse grain linen. Choose fine linen in order for the detail not to be distracted by the visibility of coarse linen weave.

Number of sittings

With the self-portrait, there is no limitation on your own availability other than the time constraints that you may have. With this in mind, try to lengthen the structure of your approach. This can mean that the way that you paint can be controlled and varied to suit your aims. You can slow down the process of observation and make a more studied and subtle picture. It is

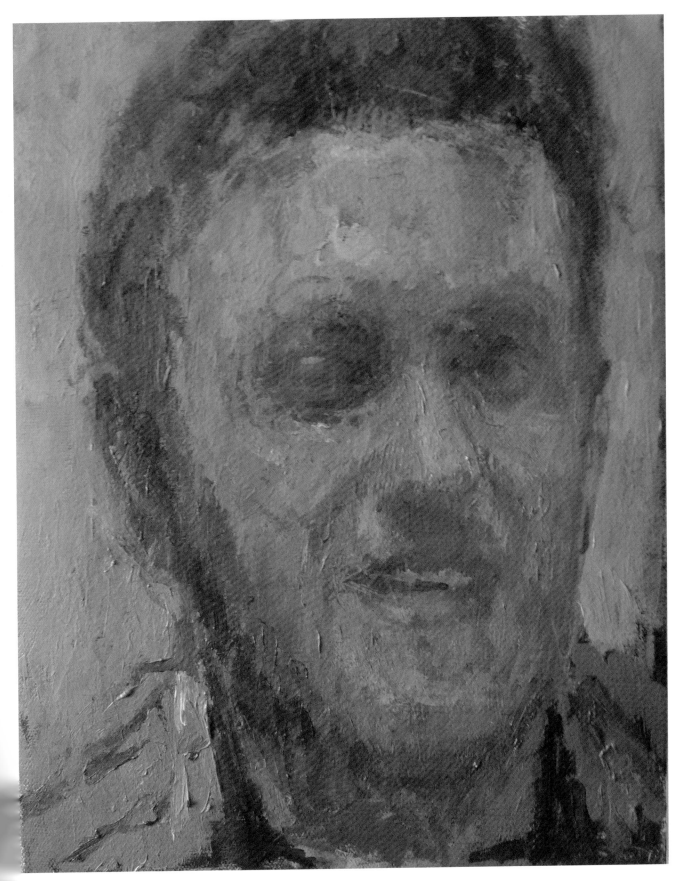

Laughing self-portrait, 2012.

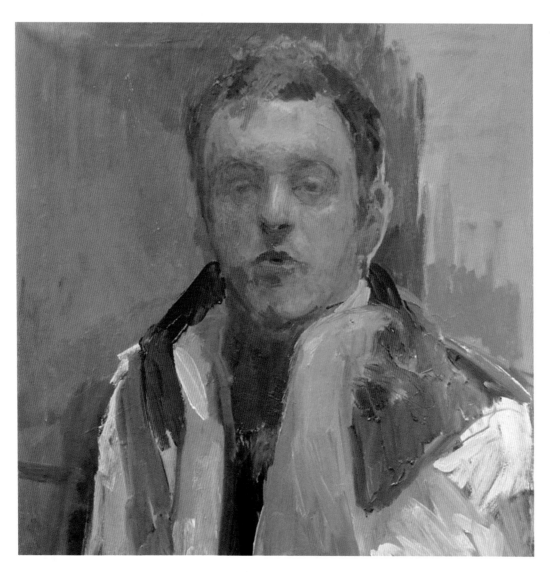

possible to build up an oil painting in thin layers, where only one or two colours are used at a time. This method will make the observation of tone more considered, and you will be able to draw with the paint for longer. Rather than starting out with a full palette, the choice of one colour forces you to reduce your observations to that of tone; and the thickness of that colour, especially if it is a transparent pigment (for instance, terre verte), will determine the tone.

Expression

What do you want the picture to say? Most probably you will be so concerned about the construction of the image that you will not consider the expressive connotations of the pose and lighting, and even the expression that you hold whilst painting. One picture that I made appears to some people as if I am laughing but that was not what I was doing. I was squinting to see the tone clearer – and when I squint my cheeks and upper lip are raised.

Variations

Distance from self

If you want to achieve a greater objectivity with your painting then it can help to get further away. People do not usually see you in the same way that you see yourself in the mirror. This is a more intimate view, up close, and people are not often that close to each other in daily life. A self-portrait can be a brilliant way to express something, even if it is only a vague feeling, by way of the close study of the facial features. Alternatively the self-portrait can aim at distance, which may make the portrait a bit more like the way others already see you.

Masaccio (1401–28) and Masolino (1383–1447) worked together painting the frescoes of the Brancacci chapel, in the church of Santa Maria del Carmine in Florence, which can still be seen today. Fifty years later these were restored by Filippino Lippi (1457–1504). As you look at the altar, the long fresco at eye level to the left contains a self-portrait of Masaccio, who

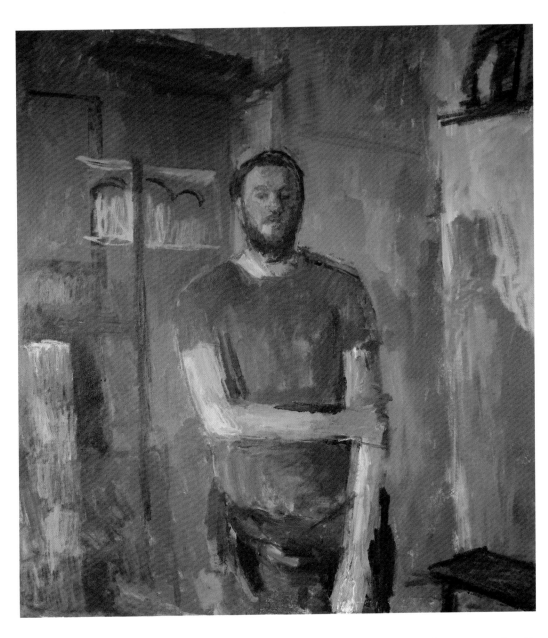

Self-portrait (in progress), 2014.

peers out at us from a doorway almost in the far corner of the space of the chapel itself. This painting is *The Raising of the Son of Theophilus and St Peter Enthroned*, where St Peter resurrected a young man who had been dead for fourteen years. Masaccio painted himself engaging with the viewer at the same time as overshadowing his older colleague Masolino. Many of the other figures were painted by Lippi in 1481–2. Lippi chose to paint his self-portrait on the opposite wall to that of Masaccio, just to the left of the centre of the fresco, which takes as its subject *The Disputation with Simon Magus and the Crucifixion of Peter*. Behind Lippi's self-portrait is a green landscape containing soldiers on horseback. This example of self-portraiture in the context of a bigger painting makes us aware of different possibilities in painting.

An example of the honesty in good self-portraiture, Ron B. Kitaj (1932–2007), made several self-portrait paintings when he himself was not well. These pictures that refer to various illnesses are a testament to the discipline of the artist and to the expressive potential of the self-portrait.

Confrontation

The self-portrait offers a painter the chance to say something about themselves. This could be a material statement about a setting, or even an item of clothing. Some artists will combine it with a still life in order to reveal more of a potential narrative. In the past a painter might try to advertise their particular skill at painting a head, or even to showcase what sort of thing they enjoyed painting the most.

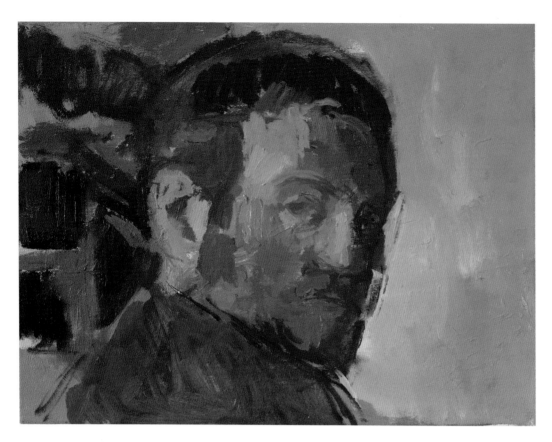

The early portraits of Caravaggio (1571–1610), which may be self-portraits, have such control in the painting, such as *Boy Bitten by a Lizard*, or the self-portrait-like appearance of *Bacchus Holding a Glass of Wine*, that the painting's content becomes about how ambitious he could be with the subject. Combining the still life or a landscape with the challenge of the self-portrait reveals an ambition with the medium of oil paint.

Relation

Rembrandt (1606–69), Lovis Corinth (1858–1925) and Max Beckmann (1884–1950) all made paintings of themselves with at least one other figure in the picture. This is another ambitious subject to paint that can only come out of an intense amount of practice and experience of painting the self-portrait.

By 'confrontation', I refer to a more total view or more inclusive presentation of your surroundings in a self-portrait. This will almost certainly not go right the first time but it can raise the level of ambition within a picture. Gustave Courbet (1819–77) painted *The Painter's Studio* in 1854–5. This picture can be seen in the Musée d'Orsay in Paris, and as Courbet himself explained, it showed 'all the people who serve my cause, sustain me in my ideal and support my activity'.

Without getting too removed from the intense scrutiny necessary for painting a believable head in oils, it will be possible for other elements to come into the pictures over time, and this may be more immediately interesting to a viewer who may or may not recognize you in your paintings.

Autobiography

Whether you consider it so or not, the paintings that you make will show something about you. Consider the amount of honesty and open attitude to this that you see in the self-portraits by other artists. Painting a self-portrait can, for example, be an attempt to look objectively at yourself in terms of style, which can include all the aspects of presentation. Wearing a hat initially for practical reasons of protecting your vision from too much light or glare can inadvertently be interpreted as a statement of style. Whether what you wear whilst painting is like what you wear in everyday life, however subtle the distinction – is not of much interest other than whether or not it makes a good picture. Try to get as much in at first, and then the duration of the picture can weed out or hone what is to be of real importance to you in the image.

Action: Showing what you are doing

Paint yourself painting; then try to paint yourself not painting. You should try including the setting of where you are, so as to give a space in the picture for the figure to inhabit.

Self-portrait, 2005.

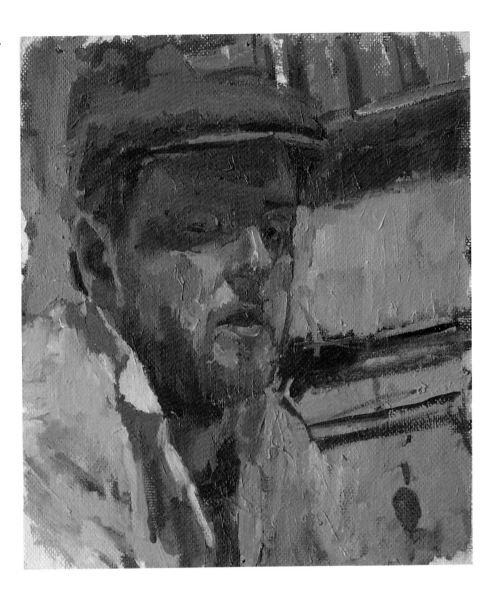

Is there an activity you can perform in the space that you are interested in presenting in a composition? There are endless potential variations on this. Include the domestic setting. An artist in the second half of the twentieth century once photographed themselves wearing the entire contents of their wardrobe. At all levels the main point is that an idea you may have should be carried out so that you can see the results.

Self-portraits by all artists made over the years do have a commonality, and sometimes artists will deliberately seek to repeat another artist's idea. There is also the fact that the challenge itself of making a set-up with a mirror, and of having the paints and palette at hand, leads to resulting similarities in composition. This can be the most important thing, that you control and make as convenient as you can the actual painting of the picture, meaning that full attention can be given to the task itself of painting as well as you can.

What do you want to communicate?

When painting you should look for those things that you can communicate in paint clearly: form, light, colour, tone, line.

Remember that a picture is only made up out of paint on a surface. Construct the picture as evenly as possible. At its best a portrait is made by focusing your attention solely upon drawing the inter-relation of the features of the face and the shape of the head. Getting eyes, nose, mouth and ears to fit right within the head shape will make it seem real. The relation of these features to each other is more important than the detail with which one of those features is drawn in isolation.

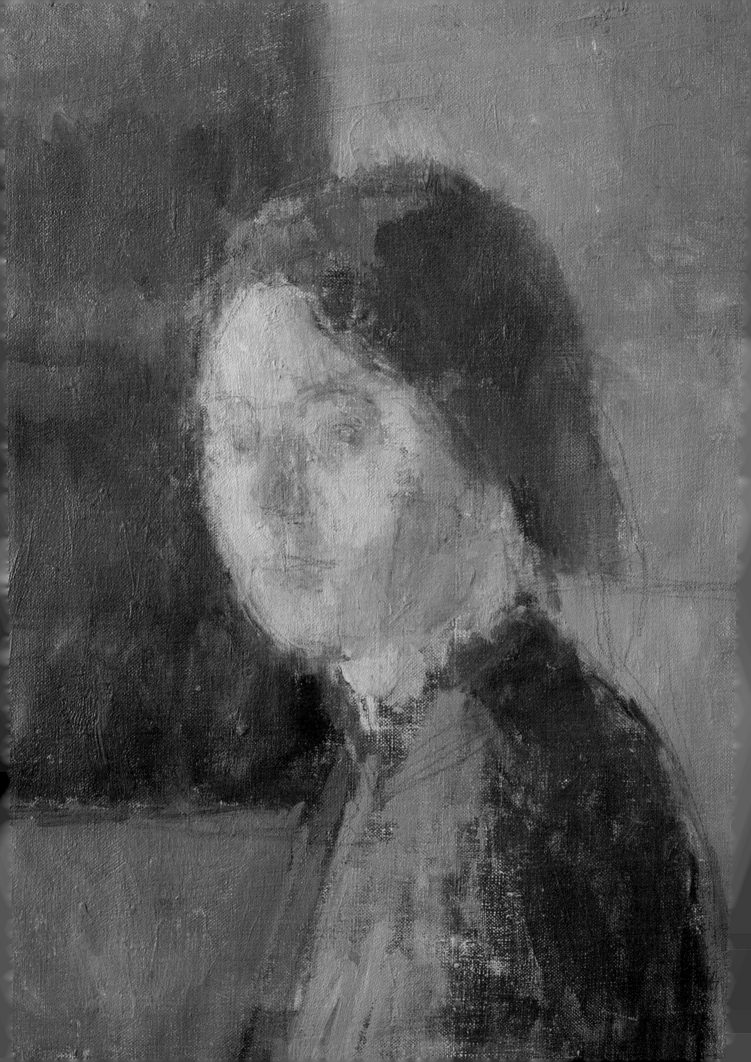

The Portrait

Finishing a painting

Think of the last touches in the painting as re-affirming the strongest part of the picture. If the gaze is thought of as the centre of the picture, although it is usually in the top half of a portrait, it is wiser to finish the picture in that area rather than somewhere on the outskirts of the composition.

At the end of a portrait, it can happen that the attention drifts to some part of the picture nearer the edges of the composition, and this may continue to be a distraction in the finished portrait. Revisiting the centre of a picture's subject is the best way to regain concentration. Cézanne used to advise students to get to the heart of what is in front of them.

The reason for suggesting saving the eyes until last is connected with this, in that the last touches can be the most noticeable part of a picture. In some paintings by Giacometti there is an incomplete drawing of the eyes, nose and mouth that appear to be disconnected from the rest of the body. It may have been that at the last part of the last session he re-painted the face working from the inside out and did not have time or even did not feel the need to go all the way to the edge.

The centre is also a good place to finish the painting. You want to end on a high note, that is, with a final touch that is of as much concentration or engagement as possible. Otherwise your picture, although it may formally have everything attended to, will not be as absorbing to look at. Think of your attention as a guide. If you are absorbed in making the picture stand out in its most important detail, then it will usually be interesting to look at. If your attention wavers then this will be visible to another painter. Do whatever it takes to make the sitter's face the most detailed or as engaging to look at as you can. Alternatively, the

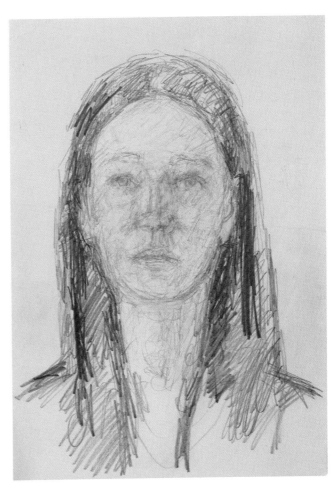

Drawing of Berni, 2015.

moment you begin to lose interest you should start another painting or drawing of a view of your subject that gives you the strongest urge to paint or draw, even if this short sketch serves no purpose other than to refresh your eye.

Lucy, 2013.

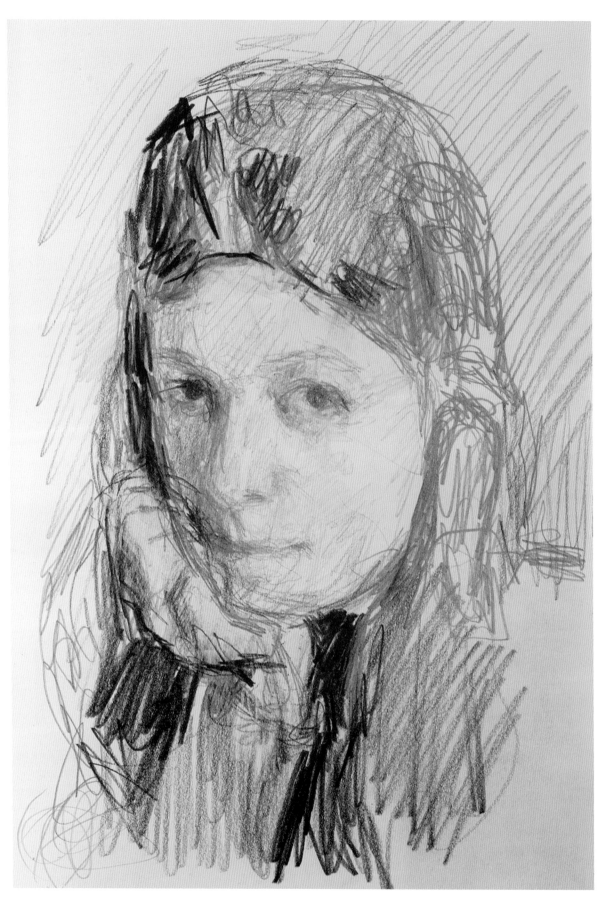

Drawing of Asya, 2015.

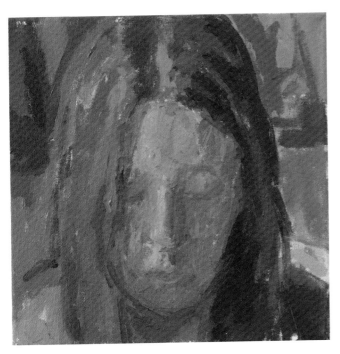

Berni, 2015.

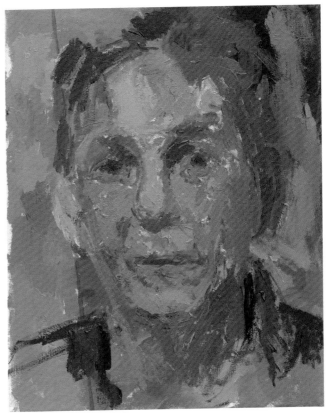

Patrick, 2015.

Working with a model

The relationship with the sitter

A portrait can take a long time to paint. Over the hours sat with your sitter, it can happen that you come to know them very well. This can also happen quite quickly since the situation is unlike most others, in that there is as little distraction as possible. Although most of the time spent painting will probably be in silence, it would be unnatural not to have some conversations. Since painting can be a solitary occupation, if you are spending too much time doing it, then a visitor can be very welcome, bringing with them their stories and daily experience. Some element of the manner and gestures of your sitter may help their likeness in the picture.

It can be preferable to work alone. Francis Bacon said that he found the presence of the sitter inhibiting to his way of painting. Concentration is difficult to begin with, and with some sitters it may not be possible. With practice you may become able to work in the way that suits you best while there is a model posing. Usually, with clear explanation, people are willing to change position, or stop talking, if that is what it will take to make the picture better. Some people are very eager to talk

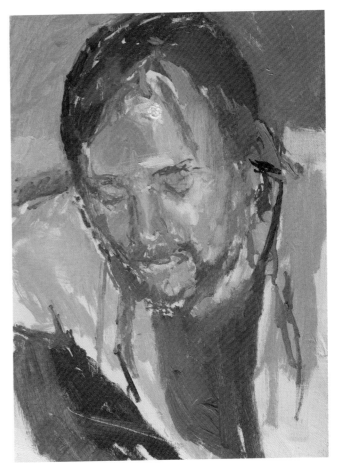

Tony, 2015.

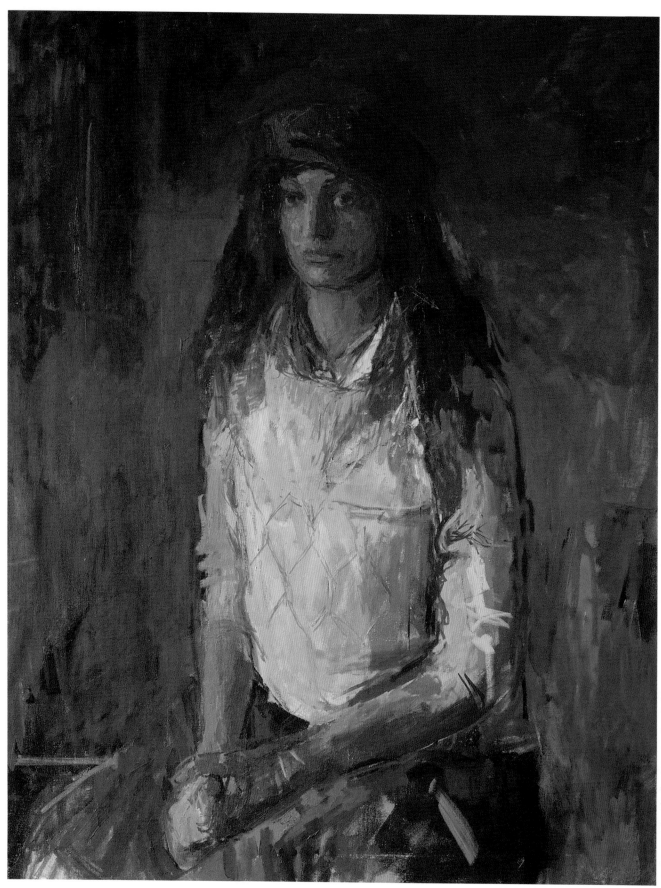

Dominique, 2015.

and get things off of their chests, and this one-to-one situation becomes a good outlet for them. Keep focused on what you are doing, but let the sitter talk, and this can also work well.

If there is movement in your subject, the challenging part is looking for the constants – the things that do not change – and then catching the other moving parts when they are in the place where you want them to be in the picture. Some animation in your subject is good, in that if you can communicate some of this too then the picture may have a bit more life in it. The way somebody sits, their posture, whether their head faces up or down, what they do with their hands and what they do with their legs – all of these elements can be characterful. Since it is this construction of likeness that you are attempting to paint, you should consider how best to get it in the picture. How can you make your composition more like your vision?

Trust

When sitting, a model can feel vulnerable. Some people will keep themselves fairly closed, focused, so that you may concentrate on the appearance as best as possible. Others will willingly open up so that it is almost as if you are not there as an observer. At the same time whilst painting you might experience some sense of vulnerability yourself. It is important to establish a relationship of trust early on, and it will be different with each person. Listening to music while painting can be a good option since it creates a focal point outside of the painting.

Timing

For single sittings a standard amount of time that people can manage without feeling too uncomfortable is forty-five minutes to an hour. With a short stretch this can then extend to an hour and a half or even two hours. Stories about artists who work for three hours with complete motionlessness in their model are extreme. Cézanne's portrait of the collector Ambroise Vollard (1865–1939) which took more than a month of daily sittings, each of three hours, is a rarity. After this amount of time the picture became abandoned rather than finished.

The demands that you make on your model should be realistic. Usually you will have to have breaks in between sessions that fit in with people's free time. It can help to paint people who have more time available for sitting. Also if they live nearby then this can help with their availability. It is better to not feel rushed, and to make progress in the observation, with as little regard for time as possible. On the other hand lengthy preparations to paint people who may have to travel for the purpose can make for good painting sessions, since the anticipation can aid the moment and the concentration too.

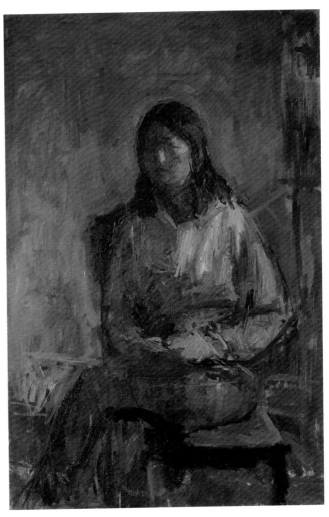

Xiao, 2015.

Painting a painter

Painters like to paint other painters. Sargent's (1856–1925) best portraits were of other artists. This may be due to the admiration felt for the model. It may be due to a sense of challenge, where if the person sitting is a good painter themselves then you feel a responsibility to make a good job of it. It may be too that the model who has a greater empathy for the activity, for instance someone who paints portraits themselves, will sit better and inspire a more interested portrait.

Conversations will no doubt be of interest because of the shared experience with the subject. Lucian Freud's, Frank Auerbach's and Francis Bacon's portraits of each other are good examples of when this appears to have worked well. All three artists knew each other for many years, and this friendship may have informed or motivated the portraits in some way. It may be a good idea for you to paint somebody who is an artist too, if this is of interest to you. The conversations that you have during the process will probably be interesting if you are interested in the person sitting.

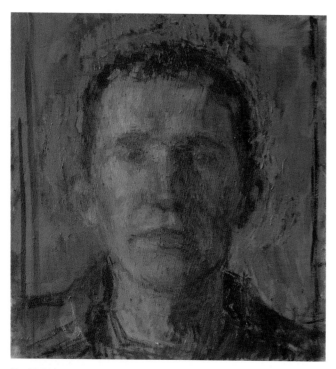

David, 2010.

John, 2013.

Self-portrait, 2004; painted at night with artificial light.

Consider beforehand

Before the model arrives be as prepared as possible, but also, and especially if it is for a session of three hours or so, make sure that you rest enough beforehand. Being in the company of a sitter for several hours is tiring, because of the amount of concentration that you are doing. Rest is even more important if you have two or more sitters throughout the day. Take breaks regularly, even as frequently as you feel like it, and you will be more refreshed as a result.

Creating something to reflect on

If a portrait can bring the memory of somebody back to us when we are with the picture, then it can be considered a success. If the memory of them is a fond one then that is even better. If you think of a portrait as something that you want to see, then it follows that it is also of somebody that you want to see. This is true of pictures of family or friends, but what about a commission or other picture of somebody that you do not know? One answer could be that you attempt to get to know them during the process of making the painting. This

Lucy, 2012.

is not always possible, but in most people you can probably find something you like or can be interested in. If you do not know the sitter so well, making them comfortable can be half the battle of the commissioned portrait from life. Compare the portraits of Tintoretto (1518–94) to those of Titian (1485–1576). Although Titian is confirmed historically as one of the greatest painters of all time, Tintoretto's portraits sometimes offer us a view of a stronger and more complete or resolved person, which may be due to some technical aspects of his painting process.

What scale?

It is more common to work smaller than life size, but larger than sight size. Life size is the same size that something is in real life, so measuring direct with callipers for instance will make an equivalent scale. Sight size is the size that something appears in your vision. Of course this depends on where you place the picture plane. This effectively is your canvas. The closer the picture plane is to you then the smaller the scale of the sight size image will be. The further away the picture plane is then the larger the scale of the sight size image will be.

You can imagine what the size of somebody sat close to you

Man against the wall (in progress), 2015.

would be when projected onto a canvas which is placed further away than your model. This image, although still termed 'sight size', is larger than life. This is because of the model's and your own position in relation to the canvas. Because of the movement necessary to and from the canvas in order to do the painting, the process can become quite difficult.

I have generally painted at a scale that is between slightly smaller than life size and a bit bigger than sight size. This will make a head appear approximately 15–25cm tall and 10–20cm wide. The largest scale that I ever painted a head at was about

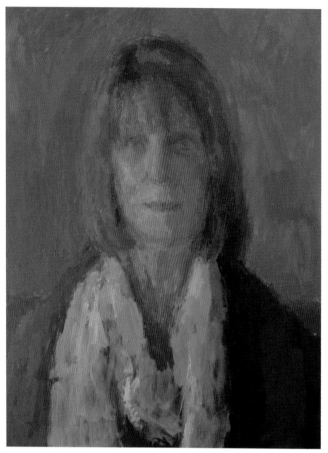

Sylvia, 2013.

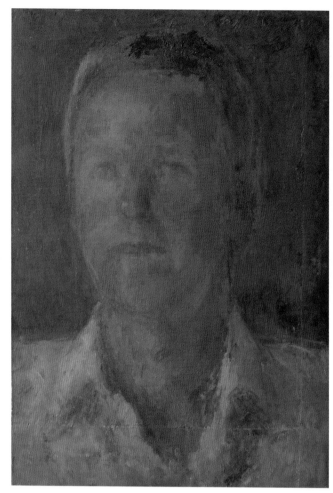

Stephen, 2011.

40cm tall. Giant heads can have an impact unlike any other type of picture; this is largely because of being able to read the expression of the face from a great distance.

Commissions

The commissioning process usually works by somebody wanting a picture to be painted of somebody else. Often it is a family member, sometimes children, but the commission can be industry based, for instance a college or business leader. If somebody has seen your way of painting and would like you to paint a picture for them, then the next step is that you receive some form of communication. Many commissions go wrong at this point, but if enough work is put into clarifying this interaction then the agreement and arrangements can be made and the painting can begin to get underway. Communication can be through a third party, for instance if you are a member of a portrait society or group; being a member of a group can enhance your visibility, so that more people will see your paintings. It is

a good idea to get as clear a notion as possible of what kind of picture the commissioner wants.

Arrangement of sittings

What is the ideal location for you? Do you like the idea of travelling to the sitter's natural environment, or would you prefer it if they came to your studio? You might need to try both in order to know what arrangement will give the best result. The next consideration is of timing, since this will affect the light.

Payment is traditionally in instalments, with either a third, or half, of the total price being made at the start. This is usually non-refundable. Be aware from the beginning that not all commissions are met with approval, and that things can go wrong. In order to minimize the chances of this happening it is best to arrange for as much as you can of the process to be on your terms. Every arrangement should be made with the aim of making the best work possible. Communication about what it is that you are intending to do can help to explain aspects of the painting, and also allow the commissioner or sitter to have an input.

Visibility throughout the process

Some painters will work in privacy, not showing anybody the picture in its state of progress. Others will allow photographs to be made, and will try to get other opinions about the picture whilst in progress. Primarily this will be from the sitter and the commissioner, but additionally a friend who is also an artist might be able to give helpful criticism. This could be about elements such as composition, form, light, but also the actual handling of the paint. Advice can help the process to be smoother in some ways, especially so that when the painting is presented it is not too much of a shock to the viewer. It is not easy to keep the picture interesting to you as a painter, and at the same time to keep improving it in the eyes of the sitter and the commissioner. Since full payment is only completed when the painting is delivered, it is important that it meets requirements and is generally liked. It can be tricky learning to trust your own judgement, and as you develop this it can be useful to hear opinions made by those who you trust.

> … an artist has to navigate forward into the unknown guided only by an internal sense of direction, keep up a set of standards which are imposed entirely from within, meanwhile maintaining faith that the task he or she has set him or herself is worth struggling constantly to achieve.
> – Lucian Freud

Difficulties can crop up

An awareness of the idea that people have of themselves is something that may aid a commissioned portrait, since the sitter will be presenting it in the picture. If your painting is primarily observational, however, then the likelihood is that your image may be a surprise to the sitter. One way around this is not to do commissions. A good commission is when the person paying for it trusts completely the view of the painter, but this might not result in the best work. When a commissioner questions the way the painter is working it can raise the standard of the picture. As with all types of pressure though there is a danger that it will all go wrong.

The commissioner is not making the painting, and at heart you should be sensitive to your own needs in order to preserve your judgement in as clear a manner as possible. Build each picture as something only you are responsible for and make it as good as you can. If this is your criterion then the weight will fall onto the observation you make, and how the appearance of the subject within the painting is portrayed.

If commissions seem difficult, then persuade friends to sit for you or use paid models. Exchanges of sitting with other painters can be a good idea too.

Achieving variety

Multiple sitters

Paint as many people as you can. I think it was Whistler (1834–1903) who said that a portrait painter's studio should have a waiting room, just like the dentist's. The less pressure you attach to each painting the more chance it will have of being a picture free of the tension and worry that can affect a painting in a negative way. The change of subject can also be visually refreshing, and new ideas, with the pose for instance, can happen quite spontaneously in this way.

Always look for the inter-relation of features that is particular to each sitter. When you look at the classical or antique head, either as a cast or an original, look to see how it is the proportion rather than the specifics that are studied most thoroughly.

Painting different genres

To complement the practice of portrait painting from life, paint other subjects at the same time. It is positive to have solitude in the studio, and to spend time painting alone. Ideas can spring up on good days, and with time you can apply yourself to painting these other pictures. The quality of the work itself is never really known during the process of painting, and it can take a very long time to see if anything you have done is any good. Pictures made with some aspect of casualness can be as appealing as ones that have been much fraught over.

When we concentrate, we feel better afterwards. So the activity is always worthwhile, even if there is not a result every time to show for it. Still life, interiors, landscapes; all of these kinds of picture will inform or influence the way that you want to paint the portrait, because of their shared observational source.

Painting the head as an object

In painting the head we usually paint the portrait. What is the distinction? A portrait can be seen to be primarily a painting of a face or an expression. When we think of a head it is the object and the form that spring to mind more immediately. Our face is only a fraction of our whole head; so it is one purpose of this book to think of the portrait in perspective and in relation to the head.

If we paint the head as an object, it can inform better and make stronger the structure and form of the painting. The head is connected to the body, and so this extended relation helps to make a portrait seem real, or convincing in the way that it is painted. One difficulty in this is in sustaining your interest visually in the subject. It is good practice to challenge your painting, but also to remove any of the paint that does not work as well. Rembrandt is a good example of this in how he

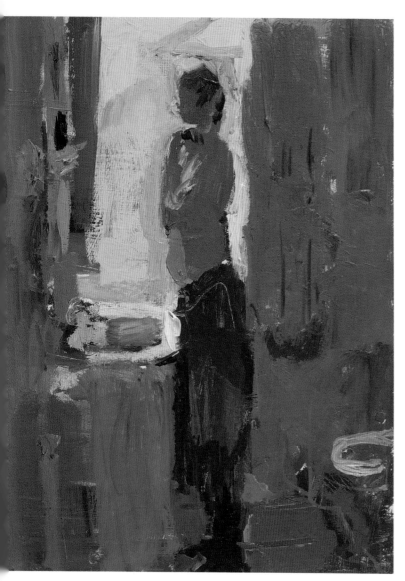

Dominique in the bathroom, 2015.

In practical terms, the younger the model the less chance there is of them sitting still for long enough. I find that direct engagement can give you the best chance – keep asking questions and maximizing the eye contact so as to give your memory the best chance at recalling them. Another method is to attempt to paint from a photograph that you have taken of the model. If you prefer to paint from life then one painter who achieved this well was Renoir. Look at the fluidity of his handling of the paint across several variations of portrait composition.

Perennial problems

Distracting edges

When you look at a picture of somebody it should keep your eye for as long as possible on their face. One technique for doing this is to have a dark background, built up with glazes in order to completely surround the head, and to set it off as well as possible.

One problem with the painted portrait is that sometimes there is a discrepancy in the language of paint used to describe the person and their surroundings. Over time, with reflection, it is worthwhile experimenting with the colour that you want. The effect of this colour that you are trying to create should be that it helps to keep the eye resting on the face in the picture for as long as possible. A flatter colour will be less distracting for the eye than a broken mark, which may contain contrasting tones. Complete flatness in a background may need some interruption to help balance the concentration. Ultimately it is the way the face is painted that is most important, but the surrounding colours must be considered too.

See it afresh

The best advice after working on a portrait is to turn it away; then when you cannot remember what it looks like you are ready to put it onto the easel again. This is Renoir's suggested method that he advised to other painters. This may take days or weeks or even months, but when you see it afresh, you will have a much better and clearer instinctive idea as to what to change in the painting. I suppose this may be why painting is viewed as a patient profession.

It is easier to paint on the picture when you know that the subject or model is going to return. This is one method to help you when attempting to remain calm and to not panic. Tampering with a painting without the model there is something that Thomas Gainsborough (1727–88) warned against. He said that he only ever painted the portrait when the sitter was there. I can think of many times when I have over-worked

simplified the surroundings in his portraits. Delacroix wrote, 'It is not really until you get to Rembrandt that you see the beginning, in pictures, of that accord between accessories and the chief subject, which seems to me to be one of the most important elements, if not the most important one.'

A range of ages

The age of your sitter will be one of the more noticeable aspects of your picture. Some painters, by means of their way of painting, have a habit of making people look older than they are. This may be due to looking for contrast in the tone, or the way of applying the paint. It can be a good test of skill to paint a range of ages.

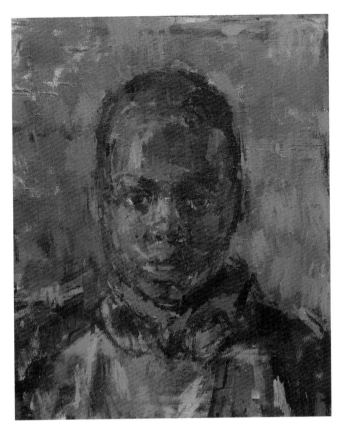

Hilcious, 2009.

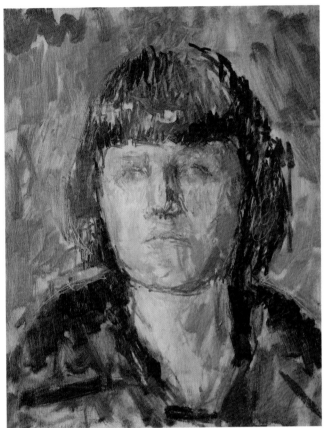

Gudrun, 2010; first session.

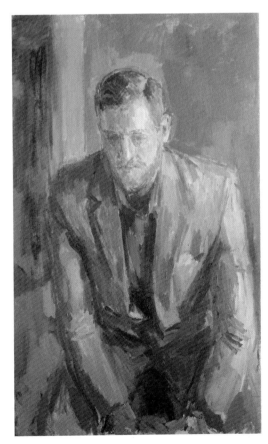

a picture without the model there, causing the image to be lost and the whole process to be started over again. A balance must be sought between developing the picture as much and as well as we would wish for, and the connection with the subject. When the sitter is there we must seek to get as close to their likeness as we can in the picture. This is only ever achieved by the inter-relation of the features and the head, as they are seen.

When we are drawing the eye must work the hardest. Look not just from one feature to the next but skip through and between eyes, nose, mouth and ears frequently, so as to check the relationships between them. This is the way of looking that you must constantly apply in order to draw the way that you see the face. It is impossible to look enough at all parts of the model, and there will always be some imperfection when we draw. It is enough to try to make the portrait as good as we can, and for it to be like the experience of looking at, and being with, that person.

Kit, 2014.

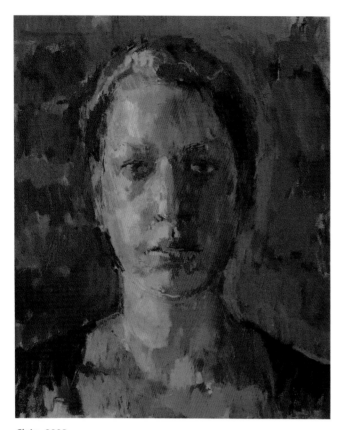

Claire, 2008.

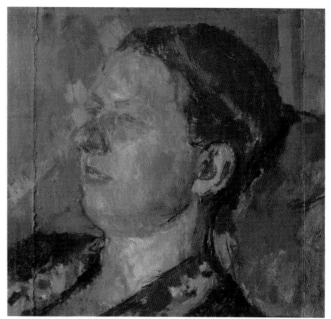

Claire (profile), 2009.

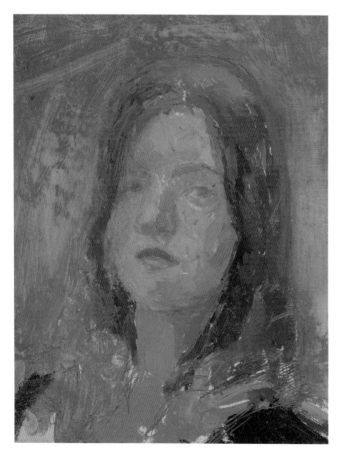

Jess, 2014.

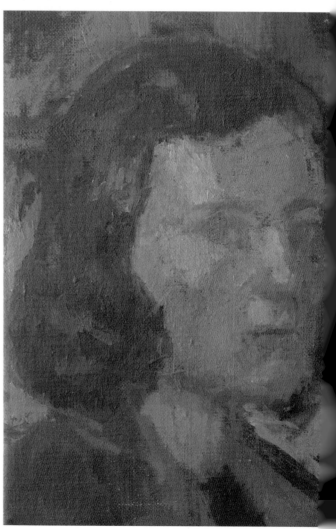

Helen, 2011.

Acknowledgements

My sincere thanks to Lucy Mellor, Nicholas Herman, Art in Action, The Royal Society of Portrait Painters, The New English Art Club, The Royal Drawing School, Chelsea College of Art and Design, The University of Hertfordshire, my grandmother Thelma Ingrey, my parents Jacqueline and Derrick Shadbolt, Susan Wilson, Ian Rowlands, Robert Dukes, Susan Engledow, Veronica Ricks, Roger Leworthy, John Walton, Tony Mott, Allan Ramsay, Danny Cuming, Alice Finbow, Tony Merrick, Jane Joseph, Carl Randall, Minna Stevens, Catherine Goodman, Thomas Newbolt, John Lessore, David Caldwell, Massimo Franco, Fred Crayk, Claire Harmer, Megan Players, David Woodcock, Atul Vohora, Elizabeth Mitchell, Tim Dry, Paul Stalham, Ruska Tuuli, Claudia Carr, Anne Waller, Clyde Hopkins, Mali Morris, Ken Howard, Kaye and Nick Howe, Tim Benson, my brothers Joe and Ben Shadbolt, my sisters Melanie Thomas and Jayde Shadbolt, Tom Smith and Millie May Smith, Morgan Thomas and brothers, Miriam Escofet, Caroline Payne, Clare Payne, Helen Martin, Jeffrey Dennis, Rob Welch, Bill Clark, Chris Offili, Jane Bond, Andy James, Antony Williams, Karn Holly, Mary Volk, Anna Babovic, Hero Johnson, Jonathan Ross, Camilla Shivarg, Chantal Joffe, Kaye Donachie, Dexter Dalwood, Ann Dowker, Jeffery Camp, Anthony Eyton, Jessica Biggs, Francesca Gonshaw, Paul Gopal-Choudhury, Sarah Jane Moon, Melissa Scott-Miller, Alan Parmenter, Sally Mae McDonald, Paulina Pluta, Laura Saksana, Gudrun Mahw, Hugh Valentine, Stephen Guy, Murphy, Patrick, Natasha, Jill Poloneicki, Aude Dib, Sharon Low, Stefania Lukoff, Matilda Tristram, Hannah Tristram, Emma and Mikey, Christelle Pardo, Kim Scouller, Helen Burgess, Michael O'Sullivan, Dennis O'Sullivan, Bernadette, Donovan, Karl-Peter Penke, Toby Eckersley, Tim Eckersley, Charlotte and Colin Kentish-Barnes, Penelope Eckersley, Jim Stoten, Tom Stallard, Dan Trilling, Beth Morgan, Anne and Angus McLean, Suzie and Matt Pope, Angelique Juliet Toy, Jenn Kyner, Ed Field, L.L.E., Lawrie Seal, Ilaria Rosselli del Turco, Alex Fowler, Will Harner, Dominique Densmore, Kit Bolton, Vida Tull, Perdita Stott, Max Willey, Lawrence Lartey, Anya, Asya Gefter, Denise and Tim Ferley, Xiaoyang, Melissa Ashford and John Hardwick, Sylvia Howe, Marcela and Hilcious Herman, Jess Overbury, David Stubbs, Patrick Sheehan, Joanna Goodman, Colleen Quill, Jane Cochrane, Alan Power, Jane Kelly, Sofija Ristic and to many others who have inspired, helped and supported me. Thank you.

INDEX